MANGA
DRAWING DELUXE

EMPOWER YOUR **DRAWING** AND **STORYTELLING SKILLS**

NAO YAZAWA

ROCKPORT

Inspiring | Educating | Creating | Entertaining

Brimming with creative inspiration, how-to projects, and useful information to enrich your everyday life, Quarto Knows is a favorite destination for those pursuing their interests and passions. Visit our site and dig deeper with our books into your area of interest: Quarto Creates, Quarto Cooks, Quarto Homes, Quarto Lives, Quarto Drives, Quarto Explores, Quarto Gifts, or Quarto Kids.

First published in 2020 by Rockport Publishers, an imprint of The Quarto Group,
100 Cummings Center, Suite 265-D, Beverly, MA 01915, USA.
T (978) 282-9590 F (978) 283-2742 QuartoKnows.com

Rockport Publishers titles are also available at discount for retail, wholesale, promotional, and bulk purchase. For details, contact the Special Sales Manager by email at specialsales@quarto.com or by mail at The Quarto Group, Attn: Special Sales Manager, 100 Cummings Center, Suite 265-D, Beverly, MA 01915, USA.

10 9 8 7 6 5 4 3 2 1

ISBN: 978-1-63159-809-8

Digital edition published in 2020
eISBN: 978-1-63159-810-4

Library of Congress Cataloging-in-Publication Data

Yazawa, Nao, author.
Manga drawing deluxe : empower your drawing and storytelling skills
 / Nao Yazawa.
1. Comic books, strips, etc.--Japan--Technique. 2. Cartooning--Technique.
3. Figure drawing--Technique.
LCC NC1764.5.J3 Y39 2020 | DDC 741.5/1--dc23

LCCN 2020002533 | ISBN 9781631598098 | ISBN 9781631598104 (eISBN)

Cover Design: Stacy Wakefield Forte
Page Layout: Sporto
Illustration: Nao Yazawa

Printed in China

CONTENTS

INTRODUCTION 4

FACE 25

BODY 55

BACKGROUND 98

COMPOSITION 116

GLOSSARY 142

ABOUT THE AUTHOR 143

ACKNOWLEDGMENTS 143

INDEX 144

HI THERE!

INTRODUCTION

Hello,

My name is Nao Yazawa. I'm a Tokyo-based, self-taught manga artist and teacher. Throughout the years, I've searched for good how-to books for drawing manga to use in my class—especially ones that discuss composition and story/panel flow. I finally decided to make one myself.

Manga Drawing Deluxe isn't your ordinary how-to book. I wrote it with a storyline, so you can follow Anne and her brother Dan along their manga adventure, guided by two manga elves and me (with a little help from my cat, Kuro).

I've included as many topics about drawing manga as possible. From drawing characters to composition, you can learn the entire manga-making process here. My hope is that you can use this book for many years, so I included some advance techniques in the background and construction sections.

Once you embark on your (and Anne's and Dan's) manga journey to get an idea of the manga drawing process, you can go through this book in order or jump to whichever part you'd like to focus on—face, body, background, or composition. Learning how to compose a graphic novel will give you a new perspective on manga and will help you enjoy reading them even more.

If you don't draw manga, this book is a good resource to learn how Japanese artists create their work.

I hope you enjoy this book and learn a lot about how to draw manga!

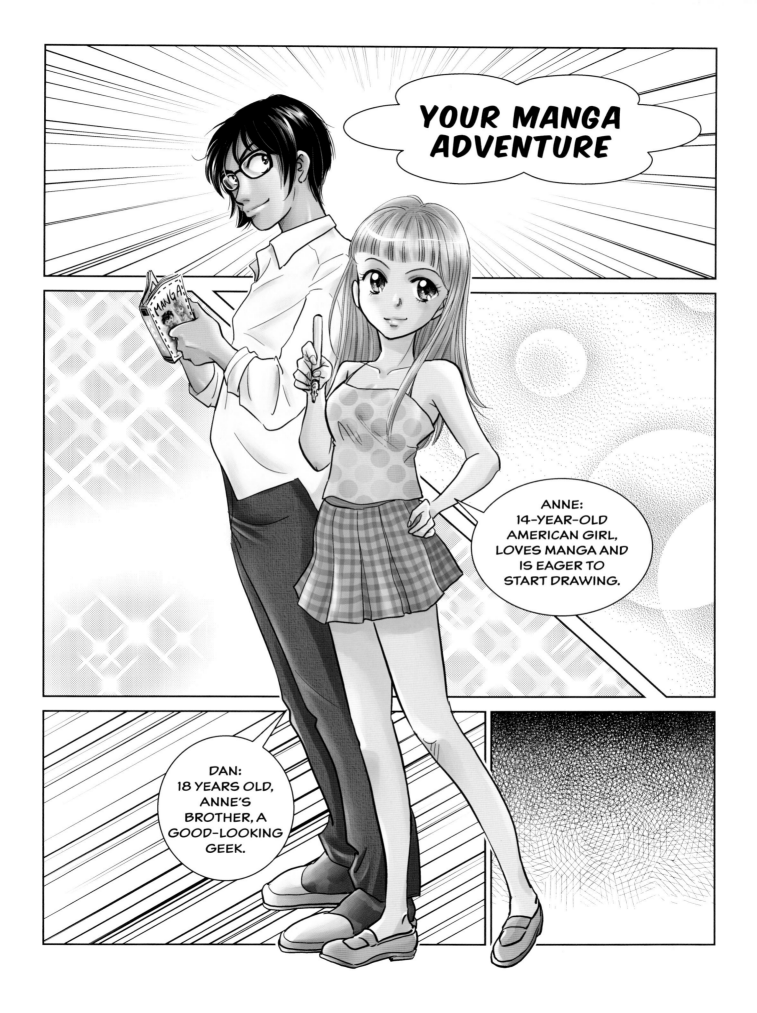

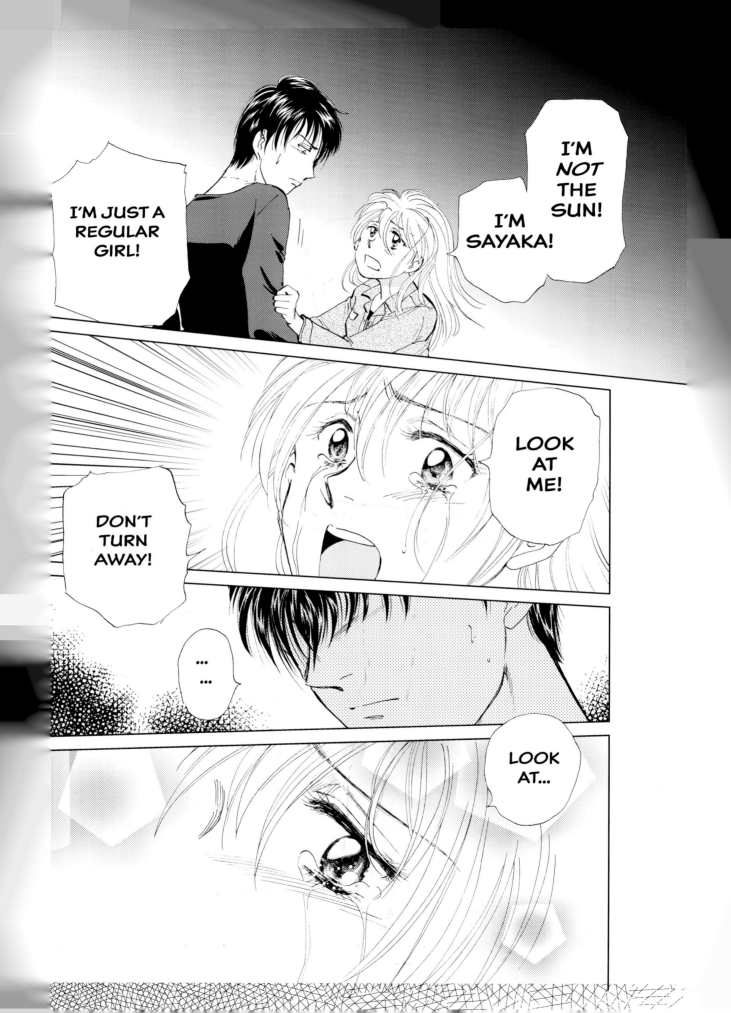

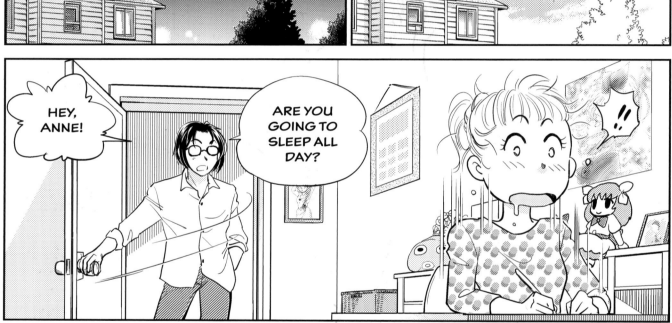

......

LOUSY.

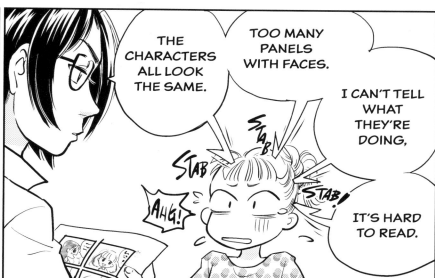

THE CHARACTERS ALL LOOK THE SAME.

TOO MANY PANELS WITH FACES.

I CAN'T TELL WHAT THEY'RE DOING,

STAB

STAB

AHG!

STAB!

IT'S HARD TO READ.

HOW MEAN!! YOU'RE SUPPOSED TO SAY "WELL DONE," "AWESOME"

YOU WANT ME TO LIE?

TO YOUR SWEET BABY SISTER.

THOSE ARE COMMON PROBLEMS FOR BEGINNERS.

?

EVERYONE DRAWS LIKE THAT AT THE BEGINNING.

DON'T WORRY!

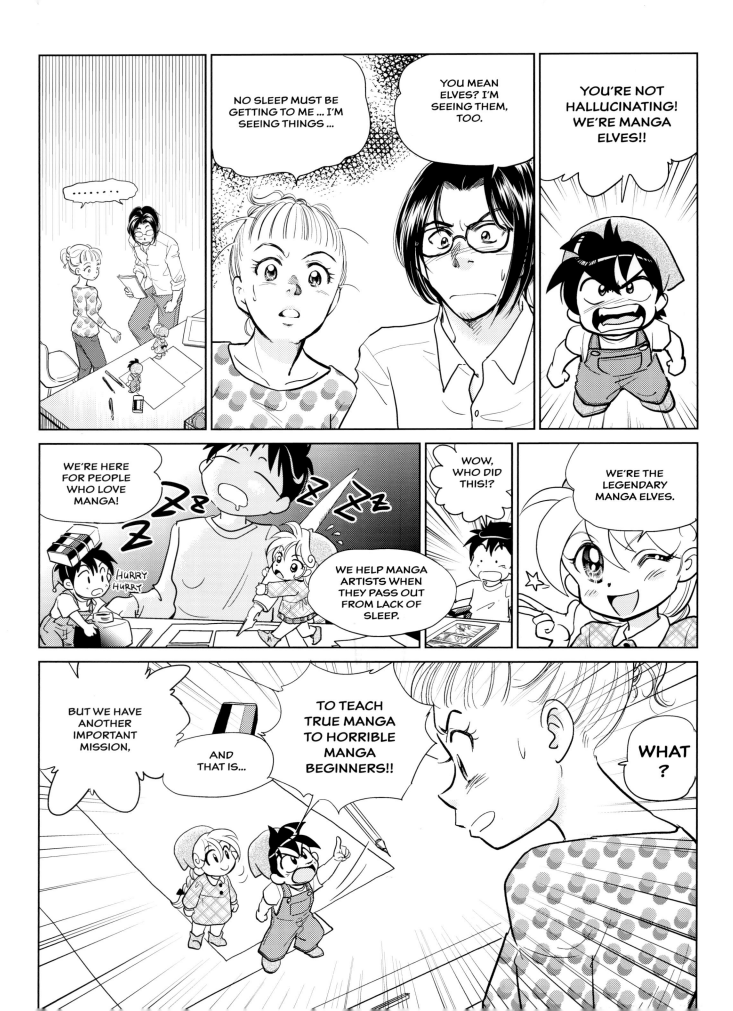

HORRIBLE?!

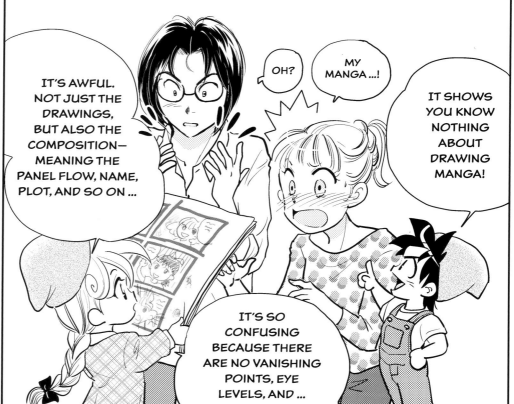

IT'S AWFUL. NOT JUST THE DRAWINGS, BUT ALSO THE COMPOSITION— MEANING THE PANEL FLOW, NAME, PLOT, AND SO ON ...

OH?

MY MANGA ...!

IT SHOWS YOU KNOW NOTHING ABOUT DRAWING MANGA!

IT'S SO CONFUSING BECAUSE THERE ARE NO VANISHING POINTS, EYE LEVELS, AND ...

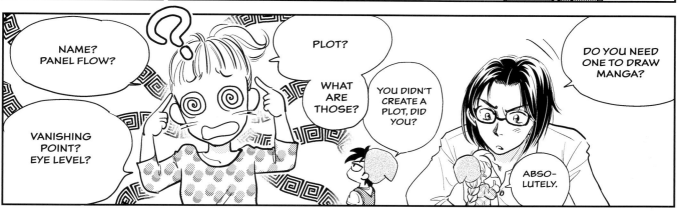

NAME? PANEL FLOW?

VANISHING POINT? EYE LEVEL?

PLOT?

WHAT ARE THOSE?

YOU DIDN'T CREATE A PLOT, DID YOU?

DO YOU NEED ONE TO DRAW MANGA?

ABSO- LUTELY.

1. IDEA

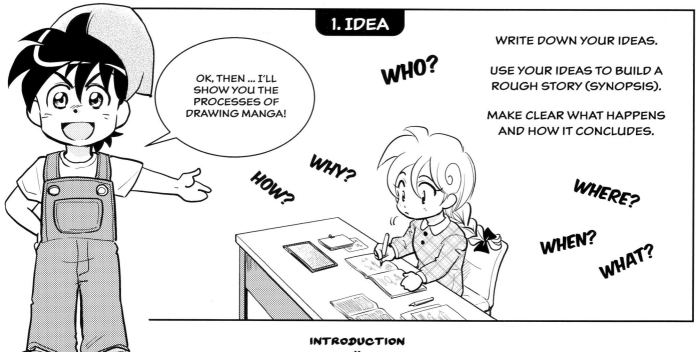

OK, THEN ... I'LL SHOW YOU THE PROCESSES OF DRAWING MANGA!

WRITE DOWN YOUR IDEAS.

USE YOUR IDEAS TO BUILD A ROUGH STORY (SYNOPSIS).

MAKE CLEAR WHAT HAPPENS AND HOW IT CONCLUDES.

WHO?

WHY?

HOW?

WHERE?

WHEN?

WHAT?

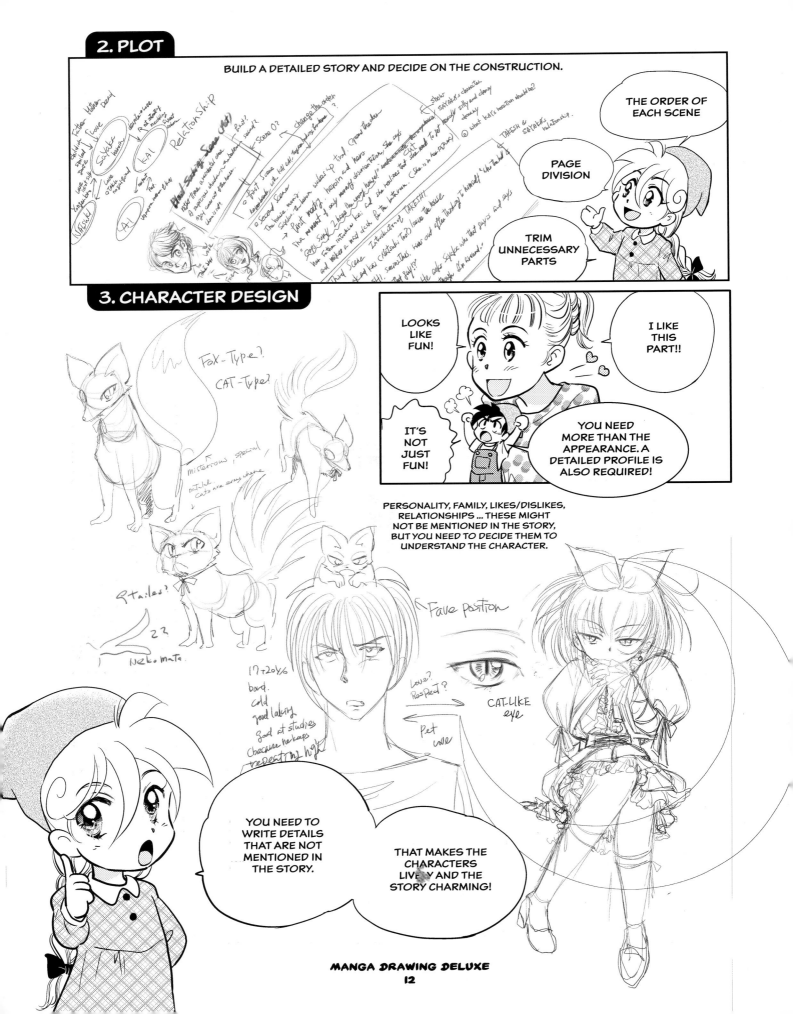

2. PLOT

BUILD A DETAILED STORY AND DECIDE ON THE CONSTRUCTION.

THE ORDER OF EACH SCENE

PAGE DIVISION

TRIM UNNECESSARY PARTS

3. CHARACTER DESIGN

LOOKS LIKE FUN!

I LIKE THIS PART!!

IT'S NOT JUST FUN!

YOU NEED MORE THAN THE APPEARANCE. A DETAILED PROFILE IS ALSO REQUIRED!

PERSONALITY, FAMILY, LIKES/DISLIKES, RELATIONSHIPS ... THESE MIGHT NOT BE MENTIONED IN THE STORY, BUT YOU NEED TO DECIDE THEM TO UNDERSTAND THE CHARACTER.

Fox-Type?
CAT-Type?

YOU NEED TO WRITE DETAILS THAT ARE NOT MENTIONED IN THE STORY.

THAT MAKES THE CHARACTERS LIVELY AND THE STORY CHARMING!

SET THE DIALOGUE AND DRAWING COMPOSITIONS.

DO THE CHARACTERS' SPEECH TONES FIT?

DO THEY AGREE WITH THE CHARACTERS?

THIS IS THE ESSENCE OF MANGA!

EVEN IF A STORY IS GREAT, A CLUMSY STORYBOARD CAN MAKE IT BORING.

TO CHECK THE BALANCE, VIEW IT IN TWO-PAGE SPREADS.

OK, YOU CAN FINALLY START DRAWING!!

PHEW

YOU DIDN'T DO ANYTHING!

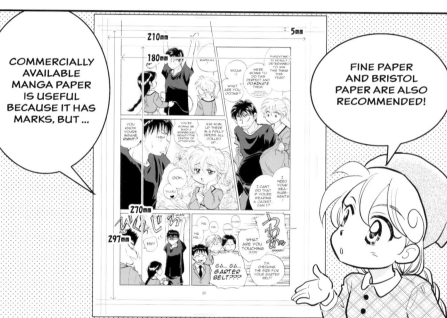

COMMERCIALLY AVAILABLE MANGA PAPER IS USEFUL BECAUSE IT HAS MARKS, BUT ...

FINE PAPER AND BRISTOL PAPER ARE ALSO RECOMMENDED!

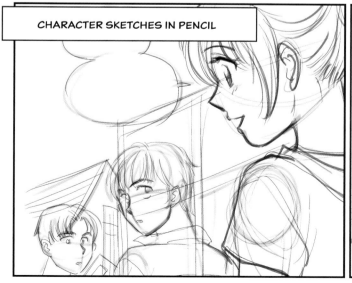

CHARACTER SKETCHES IN PENCIL

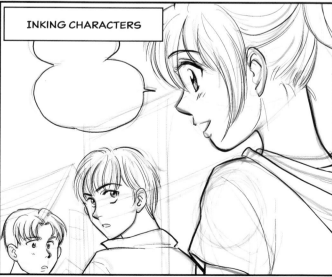

INKING CHARACTERS

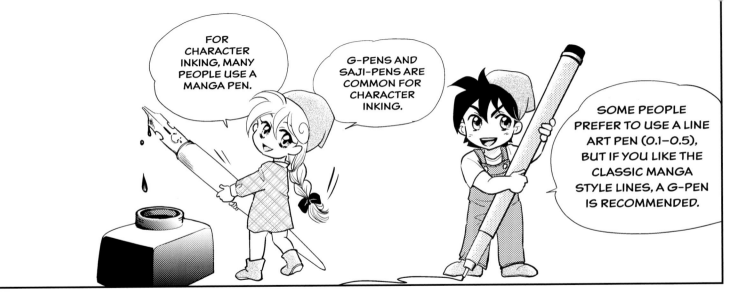

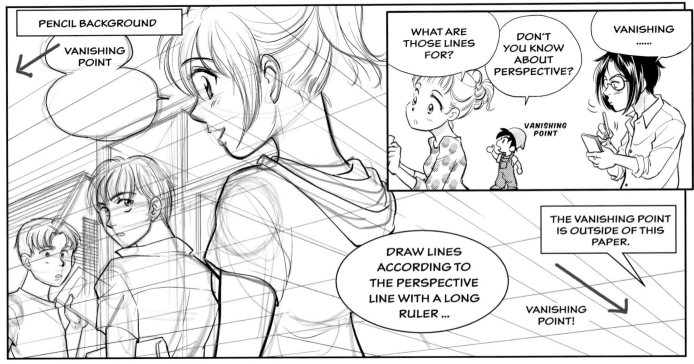

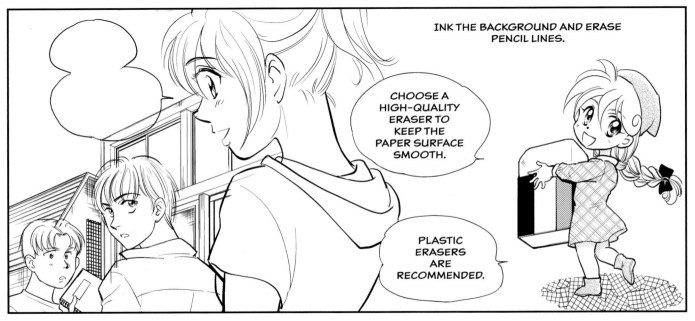

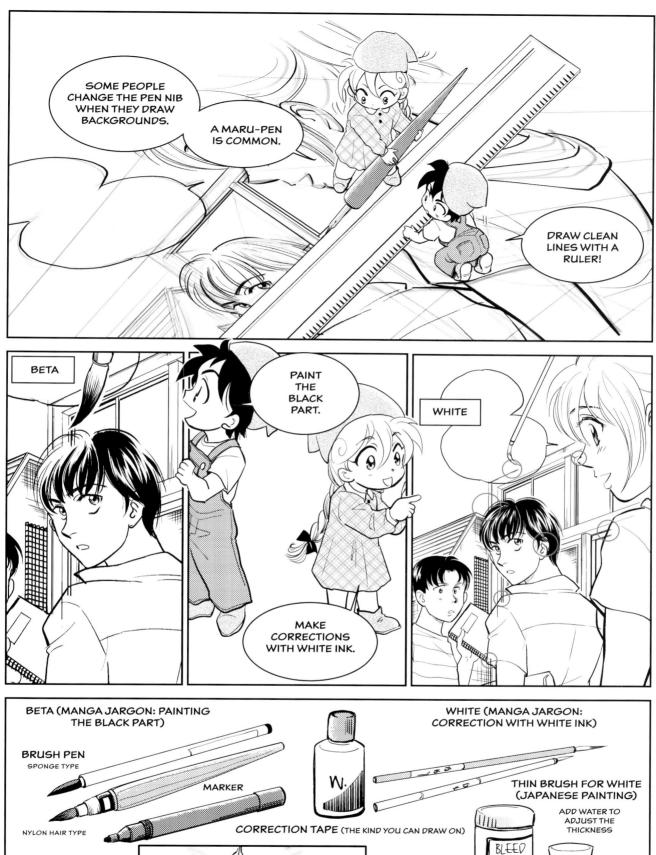

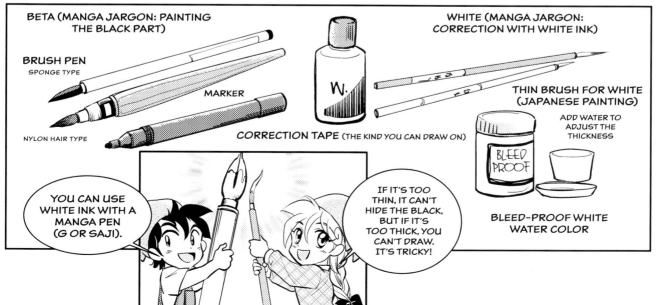

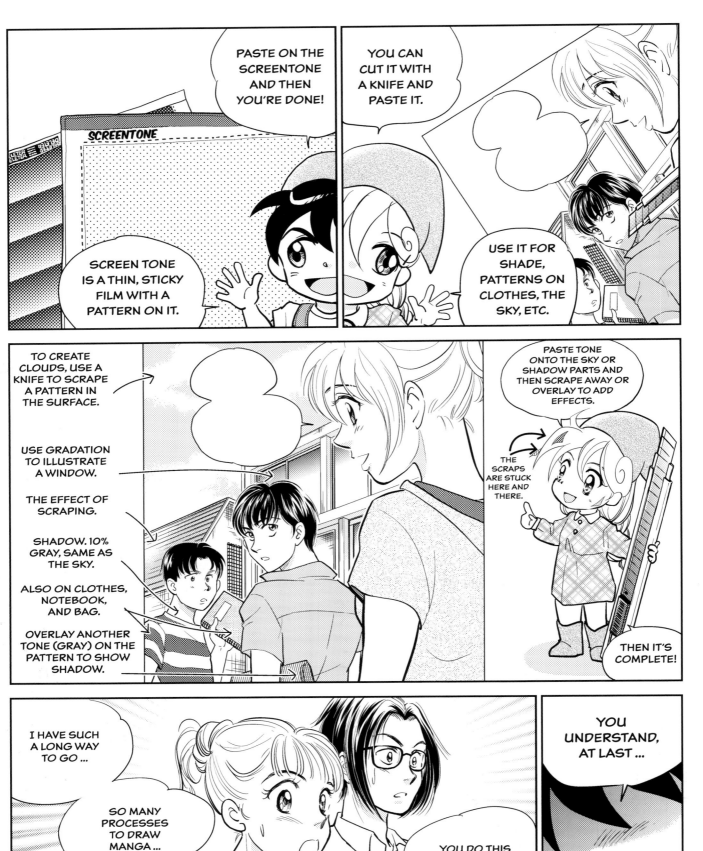

MANGA ARTISTS DO EVERYTHING THEMSELVES!

STORY! STORYBOARD! CHARACTER DESIGN! BACKGROUNDS! RESEARCH! SPECIAL EFFECTS! TONE WORK! AND MORE!

ARE YOU PREPARED TO DO THIS TO YOUR WORK?!

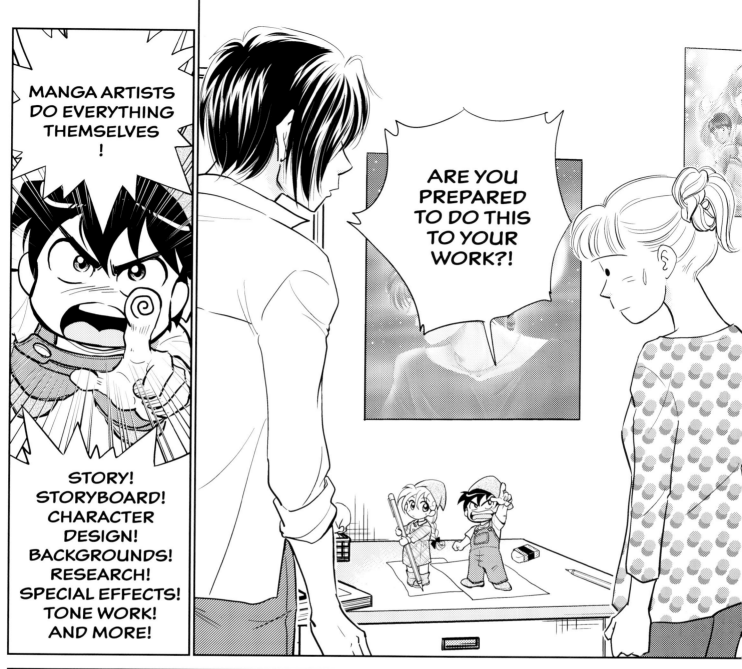

UH ...

LEARN HOW TO DRAW MANGA FROM ... A HALLUCINATION ???

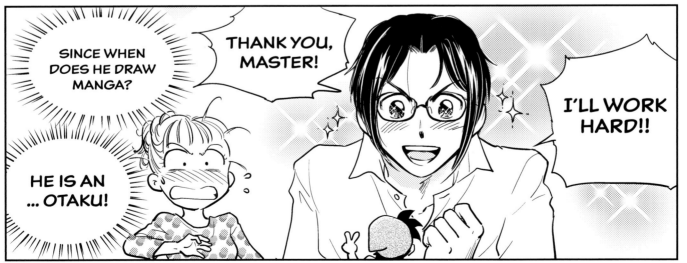

NAO YAZAWA IS GOING TO GIVE YOU A BRIEF LESSON AND THEN PROVIDE PERSONAL TIPS AS WE CONTINUE OUR MANGA JOURNEY.

HOLD ON!

IT'S GREAT THAT YOU'RE EXCITED TO START DRAWING MANGA, BUT YOU NEED TO LEARN ITS HISTORY FIRST.

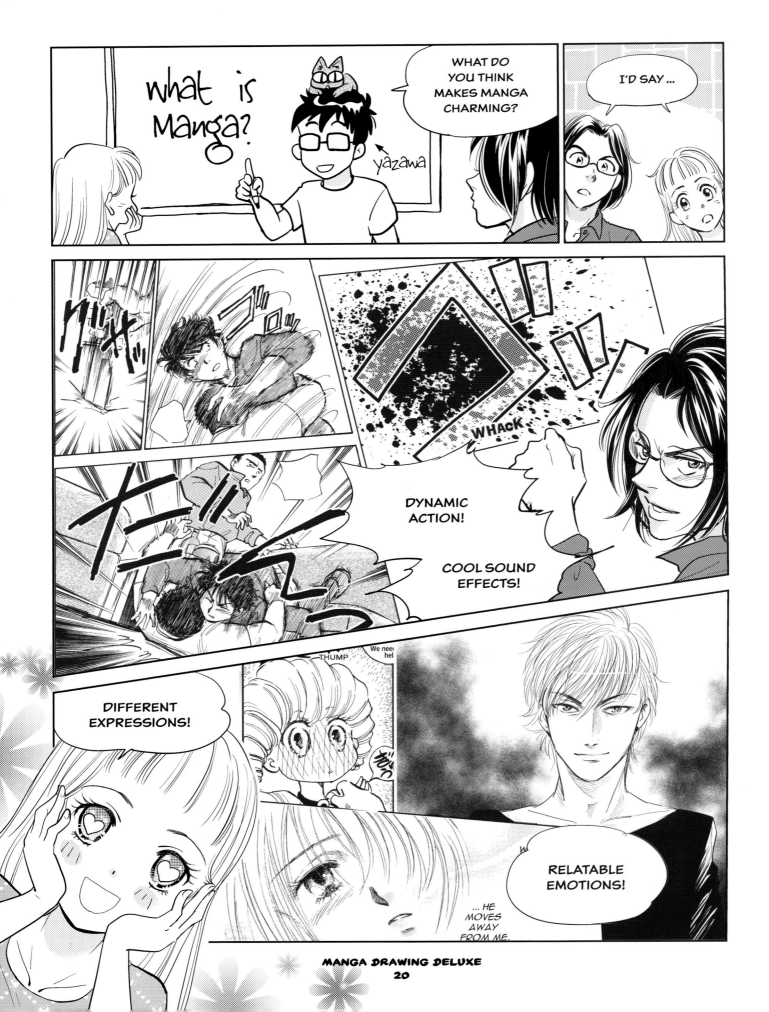

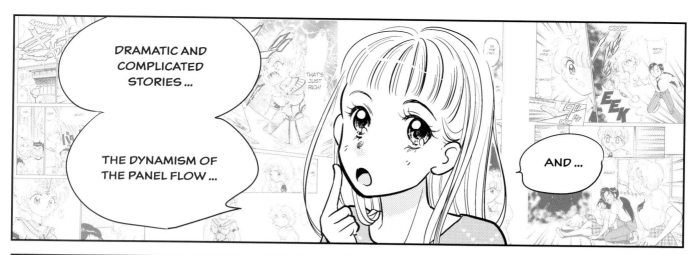

DRAMATIC AND COMPLICATED STORIES ...

THE DYNAMISM OF THE PANEL FLOW ...

AND ...

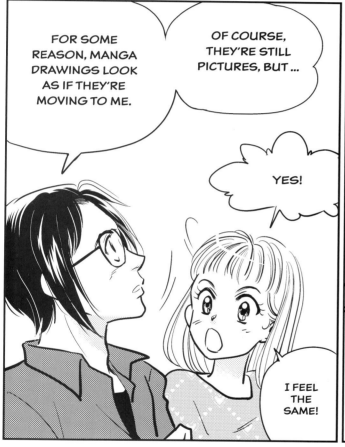

FOR SOME REASON, MANGA DRAWINGS LOOK AS IF THEY'RE MOVING TO ME.

OF COURSE, THEY'RE STILL PICTURES, BUT ...

YES!

I FEEL THE SAME!

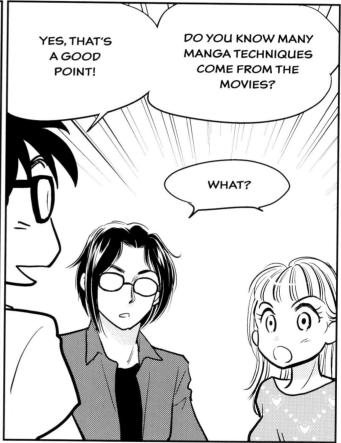

YES, THAT'S A GOOD POINT!

DO YOU KNOW MANY MANGA TECHNIQUES COME FROM THE MOVIES?

WHAT?

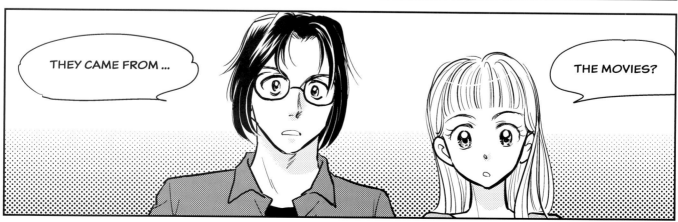

THEY CAME FROM ...

THE MOVIES?

It's well-known that Osamu Tezuka (*Astro Boy*, 1952) is a founder of contemporary manga. He is said to be the first person who imported techniques from movie to manga. A lot of dynamic panel work in manga comes from movies.

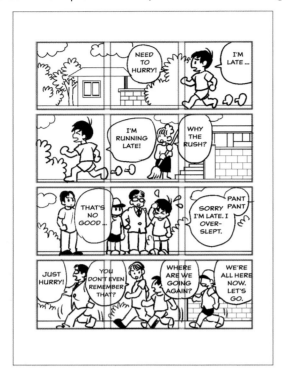

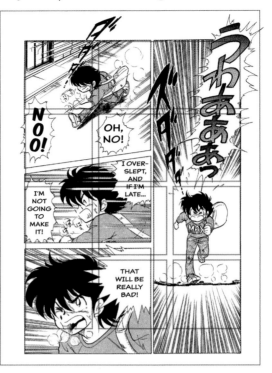

THE PANELLING IS MONOTONE.
NO VARIATION IN THE CAMERA ANGLES.
LOOKS LIKE A STAGE PRODUCTION.
THE CHARACTER SIZE STAYS THE SAME.

DYNAMIC PANELLING THAT USES DIAGONAL LINES AND THE BLEED.
THE CHARACTER'S APPROACH IS GIVEN MOVEMENT BY USING THE
RULES OF PERSPECTIVE AND A CLOSE-UP SHOT.
THE CLOSE SHOT OF THE CHARACTER'S EYES EMPHASIZES THE
URGENCY OF THE SITUATION.

*THE BLUE LINES SHOWING 3 COLUMNS AND 4 ROWS ARE THE TRADITIONAL PANELS OF MANGA.

Tezuka's work had a major impact on kids. Fascinated by manga—perhaps even addicted—some young readers went on to become manga artists. The first generation of Tezuka's followers developed manga even further.

A DIFFERENT GROUP CALLED THEIR STYLE "GEKIGA"
INSTEAD OF "MANGA." THEIR WORKS WERE FOR
GROWNUPS AND FEATURED MORE SEX AND VIOLENCE.

BUT THIS BOOK IS ABOUT MANGA TECHNIQUE,
SO I WON'T GO INTO DETAIL.

Tezuka's followers developed manga techniques and worked to improve by learning from movies and friends. Some of them wanted to make movies and fulfilled this hunger by drawing manga as if it were a movie. How could it be made like a movie? How could it be *better* than a movie?

HOW DO
WE SHOW
SOUNDS IN
MANGA?

LIKE A
MOVIE!

I HAVE A
GOOD IDEA
FROM A
KUROSAWA
MOVIE!

Back then, television was not yet widely available, so movies were a major source of entertainment. Some young manga artists watched movies all day and memorized the scenes they watched.

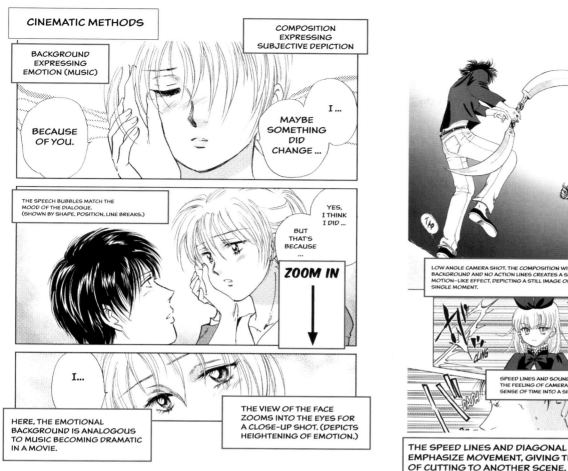

CINEMATIC METHODS

BACKGROUND EXPRESSING EMOTION (MUSIC)

COMPOSITION EXPRESSING SUBJECTIVE DEPICTION

BECAUSE OF YOU.

I ...

MAYBE SOMETHING DID CHANGE ...

THE SPEECH BUBBLES MATCH THE MOOD OF THE DIALOGUE. (SHOWN BY SHAPE, POSITION, LINE BREAKS.)

YES, I THINK I DID ...

BUT THAT'S BECAUSE ...

ZOOM IN

I...

HERE, THE EMOTIONAL BACKGROUND IS ANALOGOUS TO MUSIC BECOMING DRAMATIC IN A MOVIE.

THE VIEW OF THE FACE ZOOMS INTO THE EYES FOR A CLOSE-UP SHOT. (DEPICTS HEIGHTENING OF EMOTION.)

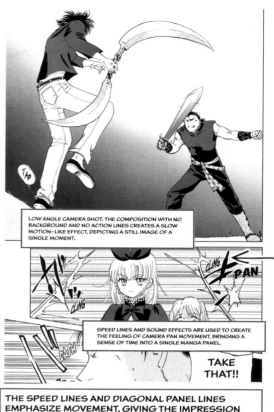

LOW ANGLE CAMERA SHOT. THE COMPOSITION WITH NO BACKGROUND AND NO ACTION LINES CREATES A SLOW MOTION–LIKE EFFECT, DEPICTING A STILL IMAGE OF A SINGLE MOMENT.

CLING
PAN
CLING

SPEED LINES AND SOUND EFFECTS ARE USED TO CREATE THE FEELING OF CAMERA PAN MOVEMENT, BRINGING A SENSE OF TIME INTO A SINGLE MANGA PANEL.

TAKE THAT!!

THE SPEED LINES AND DIAGONAL PANEL LINES EMPHASIZE MOVEMENT, GIVING THE IMPRESSION OF CUTTING TO ANOTHER SCENE.

Tezuka didn't just create new techniques of expression. He revolutionized story as well. Manga had mainly been educational works for children or satirical pieces for adults, but Tezuka featured various new topics like sci-fi and incorporated complex plots, depicting love/hate conflicts and human growth in a dramatic way, even in works meant for children. Many long manga with strong plots were created. They introduced multi-faceted characters who were neither good guys nor bad guys. These stories were told with cinematic expression.

In addition to movies, traditional Japanese arts like kabuki and Japanese painting techniques also contributed greatly.

IT HAS BEEN MORE THAN 60 YEARS SINCE TEZUKA'S DEBUT. DURING THAT TIME, MANY MANGA ARTISTS HAVE CREATED NEW EXPRESSIONS, AND SOME OF THOSE HAVE BECOME ESTABLISHED. THE MANGA OF TODAY ARE BUILT ON THOSE EXPRESSIONS.

YOU MIGHT SEE HOW MANGA HAS EVOLVED.

I WANT TO READ SHOJO MANGA FROM THE 60s!

HMM ... CINEMATIC EXPRESSION!

IF YOU HAVE THE CHANCE, I RECOMMEND READING MORE THAN JUST MANGA THAT ARE POPULAR TODAY. CHECK OUT TEZUKA'S EARLY WORKS AND MANGA FROM THE 60s AND 70s!

MANGA

FACE

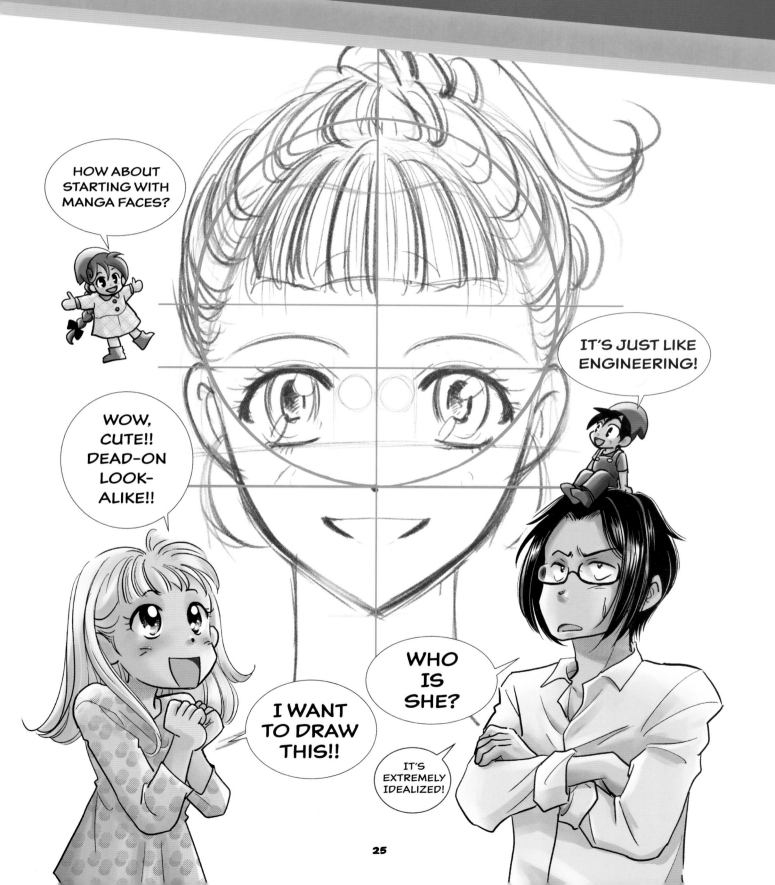

FRONT

MY DRAWING DOESN'T LOOK SO GOOD ...

HMM.

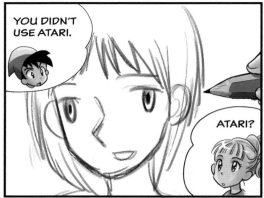

YOU DIDN'T USE ATARI.

ATARI?

USE GUIDELINES TO DRAW A CHARACTER'S FACE!

IT'S MANGA JARGON FOR GUIDELINES.

STARTING WITH A ROUGH SKETCH WILL HELP YOU POSITION EACH PART.

THE EYES, NOSE, MOUTH ... THINK ABOUT WHERE THEY ARE ON A SKULL.

EEW ... DON'T SHOW ME THAT!

CREEPY!

DRAW A CIRCLE AND SPLIT IT EVENLY, VERTICALLY, AND HORIZONTALLY.

DRAW ANOTHER LINE BELOW THE CENTER LINE (1/2 TO 1/3 OF THE WAY TO THE BOTTOM).

THE CIRCLE IS THE HEAD, AND THE FACIAL PARTS START FROM THE SECOND LINE.

DECIDE WHERE TO DRAW THE EYES AND EARS.

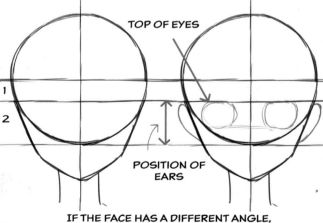

TOP OF EYES

1

2

POSITION OF EARS

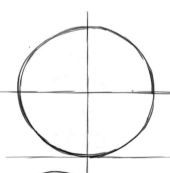

THE IMPORTANT THING IS TO DECIDE WHERE THE EYES AND EARS GO!

THERE ARE DIFFERENT METHODS FOR THIS, BUT THEY ALL HAVE THE SAME PURPOSE: TO ESTABLISH THE CENTER OF THE FACE AND THE POSITION OF THE EYES AND EARS.

IF THE FACE HAS A DIFFERENT ANGLE, THE EYE AND EAR LINES WILL BE CURVED ACCORDINGLY.

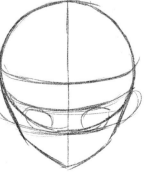

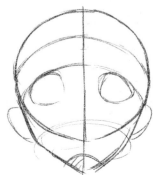

DRAWING GUIDELINES:

HEAD

FACE

JAWBONE

1/3 TO 1/2 THE WAY DOWN. THE LOWER THE LINE, THE YOUNGER THE CHARACTER LOOKS.

FILL IN THE PARTS.

THE EARS GO BETWEEN HERE.

DRAWING THEM LOWER MAKES THE CHARACTER LOOK CUTER AND YOUNGER.

DRAW THE IRIS AND THE PUPIL.

EYES ARE TYPICALLY LARGE. GIRLS HAVE BIGGER EYES.

DRAW HAIR.

HAIR WHORL

KEEP THE HAIR WHORL AND FLOW IN MIND WHEN DRAWING HAIR.

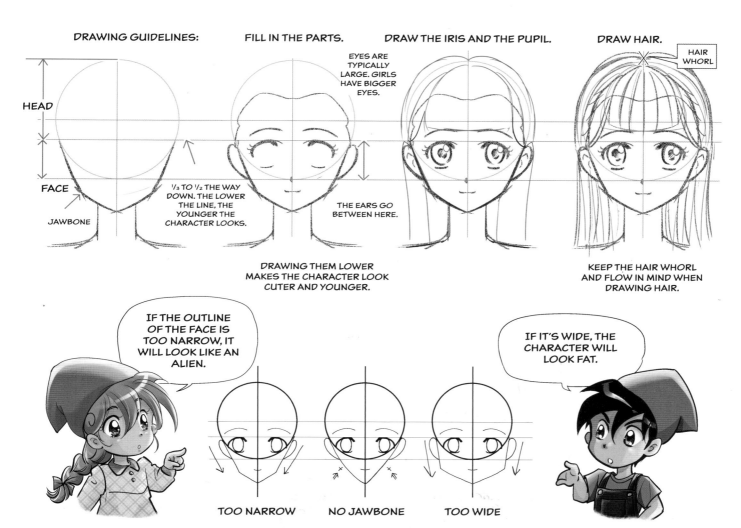

IF THE OUTLINE OF THE FACE IS TOO NARROW, IT WILL LOOK LIKE AN ALIEN.

IF IT'S WIDE, THE CHARACTER WILL LOOK FAT.

TOO NARROW

NO JAWBONE

TOO WIDE

EYES

PAY EXTRA ATTENTION TO THE HEIGHT OF THE EYES AND USE GUIDELINES TO CHECK!

THE SPACE BETWEEN THE EYES SHOULD BE THE WIDTH OF ONE EYE OR AROUND HALF THAT WIDTH.

MORE SPACE MAKES THE CHARACTER LOOK YOUNGER AND CUTER, BUT...

DRAW THE EYELID AND THEN THE EYE! PAY ATTENTION TO THE BALANCE BETWEEN THE BLACK PART AND WHITE PART OF THE EYE!

IT LOOKS CUTER WHEN THE BLACK PART IS BIGGER. LIKE A PUPPY!

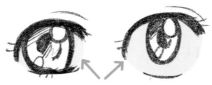

WHITE PART

THE POSITION OF THE PUPIL AND IRIS IN THE WHITE PART IS IMPORTANT TO SHOW EYE DIRECTION. WHEN YOU SET THEM SLIGHTLY INSIDE, THE CHARACTER LOOKS STRAIGHT FORWARD.

CENTER

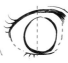

LEAVE PART OF THE EYE WHITE.

IF YOU DO TOO MUCH...

cross-eye!!

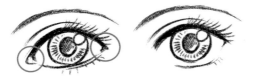

MANY ARTISTS DON'T DRAW BOTH ENDS OF THE EYES.

BE CAREFUL WITH THE WHITE PARTS OF THE EYES. THEY ARE IMPORTANT PARTS THAT SHOW WHERE THE CHARACTER IS LOOKING, WHEN THE CHARACTER IS FACING FORWARD, DRAW THE EYES SLIGHTLY INWARD.

BLACK EYES MOVE IN THE EYE DIRECTION BUT THE WHITE CIRCLES STAY IN SAME SIDE, BECAUSE IT IS A REFLECTION OF LIGHT.

NO!

THE WHITE CIRCLES ARE REFLECTED LIGHT, SO THEY SHOULD NOT BE SYMMETRICAL. DRAW THEM ON THE SAME SIDE OF EACH EYE!

HAIR

THINK OF HAIR AS HAVING THREE PARTS!

NOOOOO ~

WHEN DRAWING HAIR, THE DARK PARTS AND THE HAIRLINE SHOULD BE DENSE, AND PARTS UNDER LIGHT SHOULD BE BLANK OR DRAWN SPARSELY.

HAIR STREAM

THE BANGS, THE LEFT AND RIGHT SIDES, AND THE BACK!

BACK

FRONT

SIDE

NOT GOOD

OK

DON'T DRAW EVENLY SPACED GAPS!

NOSE

THERE ARE MANY DIFFERENT TYPES OF NOSES.

REAL

MANGA

THIS NOSE IS WRONG BECAUSE IT IS A PROFILE AND THREE-QUARTER NOSE SHAPE!

NO!

SHE IS LOOKING AT HER NOSE SO THE EYES CROSS!

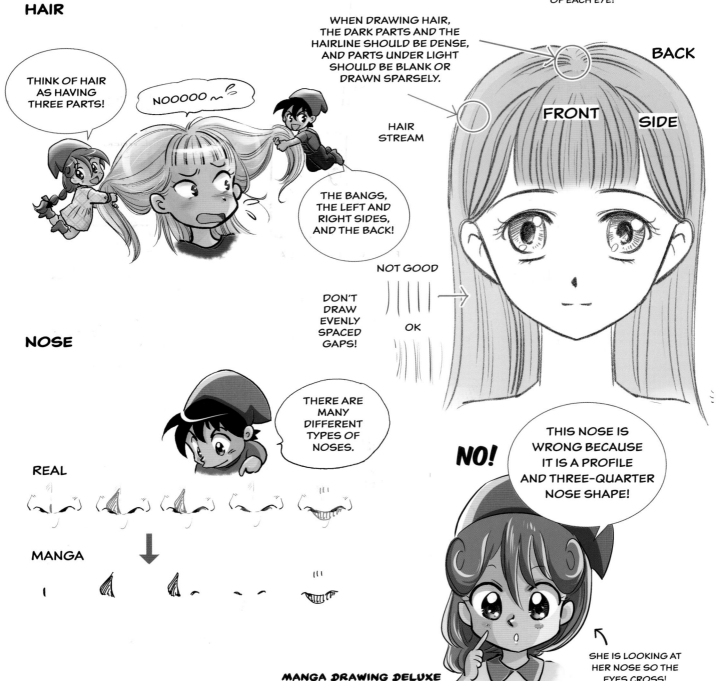

PROFILE

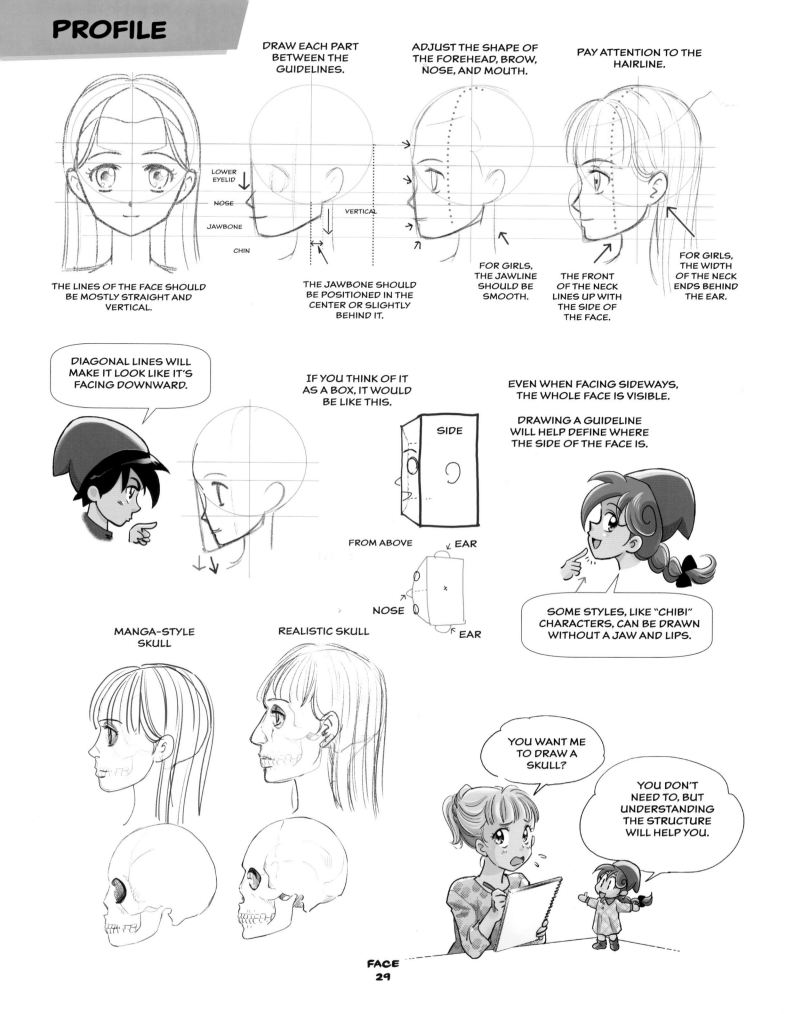

DRAW EACH PART BETWEEN THE GUIDELINES.

ADJUST THE SHAPE OF THE FOREHEAD, BROW, NOSE, AND MOUTH.

PAY ATTENTION TO THE HAIRLINE.

LOWER EYELID

NOSE

JAWBONE

CHIN

VERTICAL

THE LINES OF THE FACE SHOULD BE MOSTLY STRAIGHT AND VERTICAL.

THE JAWBONE SHOULD BE POSITIONED IN THE CENTER OR SLIGHTLY BEHIND IT.

FOR GIRLS, THE JAWLINE SHOULD BE SMOOTH.

THE FRONT OF THE NECK LINES UP WITH THE SIDE OF THE FACE.

FOR GIRLS, THE WIDTH OF THE NECK ENDS BEHIND THE EAR.

DIAGONAL LINES WILL MAKE IT LOOK LIKE IT'S FACING DOWNWARD.

IF YOU THINK OF IT AS A BOX, IT WOULD BE LIKE THIS.

SIDE

FROM ABOVE

EAR

NOSE

EAR

EVEN WHEN FACING SIDEWAYS, THE WHOLE FACE IS VISIBLE.

DRAWING A GUIDELINE WILL HELP DEFINE WHERE THE SIDE OF THE FACE IS.

SOME STYLES, LIKE "CHIBI" CHARACTERS, CAN BE DRAWN WITHOUT A JAW AND LIPS.

MANGA-STYLE SKULL

REALISTIC SKULL

YOU WANT ME TO DRAW A SKULL?

YOU DON'T NEED TO, BUT UNDERSTANDING THE STRUCTURE WILL HELP YOU.

FACE
29

FROM THE SIDE, THE EYE LOOKS TRIANGULAR.

THE EYE IS IN THE SOCKET AND THE EYEBROW IS ON THE BONE, SO THE EYEBROW IS ALWAYS FARTHER FORWARD THAN THE EYE.

FRONT SIDE BACK

FROM THE SIDE, THE NOSE IS POINTED UPWARD, ESPECIALLY FOR WOMEN AND CHILDREN. IT LOOKS QUITE DIFFERENT FROM AN ACTUAL NOSE.

NOT CUTE!!

³/₄ VIEW

CENTER LINE

FAR SIDE

FLAT FOREHEAD

SIDE

FACE LINE STARTS

DENT WHERE THE SOCKET IS

CHEEK-BONE

CHEEKBONE

JAWBONE

CHIN

ROUND JAW. THE NECK STARTS BEHIND THE EAR.

ON THE LEFT SIDE, THE ANGLE SHOULD CHANGE AT THE CHEEKBONE, NOT AT THE JAWBONE.

ON THE RIGHT SIDE, THE LINE GOES FROM UNDER THE EAR, THROUGH THE JAWBONE, AND TO THE TIP OF THE CHIN.

THE EAR SHOULD BE FARTHER OUTSIDE THAN WHEN IN PROFILE POSITION. IT SHOULD BE NEAR THE EDGE OF THE CIRCLE.

THE NOSE STARTS FROM THE CENTER LINE, RISES UP, AND LANDS BACK ON THE CENTER LINE.

PAY ATTENTION TO THE FRONT VIEW, THE SIDE VIEW, AND THE CENTER LINE OF THE FACE. THIS INVOLVES THE RULES OF PERSPECTIVE, SO IT MIGHT BE TRICKY.

THE FACE IS SPHERICAL, SO THE HORIZONTAL LINES SHOULD ACTUALLY BE CURVED, BUT IN OUR EXAMPLES, THEY ARE STRAIGHT TO KEEP THINGS SIMPLE.

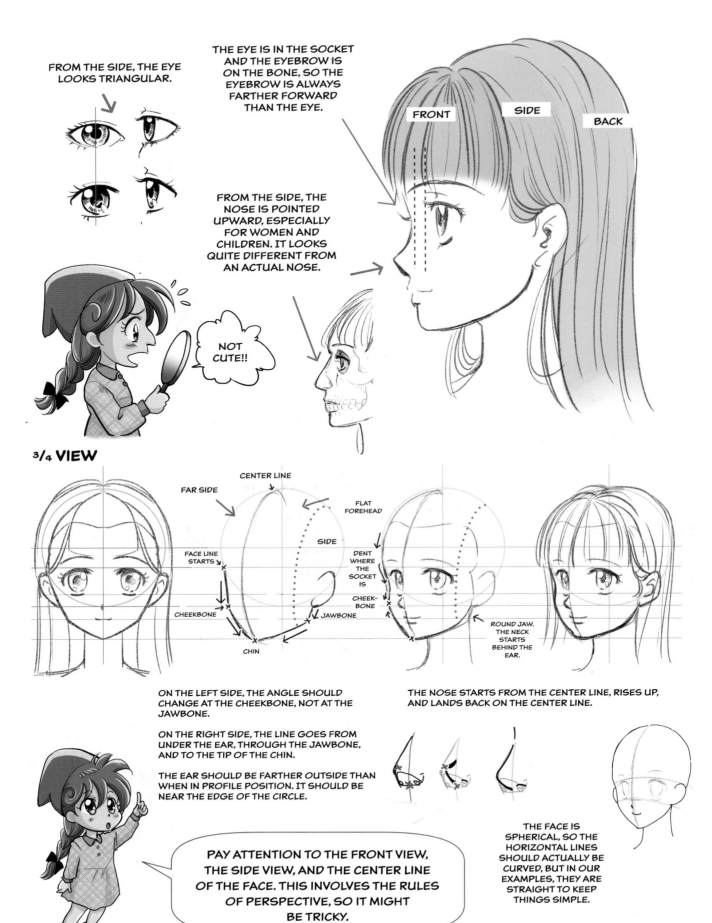

THE EYES, NOSE, AND MOUTH ARE ON THE FRONT SIDE OF THE FACE. IN A DIAGONAL VIEW, THINGS ARE AT AN ANGLE, SO THE FAR SIDE LOOKS NARROWER AND LONGER, DUE TO THE RULES OF PERSPECTIVE.

IN MANGA, IT LOOKS CUTER WHEN THE BRIDGE OF THE NOSE IS LOWER, ESPECIALLY FOR GIRLS AND CHILDREN, SO IN MOST CASES, THE EYE ON THE LEFT IS NOT CONCEALED BY THE NOSE.

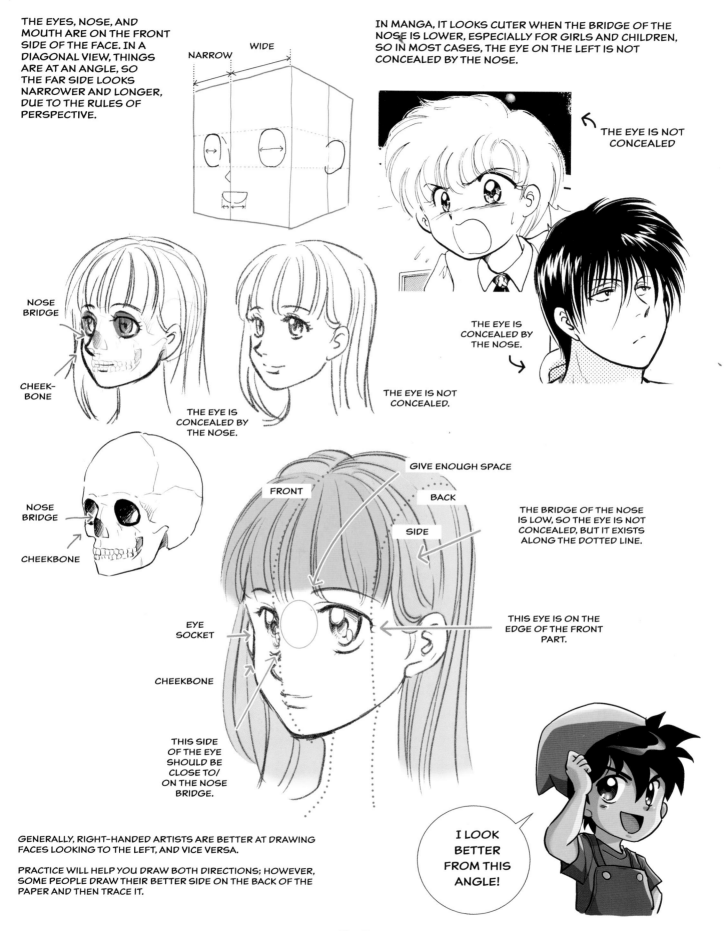

NARROW

WIDE

THE EYE IS NOT CONCEALED

NOSE BRIDGE

CHEEK-BONE

THE EYE IS CONCEALED BY THE NOSE.

THE EYE IS NOT CONCEALED.

THE EYE IS CONCEALED BY THE NOSE.

NOSE BRIDGE

CHEEKBONE

GIVE ENOUGH SPACE

FRONT

BACK

SIDE

THE BRIDGE OF THE NOSE IS LOW, SO THE EYE IS NOT CONCEALED, BUT IT EXISTS ALONG THE DOTTED LINE.

EYE SOCKET

CHEEKBONE

THIS EYE IS ON THE EDGE OF THE FRONT PART.

THIS SIDE OF THE EYE SHOULD BE CLOSE TO/ ON THE NOSE BRIDGE.

GENERALLY, RIGHT-HANDED ARTISTS ARE BETTER AT DRAWING FACES LOOKING TO THE LEFT, AND VICE VERSA.

PRACTICE WILL HELP YOU DRAW BOTH DIRECTIONS; HOWEVER, SOME PEOPLE DRAW THEIR BETTER SIDE ON THE BACK OF THE PAPER AND THEN TRACE IT.

I LOOK BETTER FROM THIS ANGLE!

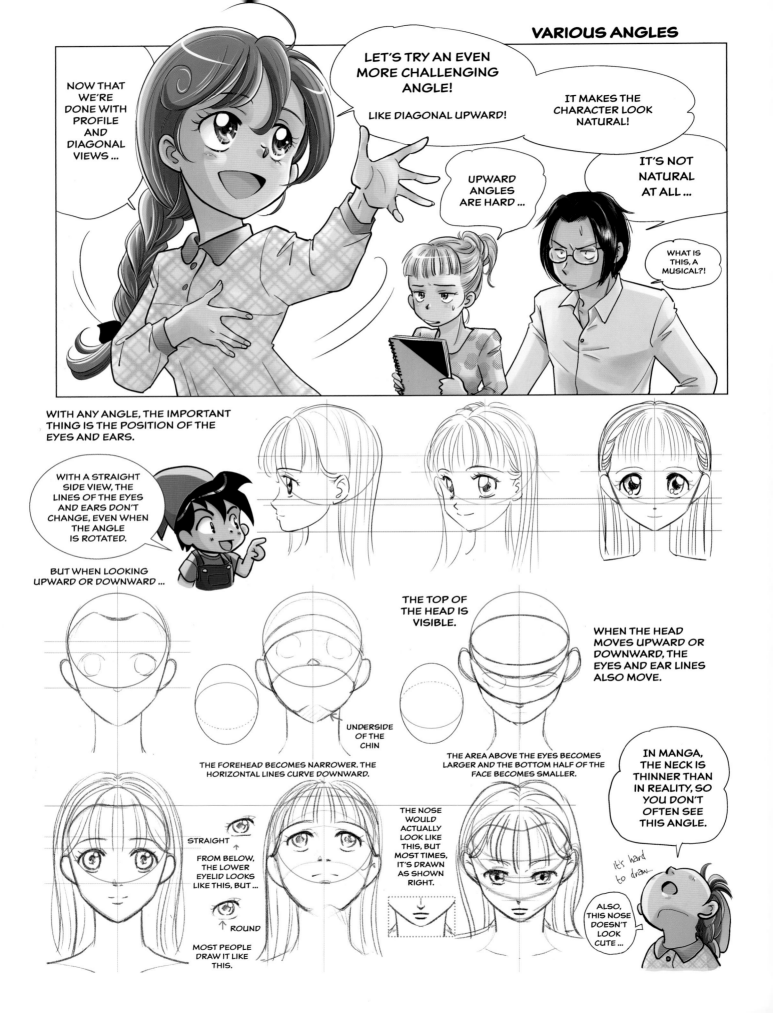

NOW THAT WE'RE DONE WITH PROFILE AND DIAGONAL VIEWS ...

LET'S TRY AN EVEN MORE CHALLENGING ANGLE!

LIKE DIAGONAL UPWARD!

IT MAKES THE CHARACTER LOOK NATURAL!

UPWARD ANGLES ARE HARD ...

IT'S NOT NATURAL AT ALL ...

WHAT IS THIS, A MUSICAL?!

WITH ANY ANGLE, THE IMPORTANT THING IS THE POSITION OF THE EYES AND EARS.

WITH A STRAIGHT SIDE VIEW, THE LINES OF THE EYES AND EARS DON'T CHANGE, EVEN WHEN THE ANGLE IS ROTATED.

BUT WHEN LOOKING UPWARD OR DOWNWARD ...

THE TOP OF THE HEAD IS VISIBLE.

WHEN THE HEAD MOVES UPWARD OR DOWNWARD, THE EYES AND EAR LINES ALSO MOVE.

UNDERSIDE OF THE CHIN

THE FOREHEAD BECOMES NARROWER. THE HORIZONTAL LINES CURVE DOWNWARD.

THE AREA ABOVE THE EYES BECOMES LARGER AND THE BOTTOM HALF OF THE FACE BECOMES SMALLER.

IN MANGA, THE NECK IS THINNER THAN IN REALITY, SO YOU DON'T OFTEN SEE THIS ANGLE.

STRAIGHT

FROM BELOW, THE LOWER EYELID LOOKS LIKE THIS, BUT ...

ROUND

MOST PEOPLE DRAW IT LIKE THIS.

THE NOSE WOULD ACTUALLY LOOK LIKE THIS, BUT MOST TIMES, IT'S DRAWN AS SHOWN RIGHT.

It's hard to draw....

ALSO, THIS NOSE DOESN'T LOOK CUTE ...

THE NARROWER THIS SPACE, THE SHARPER THE ANGLE.

DRAW THE OUTLINE OF AN EGG-SHAPED FACE AND DECIDE WHERE THE CENTER OF THE FACE IS.

IF YOU'RE NOT SURE WHERE THE LINE FOR THE EYES SHOULD GO, DRAW A CIRCLE INSIDE THE HEAD.

DRAW THE CURVED LINES OF THE FACE, KEEPING IN MIND THAT IT IS LOOKING DOWNWARD. DRAW THE CENTER LINE, THE HORIZONTAL LINES, AND THE LINE MARKING THE SIDE OF THE FACE.

EYE SOCKET

MANY PEOPLE OMIT THE LINE IN THE WHITE PART OF THE EYE.

CHEEK-BONE

CHIN LINE

THE EARS GO HIGHER THAN THE EYES.

THE JAWBONE SHOULD LOOK FEMININE.

IN THIS CASE, THE ANGLE IS SHARP, SO THE FACE IS ALMOST A PROFILE VIEW. IT'S LOOKING DOWNWARD, SO THE CHIN SHOULD BE NARROW AND SMALL.

THAT WILL SHOW YOU WHERE THE EAR GOES!

WHEN LOOKING DOWNWARD, LONG HAIR COVERS THE FACE ...

... AND THE EYES ALSO LOOK DOWNWARD. THE WHITE PART AT THE BOTTOM OF THE EYE IS EITHER VERY NARROW OR THE IRIS SHOULD TOUCH THE BOTTOM EYELID.

IF THE FACE'S ANGLE IS UPWARD, THE EYES ALSO LOOK UPWARD. THE WHITE PART AT THE BOTTOM OF THE EYE IS LARGER AND THE IRIS TOUCHES THE UPPER EYELID.

HEHE

IF THE WHITE PART AT THE BOTTOM OF THE EYE IS LARGER...

IT LOOKS LIKE THE CHARACTER IS GLARING UPWARD.

UNLIKE THE DOWNWARD VIEW, THE BOTTOM OF THE CHIN IS VISIBLE AND THE TOP OF THE HEAD IS NOT.

UNDERSIDE OF THE CHIN

POINT!

I DON'T USUALLY DRAW A CIRCLE, BUT IF I CAN'T FIND THE BALANCE, I SOMETIMES USE A CIRCLE TO DECIDE WHERE THE EAR GOES.

IT'S UNCOMMON TO HAVE THE CHARACTER FACING UPWARD WITH THE EYES LOOKING DOWNWARD. THAT WOULD LOOK UNNATURAL.

THIS IS A MALE CHARACTER, SO THE LINE UNDER THE CHEEKBONE IS STRAIGHT.

BUT IF WEARING BIFOCALS ...

ANGULAR JAW

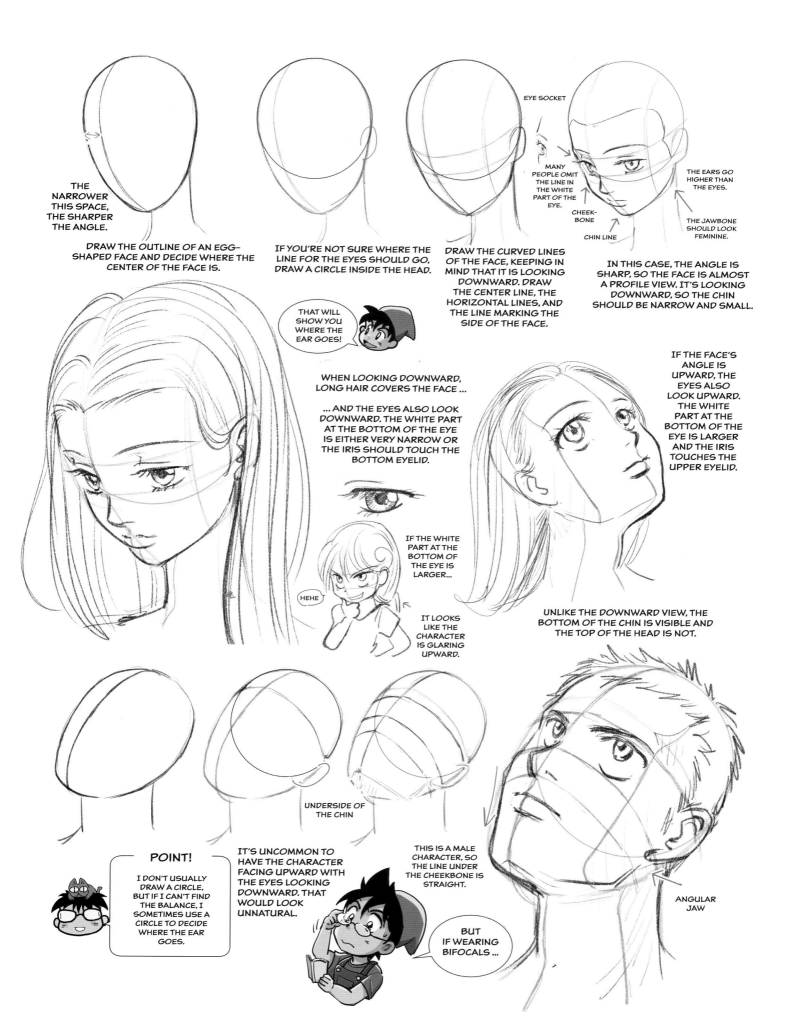

DIFFERENCES BETWEEN BOYS AND GIRLS

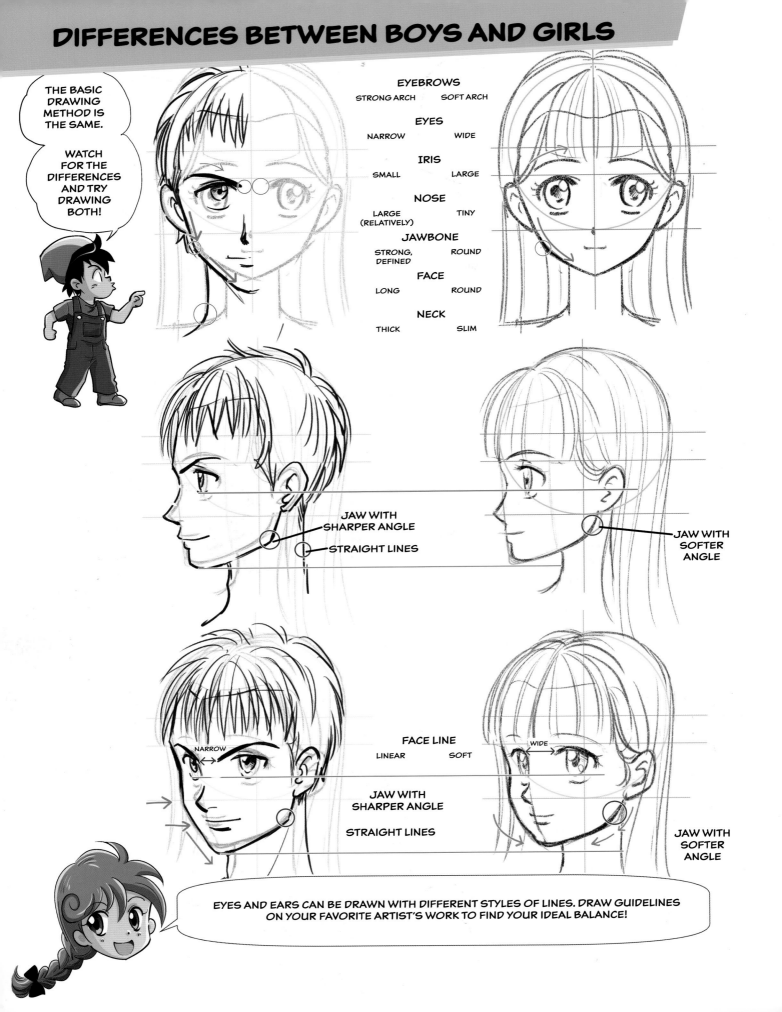

THE BASIC DRAWING METHOD IS THE SAME.

WATCH FOR THE DIFFERENCES AND TRY DRAWING BOTH!

EYEBROWS
STRONG ARCH — SOFT ARCH

EYES
NARROW — WIDE

IRIS
SMALL — LARGE

NOSE
LARGE (RELATIVELY) — TINY

JAWBONE
STRONG, DEFINED — ROUND

FACE
LONG — ROUND

NECK
THICK — SLIM

JAW WITH SHARPER ANGLE

STRAIGHT LINES

JAW WITH SOFTER ANGLE

NARROW

FACE LINE
LINEAR — SOFT

WIDE

JAW WITH SHARPER ANGLE

STRAIGHT LINES

JAW WITH SOFTER ANGLE

EYES AND EARS CAN BE DRAWN WITH DIFFERENT STYLES OF LINES. DRAW GUIDELINES ON YOUR FAVORITE ARTIST'S WORK TO FIND YOUR IDEAL BALANCE!

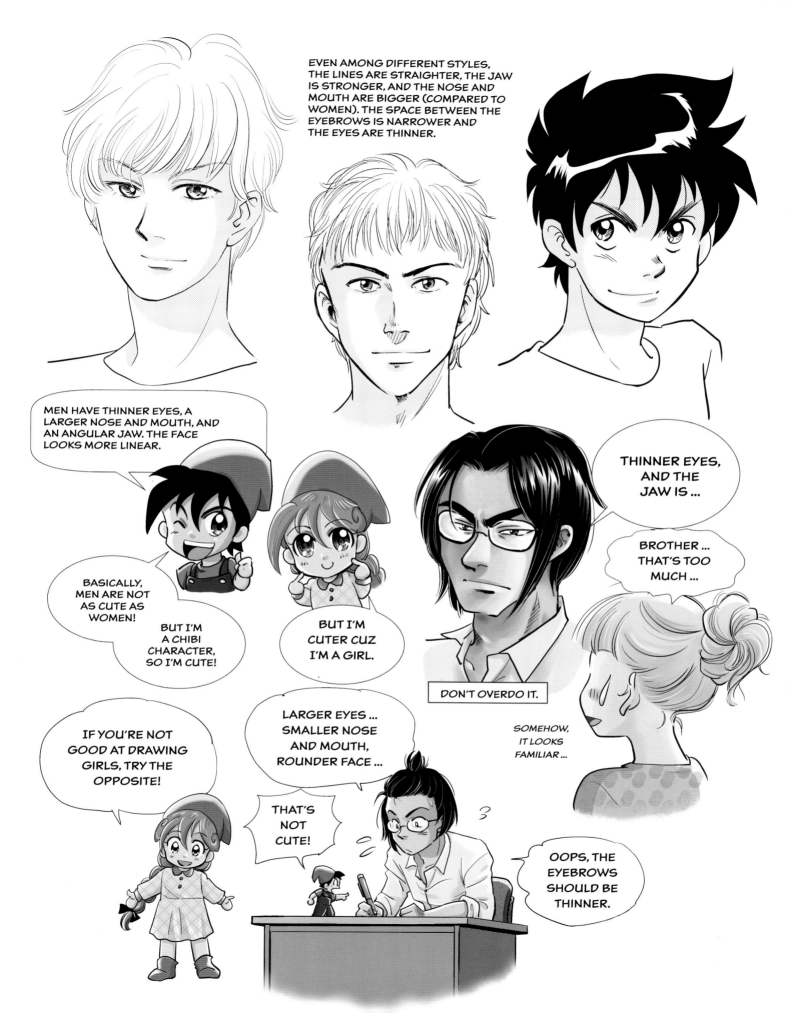

THE FLOW OF HAIR

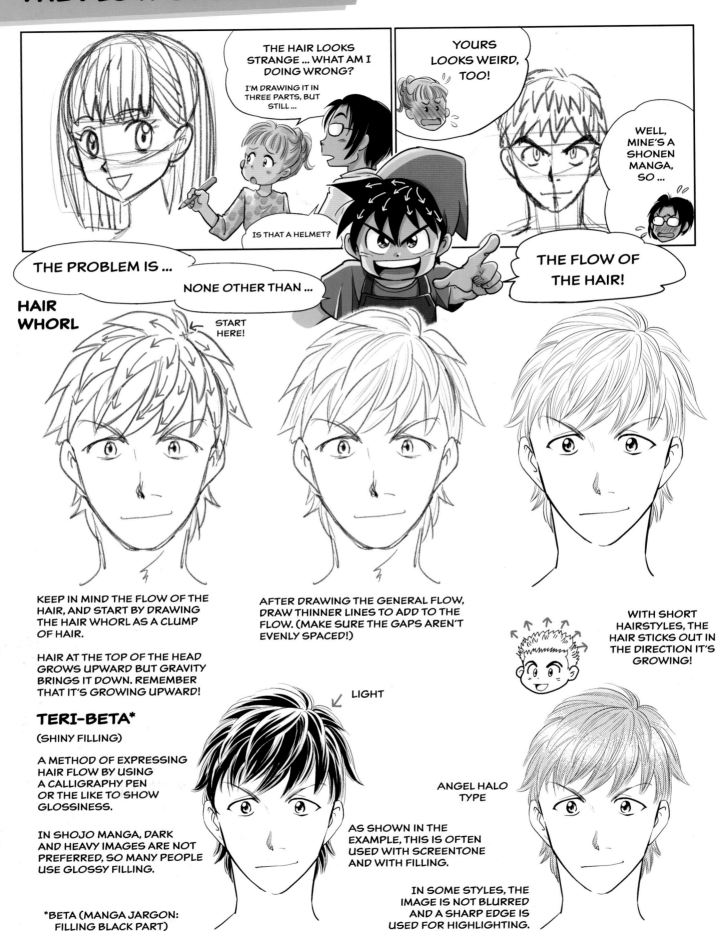

THE HAIR LOOKS STRANGE ... WHAT AM I DOING WRONG?

I'M DRAWING IT IN THREE PARTS, BUT STILL ...

IS THAT A HELMET?

YOURS LOOKS WEIRD, TOO!

WELL, MINE'S A SHONEN MANGA, SO ...

THE PROBLEM IS ...

NONE OTHER THAN ...

THE FLOW OF THE HAIR!

HAIR WHORL

START HERE!

KEEP IN MIND THE FLOW OF THE HAIR, AND START BY DRAWING THE HAIR WHORL AS A CLUMP OF HAIR.

HAIR AT THE TOP OF THE HEAD GROWS UPWARD BUT GRAVITY BRINGS IT DOWN. REMEMBER THAT IT'S GROWING UPWARD!

AFTER DRAWING THE GENERAL FLOW, DRAW THINNER LINES TO ADD TO THE FLOW. (MAKE SURE THE GAPS AREN'T EVENLY SPACED!)

WITH SHORT HAIRSTYLES, THE HAIR STICKS OUT IN THE DIRECTION IT'S GROWING!

TERI-BETA*

(SHINY FILLING)

A METHOD OF EXPRESSING HAIR FLOW BY USING A CALLIGRAPHY PEN OR THE LIKE TO SHOW GLOSSINESS.

IN SHOJO MANGA, DARK AND HEAVY IMAGES ARE NOT PREFERRED, SO MANY PEOPLE USE GLOSSY FILLING.

*BETA (MANGA JARGON: FILLING BLACK PART)

LIGHT

ANGEL HALO TYPE

AS SHOWN IN THE EXAMPLE, THIS IS OFTEN USED WITH SCREENTONE AND WITH FILLING.

IN SOME STYLES, THE IMAGE IS NOT BLURRED AND A SHARP EDGE IS USED FOR HIGHLIGHTING.

DRANING THE FLOW

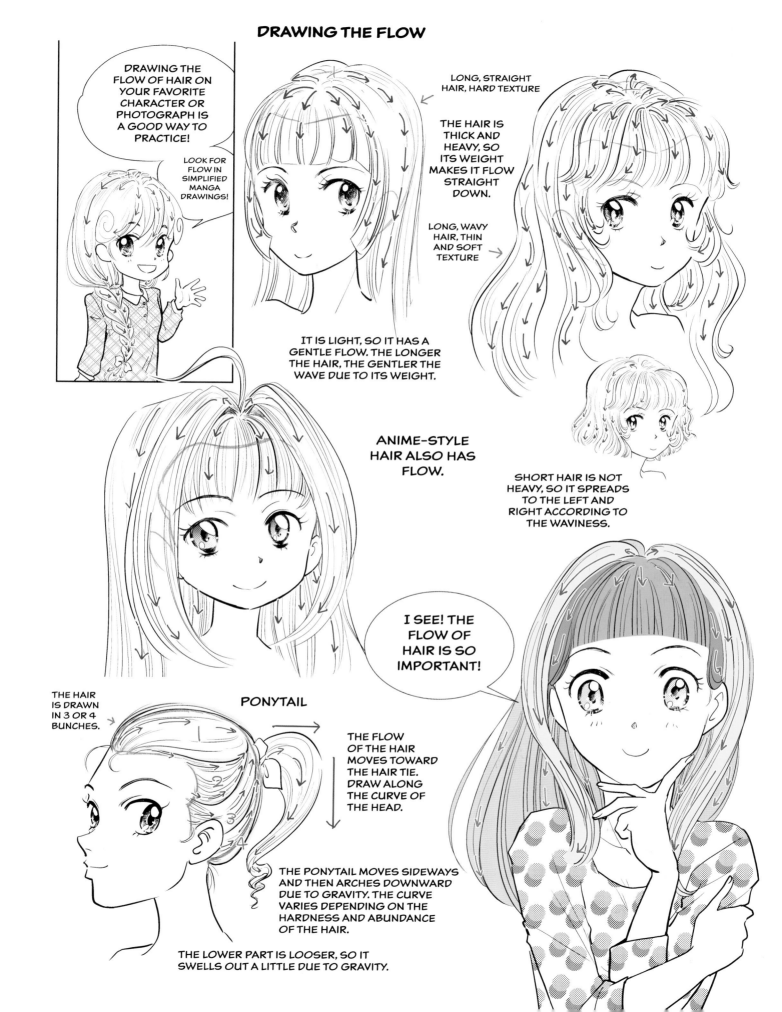

DRAWING THE FLOW OF HAIR ON YOUR FAVORITE CHARACTER OR PHOTOGRAPH IS A GOOD WAY TO PRACTICE!

LOOK FOR FLOW IN SIMPLIFIED MANGA DRAWINGS!

LONG, STRAIGHT HAIR, HARD TEXTURE

THE HAIR IS THICK AND HEAVY, SO ITS WEIGHT MAKES IT FLOW STRAIGHT DOWN.

LONG, WAVY HAIR, THIN AND SOFT TEXTURE

IT IS LIGHT, SO IT HAS A GENTLE FLOW. THE LONGER THE HAIR, THE GENTLER THE WAVE DUE TO ITS WEIGHT.

ANIME-STYLE HAIR ALSO HAS FLOW.

SHORT HAIR IS NOT HEAVY, SO IT SPREADS TO THE LEFT AND RIGHT ACCORDING TO THE WAVINESS.

I SEE! THE FLOW OF HAIR IS SO IMPORTANT!

THE HAIR IS DRAWN IN 3 OR 4 BUNCHES.

PONYTAIL

THE FLOW OF THE HAIR MOVES TOWARD THE HAIR TIE. DRAW ALONG THE CURVE OF THE HEAD.

THE PONYTAIL MOVES SIDEWAYS AND THEN ARCHES DOWNWARD DUE TO GRAVITY. THE CURVE VARIES DEPENDING ON THE HARDNESS AND ABUNDANCE OF THE HAIR.

THE LOWER PART IS LOOSER, SO IT SWELLS OUT A LITTLE DUE TO GRAVITY.

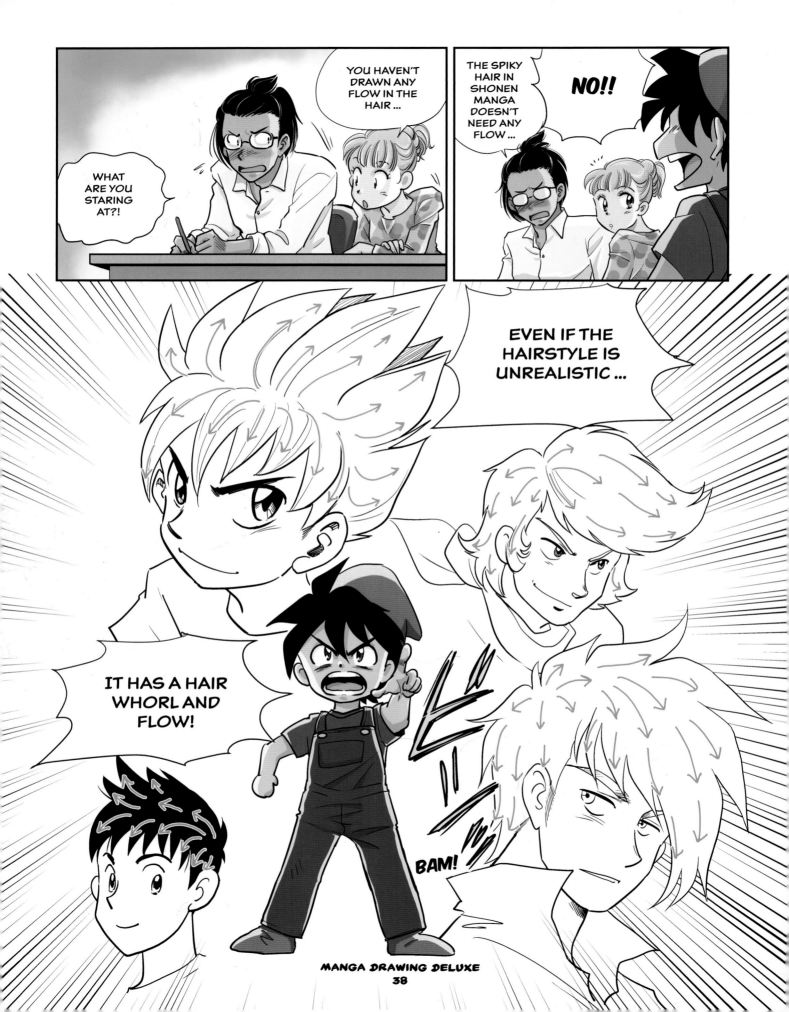

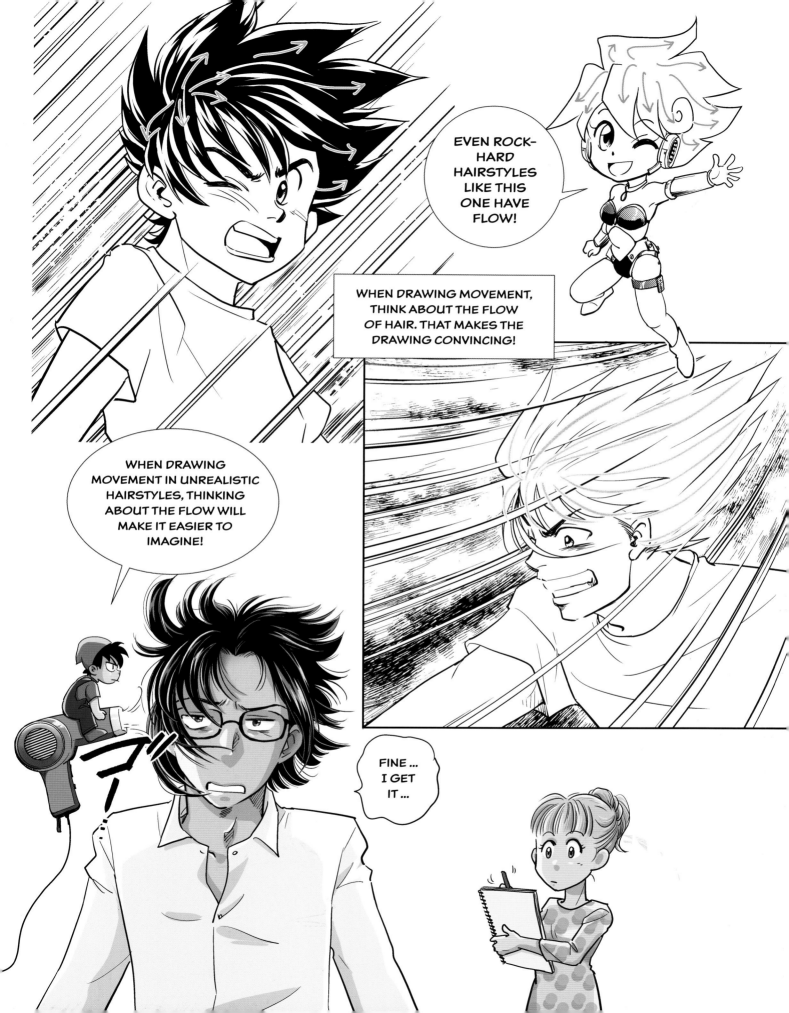

DRAWING CHARACTERS OF DIFFERENT AGES

THE KEY POINTS ARE THE HEIGHT OF THE EYES AND THE OUTLINE OF THE FACE. WHEN THE EYES ARE BELOW THE CENTER OF THE FACE, THE CHARACTER LOOKS YOUNGER AND VICE VERSA.

ADJUSTING THIS LENGTH WILL CHANGE THE CHARACTER'S AGE

THE WIDER THE SPACE BETWEEN THE EYES AND THE LOWER THE FACIAL PARTS ARE, THE YOUNGER AND CUTER THE CHARACTER LOOKS.

LIKE ME!

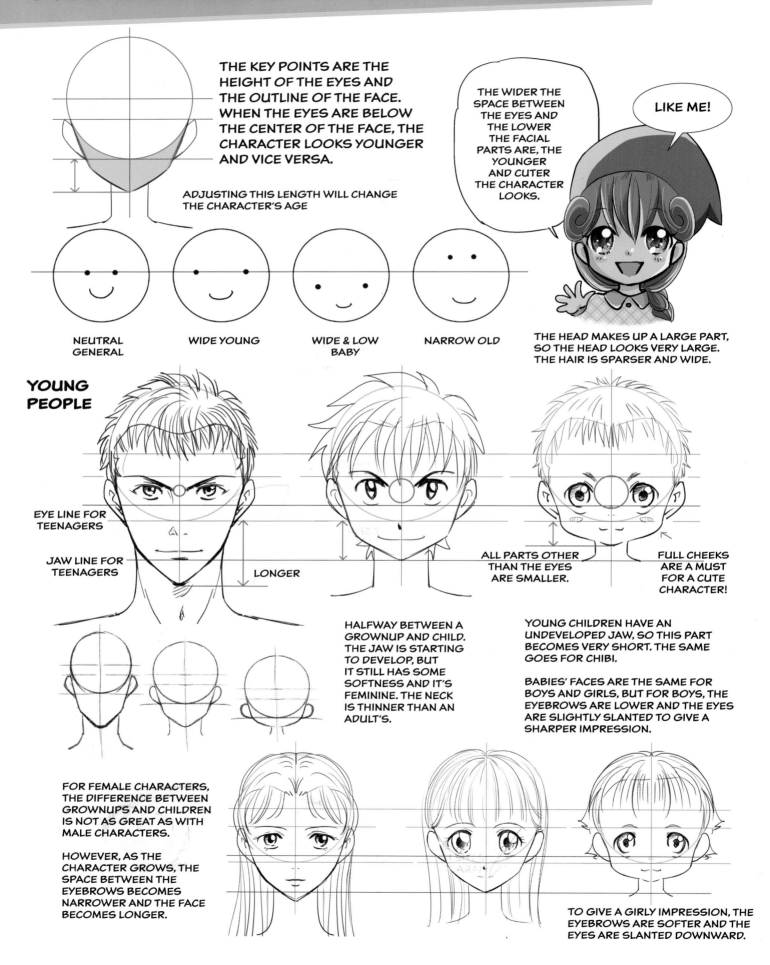

NEUTRAL GENERAL

WIDE YOUNG

WIDE & LOW BABY

NARROW OLD

THE HEAD MAKES UP A LARGE PART, SO THE HEAD LOOKS VERY LARGE. THE HAIR IS SPARSER AND WIDE.

YOUNG PEOPLE

EYE LINE FOR TEENAGERS

JAW LINE FOR TEENAGERS

LONGER

ALL PARTS OTHER THAN THE EYES ARE SMALLER.

FULL CHEEKS ARE A MUST FOR A CUTE CHARACTER!

HALFWAY BETWEEN A GROWNUP AND CHILD. THE JAW IS STARTING TO DEVELOP, BUT IT STILL HAS SOME SOFTNESS AND IT'S FEMININE. THE NECK IS THINNER THAN AN ADULT'S.

YOUNG CHILDREN HAVE AN UNDEVELOPED JAW, SO THIS PART BECOMES VERY SHORT. THE SAME GOES FOR CHIBI.

BABIES' FACES ARE THE SAME FOR BOYS AND GIRLS, BUT FOR BOYS, THE EYEBROWS ARE LOWER AND THE EYES ARE SLIGHTLY SLANTED TO GIVE A SHARPER IMPRESSION.

FOR FEMALE CHARACTERS, THE DIFFERENCE BETWEEN GROWNUPS AND CHILDREN IS NOT AS GREAT AS WITH MALE CHARACTERS.

HOWEVER, AS THE CHARACTER GROWS, THE SPACE BETWEEN THE EYEBROWS BECOMES NARROWER AND THE FACE BECOMES LONGER.

TO GIVE A GIRLY IMPRESSION, THE EYEBROWS ARE SOFTER AND THE EYES ARE SLANTED DOWNWARD.

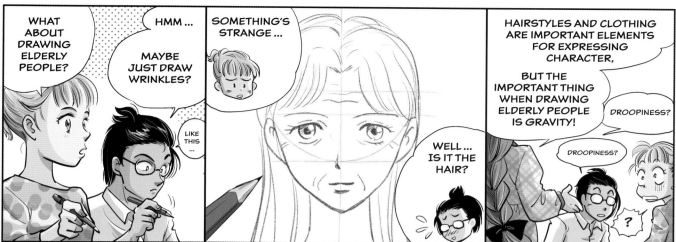

ELDERLY PEOPLE

THE MUSCLES ARE WEAKER, SO THE OVERALL IMPRESSION IS LOOSER.

THERE ARE WRINKLES AT THE CORNER OF THE EYE, AT THE MOUTH, AND UNDER THE NOSE.

THE MUSCLES AT THE CHEEKS AND CHIN ARE WEAKER, SO THEY SAG.

THE EYES ARE SUNKEN DEEPER AND THE OUTER CORNER OF THE EYES SAG DOWNWARD.

SLACKENING UNDER THE EYES

THE WEAKENED MUSCLES MAKE THE JAWBONE MORE NOTICEABLE.

THE SKIN SAGS, SO THE FACE LOOKS BONIER.

USE THESE RULES TO DRAW AN ELDERLY VERSION ON YOUR CHARACTER!

A CUTE OLD LADY LIKE ME.

WITCH?!

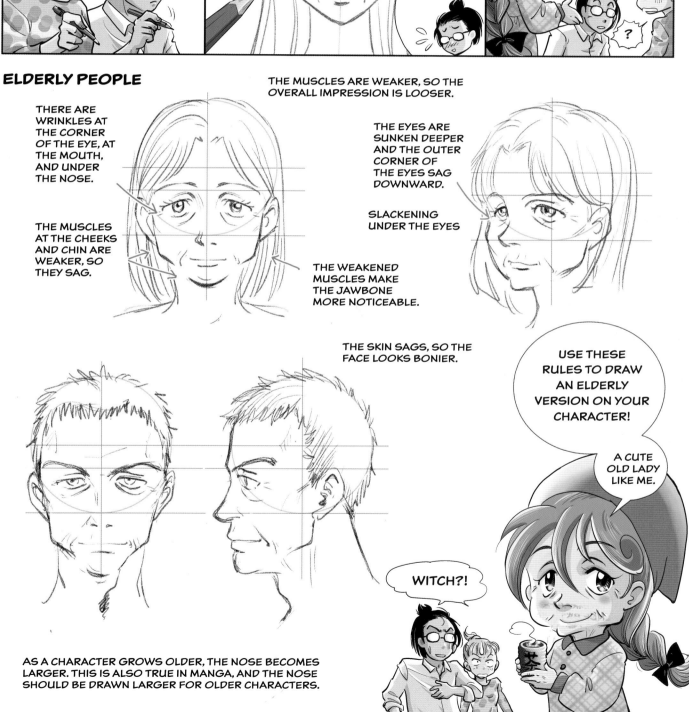

AS A CHARACTER GROWS OLDER, THE NOSE BECOMES LARGER. THIS IS ALSO TRUE IN MANGA, AND THE NOSE SHOULD BE DRAWN LARGER FOR OLDER CHARACTERS.

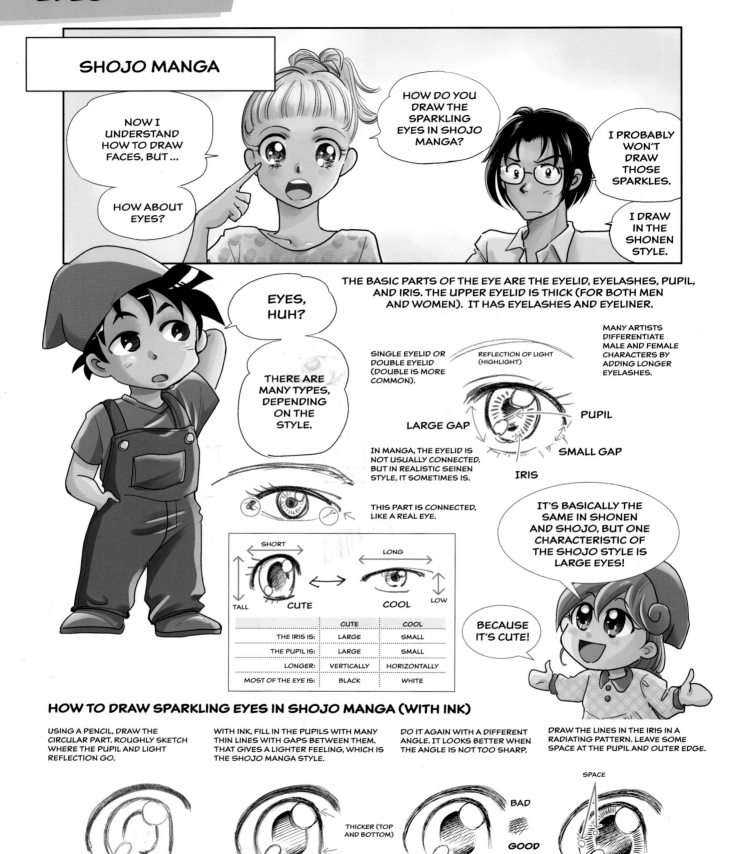

SHOJO MANGA

NOW I UNDERSTAND HOW TO DRAW FACES, BUT ...

HOW ABOUT EYES?

HOW DO YOU DRAW THE SPARKLING EYES IN SHOJO MANGA?

I PROBABLY WON'T DRAW THOSE SPARKLES.

I DRAW IN THE SHONEN STYLE.

EYES, HUH?

THERE ARE MANY TYPES, DEPENDING ON THE STYLE.

THE BASIC PARTS OF THE EYE ARE THE EYELID, EYELASHES, PUPIL, AND IRIS. THE UPPER EYELID IS THICK (FOR BOTH MEN AND WOMEN). IT HAS EYELASHES AND EYELINER.

SINGLE EYELID OR DOUBLE EYELID (DOUBLE IS MORE COMMON).

MANY ARTISTS DIFFERENTIATE MALE AND FEMALE CHARACTERS BY ADDING LONGER EYELASHES.

REFLECTION OF LIGHT (HIGHLIGHT)

LARGE GAP

PUPIL

SMALL GAP

IRIS

IN MANGA, THE EYELID IS NOT USUALLY CONNECTED, BUT IN REALISTIC SEINEN STYLE, IT SOMETIMES IS.

THIS PART IS CONNECTED, LIKE A REAL EYE.

IT'S BASICALLY THE SAME IN SHONEN AND SHOJO, BUT ONE CHARACTERISTIC OF THE SHOJO STYLE IS LARGE EYES!

BECAUSE IT'S CUTE!

SHORT

LONG

TALL

CUTE

COOL

LOW

	CUTE	COOL
THE IRIS IS:	LARGE	SMALL
THE PUPIL IS:	LARGE	SMALL
LONGER:	VERTICALLY	HORIZONTALLY
MOST OF THE EYE IS:	BLACK	WHITE

HOW TO DRAW SPARKLING EYES IN SHOJO MANGA (WITH INK)

USING A PENCIL, DRAW THE CIRCULAR PART. ROUGHLY SKETCH WHERE THE PUPIL AND LIGHT REFLECTION GO.

WITH INK, FILL IN THE PUPILS WITH MANY THIN LINES WITH GAPS BETWEEN THEM. THAT GIVES A LIGHTER FEELING, WHICH IS THE SHOJO MANGA STYLE.

DO IT AGAIN WITH A DIFFERENT ANGLE. IT LOOKS BETTER WHEN THE ANGLE IS NOT TOO SHARP.

DRAW THE LINES IN THE IRIS IN A RADIATING PATTERN. LEAVE SOME SPACE AT THE PUPIL AND OUTER EDGE.

SPACE

THINNER IN THE MIDDLE

THICKER (TOP AND BOTTOM)

GAPS GRADUALLY WIDEN

BAD

GOOD

BE CAREFUL WITH THE ANGLE OF THE CROSSING LINES!

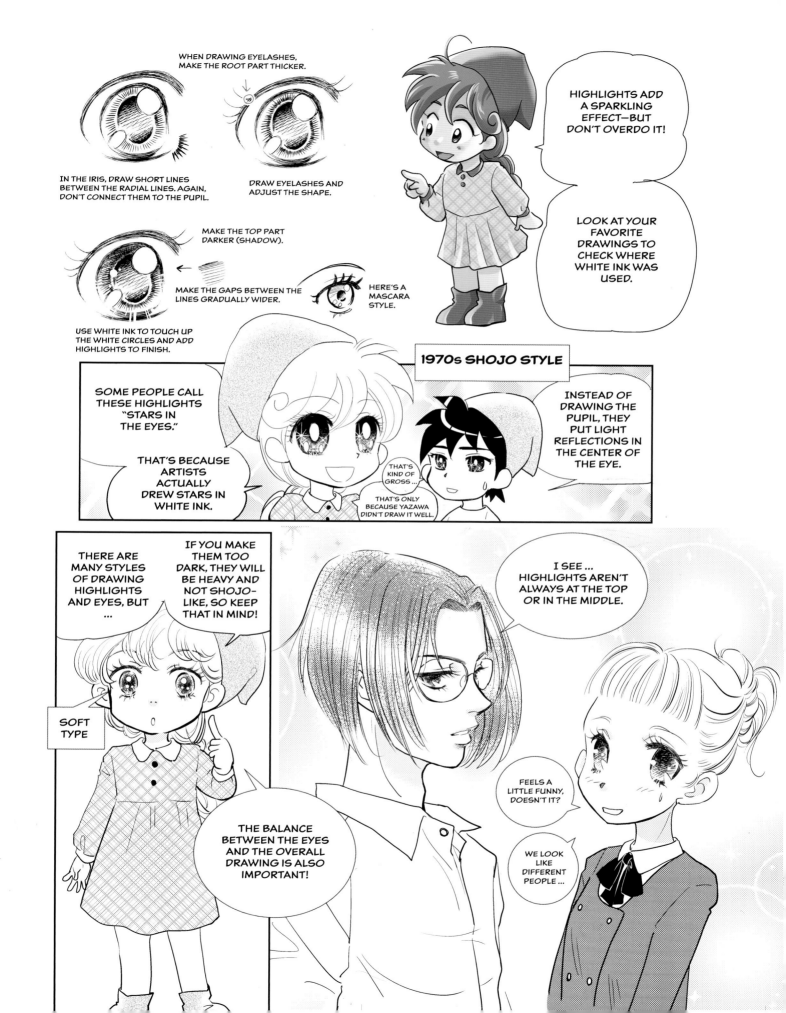

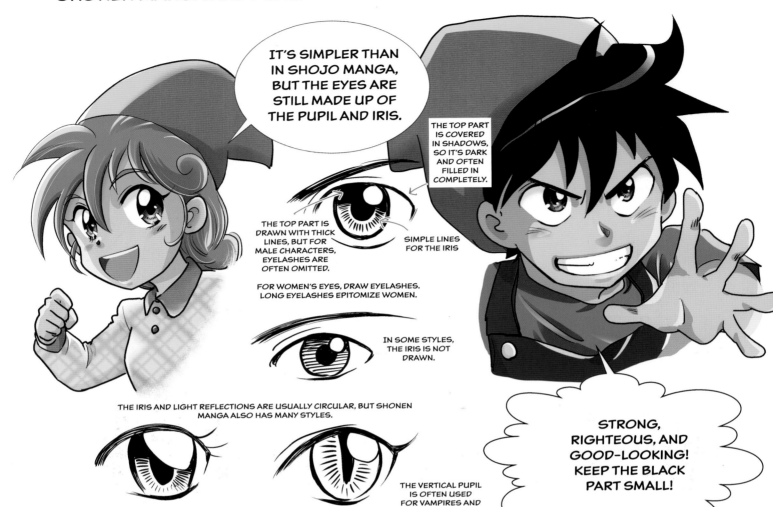

IT'S SIMPLER THAN IN SHOJO MANGA, BUT THE EYES ARE STILL MADE UP OF THE PUPIL AND IRIS.

THE TOP PART IS COVERED IN SHADOWS, SO IT'S DARK AND OFTEN FILLED IN COMPLETELY.

THE TOP PART IS DRAWN WITH THICK LINES, BUT FOR MALE CHARACTERS, EYELASHES ARE OFTEN OMITTED.

SIMPLE LINES FOR THE IRIS

FOR WOMEN'S EYES, DRAW EYELASHES. LONG EYELASHES EPITOMIZE WOMEN.

IN SOME STYLES, THE IRIS IS NOT DRAWN.

THE IRIS AND LIGHT REFLECTIONS ARE USUALLY CIRCULAR, BUT SHONEN MANGA ALSO HAS MANY STYLES.

UN-CIRCULAR LIGHT REFLECTION

THE VERTICAL PUPIL IS OFTEN USED FOR VAMPIRES AND OTHER NON-HUMAN CHARACTERS.

STRONG, RIGHTEOUS, AND GOOD-LOOKING! KEEP THE BLACK PART SMALL!

THE EYES EXPRESS THE CHARACTER'S SITUATION.

NORMAL EYES

NO PUPIL AND NO HIGHLIGHTS

THE EYES LOOK OUT OF FOCUS LIKE THE CHARACTER IS NOT LOOKING AT ANYTHING. THIS IS USED TO SHOW A STATE OF SHOCK OR WHEN THE CHARACTER IS LYING. (THE EYE DOESN'T SHOW THE CHARACTER'S MIND.)

LARGE PUPIL AND NO HIGHLIGHTS

SIMILAR TO THE EYES OF THE DEAD. IT GIVES A CREEPY IMPRESSION USED FOR ZOMBIES, A PERSON POSSESSED BY EVIL SPIRITS, OR EVEN A SERIAL MURDERER.

LARGE PUPIL WITH HIGHLIGHTS

THIS LOOK ALSO FEATURES A BIG PUPIL, BUT WITH THE HIGHLIGHTS, THE IMPRESSION IS COMPLETELY DIFFERENT. HIGHLIGHTS GIVE A SOUL TO THE CHARACTER.

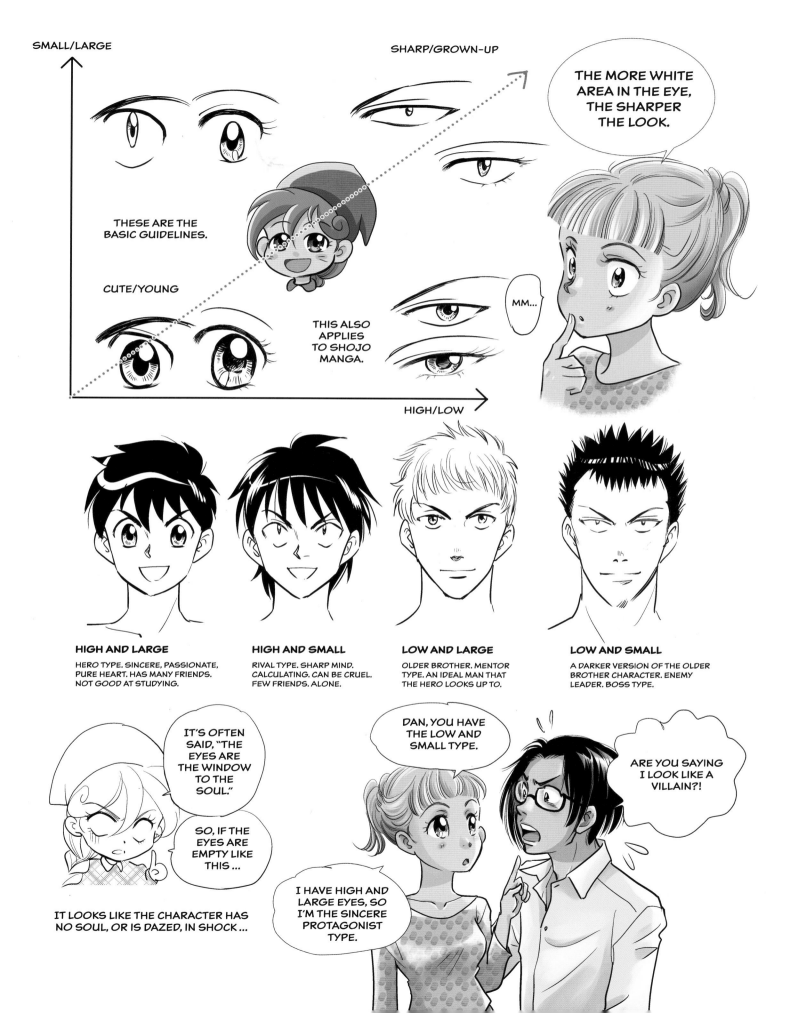

DEPICTING EMOTIONS

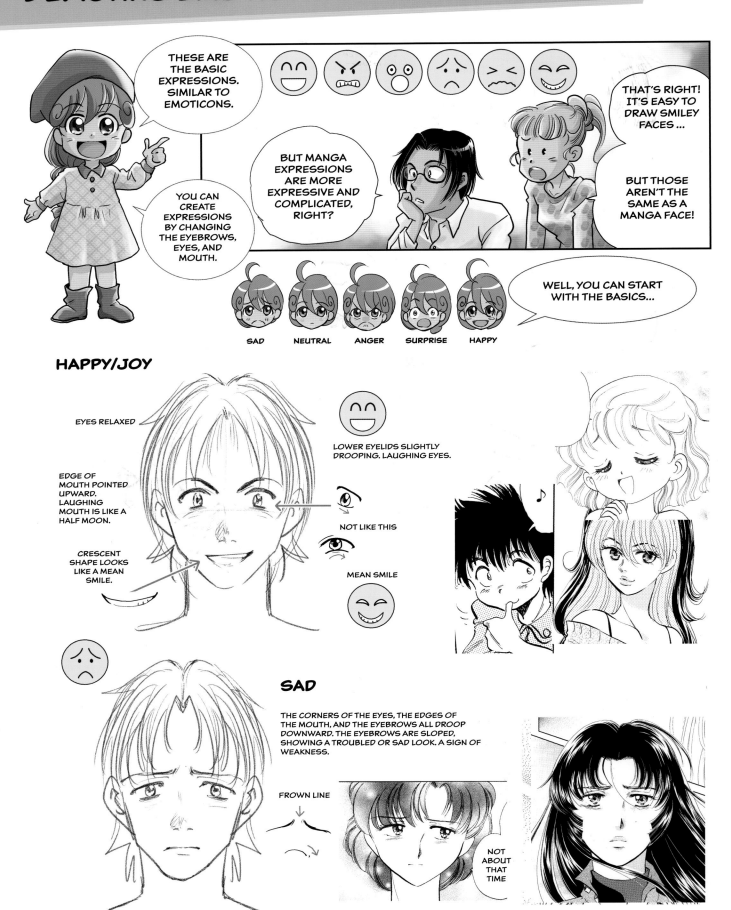

THESE ARE THE BASIC EXPRESSIONS. SIMILAR TO EMOTICONS.

YOU CAN CREATE EXPRESSIONS BY CHANGING THE EYEBROWS, EYES, AND MOUTH.

BUT MANGA EXPRESSIONS ARE MORE EXPRESSIVE AND COMPLICATED, RIGHT?

THAT'S RIGHT! IT'S EASY TO DRAW SMILEY FACES ...

BUT THOSE AREN'T THE SAME AS A MANGA FACE!

WELL, YOU CAN START WITH THE BASICS...

SAD NEUTRAL ANGER SURPRISE HAPPY

HAPPY/JOY

EYES RELAXED

EDGE OF MOUTH POINTED UPWARD. LAUGHING MOUTH IS LIKE A HALF MOON.

CRESCENT SHAPE LOOKS LIKE A MEAN SMILE.

LOWER EYELIDS SLIGHTLY DROOPING. LAUGHING EYES.

NOT LIKE THIS

MEAN SMILE

SAD

THE CORNERS OF THE EYES, THE EDGES OF THE MOUTH, AND THE EYEBROWS ALL DROOP DOWNWARD. THE EYEBROWS ARE SLOPED, SHOWING A TROUBLED OR SAD LOOK. A SIGN OF WEAKNESS.

FROWN LINE

NOT ABOUT THAT TIME

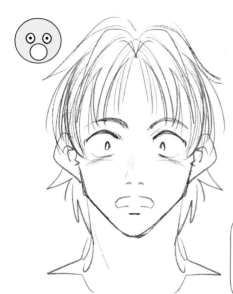

SURPRISE

LIKE IN REAL LIFE, THE EYEBROWS ARE RAISED, THE EYES ARE OPEN WIDE, AND THE MOUTH IS HALF-OPENED.

WHEN THE BLACK PART OF THE EYE IS SMALLER, THE WHITE PART BECOMES LARGER AND IT LOOKS LIKE THE CHARACTER IS OPENING HIS EYES WIDER.

THE EYES ARE LARGE TO BEGIN WITH, SO YOU CAN'T DRAW THEM ANY BIGGER. DRAW THE BLACK PART SMALLER ...

IT ALSO MAKES THE PUPIL LOOK SMALLER.

FROWN LINE

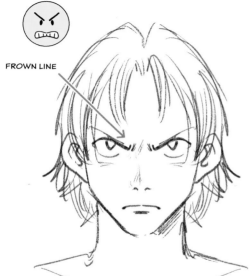

ANGER

THE EYEBROWS ARE RAISED. THE DEPTH OF THE WRINKLES SHOWS HOW INTENSE THE ANGER IS.

WHEN THE BLACK PART OF THE EYE IS SMALLER (A SHARP LOOK; NOT AS SMALL AS A SURPRISED LOOK) AND TOUCHES THE UPPER EYELID, IT GIVES A GLARING LOOK.

THE EDGE OF THE MOUTH DROOPS DOWNWARD AND THE TEETH ARE CLENCHED.

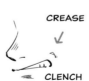

CREASE

CLENCH

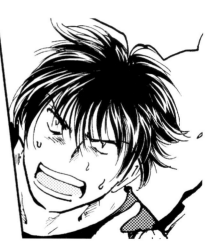

NEUTRAL

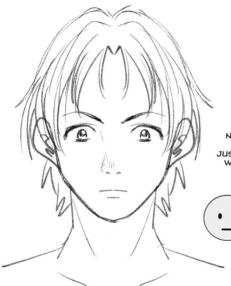

NOT MUCH GOING ON HERE. JUST A REGULAR FACE WITH NO EMOTION AT ALL.

SO ... CHANGING THE PARTS GIVES YOU DIFFERENT EXPRESSIONS ...

BUT ACTUAL MANGA EXPRESSIONS ARE NOT JUST CHANGING THE PARTS ACCORDING TO RULES!

IT'S MORE THAN THAT!

VISUAL EXPRESSIONS

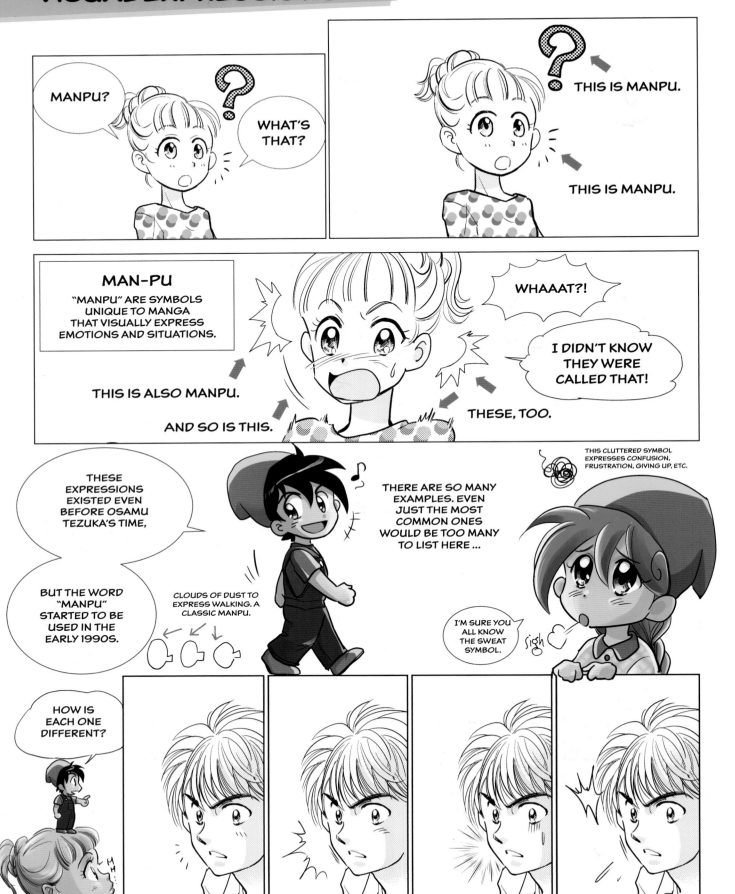

MANPU?

WHAT'S THAT?

THIS IS MANPU.

THIS IS MANPU.

MAN-PU

"MANPU" ARE SYMBOLS UNIQUE TO MANGA THAT VISUALLY EXPRESS EMOTIONS AND SITUATIONS.

THIS IS ALSO MANPU.

AND SO IS THIS.

WHAAAT?!

I DIDN'T KNOW THEY WERE CALLED THAT!

THESE, TOO.

THESE EXPRESSIONS EXISTED EVEN BEFORE OSAMU TEZUKA'S TIME,

BUT THE WORD "MANPU" STARTED TO BE USED IN THE EARLY 1990S.

CLOUDS OF DUST TO EXPRESS WALKING. A CLASSIC MANPU.

THERE ARE SO MANY EXAMPLES. EVEN JUST THE MOST COMMON ONES WOULD BE TOO MANY TO LIST HERE ...

THIS CLUTTERED SYMBOL EXPRESSES CONFUSION, FRUSTRATION, GIVING UP, ETC.

I'M SURE YOU ALL KNOW THE SWEAT SYMBOL.

sigh

HOW IS EACH ONE DIFFERENT?

EXAMPLES: VARIATIONS OF MANPU USED WHEN A CHARACTER NOTICES SOMETHING

EMOTIONS EXPRESSED DIFFERENTLY DEPENDING ON THE MANPU

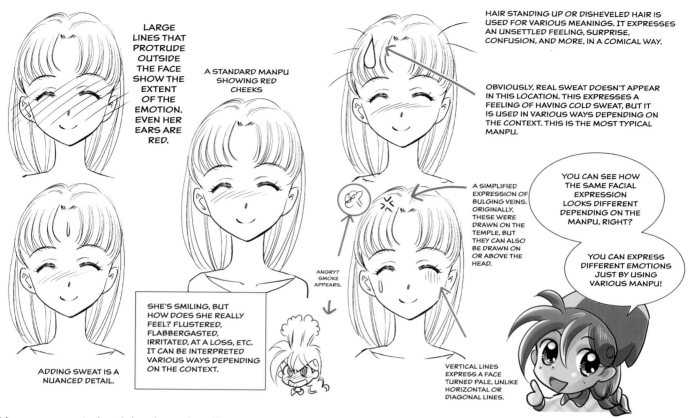

LARGE LINES THAT PROTRUDE OUTSIDE THE FACE SHOW THE EXTENT OF THE EMOTION. EVEN HER EARS ARE RED.

A STANDARD MANPU SHOWING RED CHEEKS

HAIR STANDING UP OR DISHEVELED HAIR IS USED FOR VARIOUS MEANINGS. IT EXPRESSES AN UNSETTLED FEELING, SURPRISE, CONFUSION, AND MORE, IN A COMICAL WAY.

OBVIOUSLY, REAL SWEAT DOESN'T APPEAR IN THIS LOCATION. THIS EXPRESSES A FEELING OF HAVING COLD SWEAT, BUT IT IS USED IN VARIOUS WAYS DEPENDING ON THE CONTEXT. THIS IS THE MOST TYPICAL MANPU.

A SIMPLIFIED EXPRESSION OF BULGING VEINS. ORIGINALLY, THESE WERE DRAWN ON THE TEMPLE, BUT THEY CAN ALSO BE DRAWN ON OR ABOVE THE HEAD.

YOU CAN SEE HOW THE SAME FACIAL EXPRESSION LOOKS DIFFERENT DEPENDING ON THE MANPU, RIGHT?

YOU CAN EXPRESS DIFFERENT EMOTIONS JUST BY USING VARIOUS MANPU!

ADDING SWEAT IS A NUANCED DETAIL.

SHE'S SMILING, BUT HOW DOES SHE REALLY FEEL? FLUSTERED, FLABBERGASTED, IRRITATED, AT A LOSS, ETC. IT CAN BE INTERPRETED VARIOUS WAYS DEPENDING ON THE CONTEXT.

ANGRY? SMOKE APPEARS.

VERTICAL LINES EXPRESS A FACE TURNED PALE, UNLIKE HORIZONTAL OR DIAGONAL LINES.

Manpu are comical and they have the effect of softening a serious scene. That's why they're often used with the Chibi style or as a comedic touch. But it's not only for comedy—they're used in almost all genres of manga.

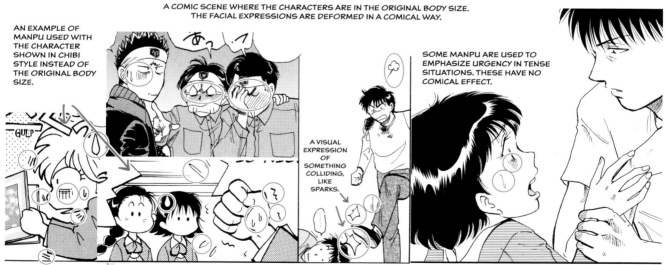

A COMIC SCENE WHERE THE CHARACTERS ARE IN THE ORIGINAL BODY SIZE. THE FACIAL EXPRESSIONS ARE DEFORMED IN A COMICAL WAY.

AN EXAMPLE OF MANPU USED WITH THE CHARACTER SHOWN IN CHIBI STYLE INSTEAD OF THE ORIGINAL BODY SIZE.

SOME MANPU ARE USED TO EMPHASIZE URGENCY IN TENSE SITUATIONS. THESE HAVE NO COMICAL EFFECT.

A VISUAL EXPRESSION OF SOMETHING COLLIDING, LIKE SPARKS.

This isn't limited to Manpu, but manga expression has developed gradually through the work of many artists. The new ways of expressing that artists came up with became established as new expressions.

These were further polished and developed to become other new expressions. There were also many failed expressions that have since disappeared.

The rich manga expressions we have today are the result of hard work by artists. This process is ongoing. Changes happen every day.

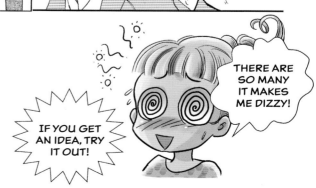

THERE ARE SO MANY IT MAKES ME DIZZY!

IF YOU GET AN IDEA, TRY IT OUT!

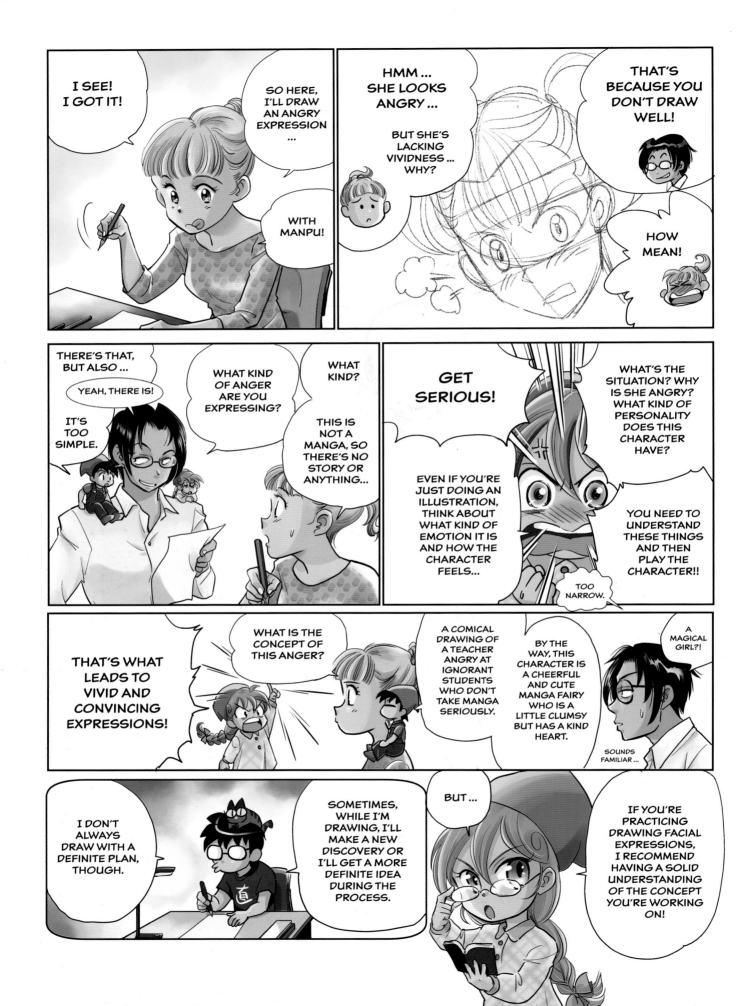

THE ANGER OF A SINGLE CHARACTER CAN EXIST IN MANY DIFFERENT WAYS!

EVEN WITH THE SAME CHARACTER,

A DIFFERENT TYPE OF ANGER WOULD RESULT IN A DIFFERENT FACIAL EXPRESSION.

BUT IN MANGA, THE DIRECTOR AND ALL OF THE ACTORS ARE PLAYED BY THE ARTIST, OF COURSE.

YOU CAN'T JUST HAVE A TEMPLATE.

OR YOU'LL END UP LIKE A BAD ACTOR WHO CAN'T UNDERSTAND THE EMOTIONS OF A CHARACTER.

DRAWING SUBTLE EXPRESSIONS CAN BE HARD.

EVEN PROFESSIONALS REDO THEIR DRAWING MANY TIMES.

HMM ... THAT'S NOT IT. THIS ISN'T WHAT I'M GOING FOR ...

LIKE IN MOVIES, WHEN A DIRECTOR SAYS 'NO' TO A SCENE MANY TIMES.

I DIDN'T KNOW PROFESSIONALS REDO THEIR DRAWINGS MANY TIMES!

DO YOU EVER GET STUCK DRAWING?

WHEN THAT HAPPENS ...

IT'S NO USE ... I CAN'T DRAW.

I'LL JUST SLEEP.

THAT'S NO GOOD ...

FACIAL EXPRESSIONS COME IN VARIOUS TYPES, DEPENDING ON THE STYLE AND GENRE, SO IT'S GOOD TO STUDY YOUR FAVORITE MANGA!

I NEED A BREAK.

I TAKE A WALK OR LISTEN TO MUSIC.

THINK ABOUT WHAT KIND OF EMOTION IS BEING EXPRESSED!

FACE
51

HOW CAN I DRAW LIVELY FACIAL EXPRESSIONS?

I'm asked that question a lot. That's because one of the most attractive parts of Japanese manga is the characters' facial expressions. But it's not easy. There are methods of drawing that can be used to make a character look sad or angry, for example, by drawing a certain way, as I've explained already. However, that is an engineer-like approach. Truly lively expression goes beyond that.

Some manga artists are good at drawing facial expressions while others are not. Sometimes I can't draw the facial expression I have in mind and I get stuck, but overall, I think I'm pretty good at drawing facial expressions. Facial expressions are fun to draw and editors and Senpai-manga artists have told me I'm good at it, so that's probably true. But why did I become good at it? I can think of one reason.

You know how children play make believe? Where you become a hero or a princess? You play the part yourself or you use dolls when you're playing with friends. I used to do that a lot. But since I loved to draw, I did it alone by drawing instead of using dolls. I would pretend to be characters from my favorite anime or special effects action show, and I would mumble their dialogue as I drew the characters (especially their faces).

I loved doing that, so I did it every day—for hours. I would pretend to be many different characters, drawing their faces and saying their dialogue. I did this simply for fun, so I didn't redraw the faces until I had the exact look I had in mind. After all, make believe stories just keep going. My drawings were terrible and none of them was done thoroughly.

But I kept drawing every day. I must have done several thousand or tens of thousands of drawings. Without realizing it, I acquired the skill of drawing facial expressions. Drawing while acting out a part in your mind is very good practice. I just drew without thinking anything, so it took me tens of thousands of drawings to acquire the technique, but I'm sure that you can improve much faster if you think about specific things and redo the drawings many times.

Keep drawing and learn how to draw facial expressions exactly how you want!

> THINK ABOUT HOW YOU WOULD UNDERSTAND THE SCENARIO AND HOW YOU WOULD PLAY THE CHARACTER IF YOU WERE AN ACTOR!

> IT'S IMPORTANT TO SYNC YOURSELF WITH THE CHARACTER'S EMOTIONS!

THIS IS THE KIND OF KID I WAS.

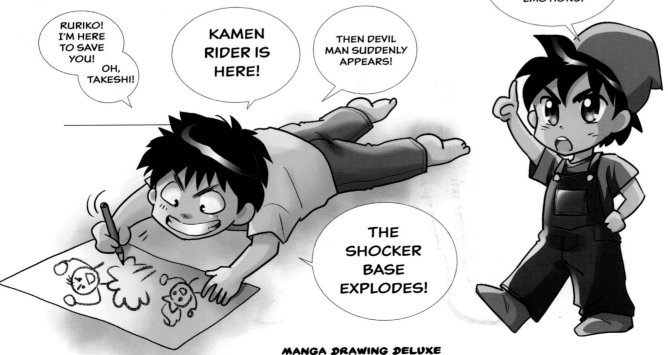

> RURIKO! I'M HERE TO SAVE YOU! OH, TAKESHI!

> KAMEN RIDER IS HERE!

> THEN DEVIL MAN SUDDENLY APPEARS!

> THE SHOCKER BASE EXPLODES!

Even now, when I'm coming up with a story, I do lots of sketches to work out the details.
It's very similar to what I did in my childhood.

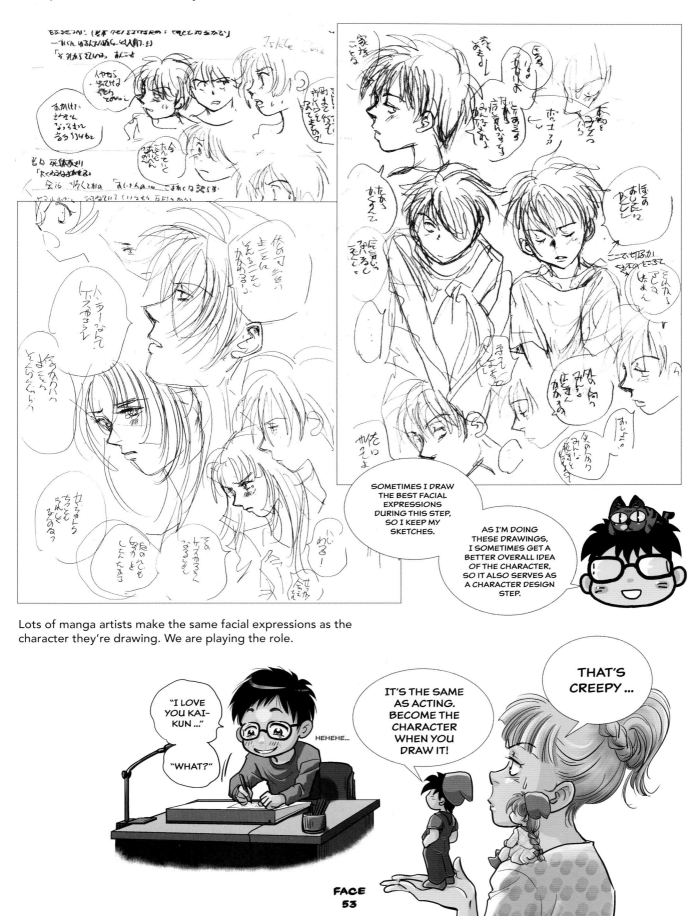

SOMETIMES I DRAW THE BEST FACIAL EXPRESSIONS DURING THIS STEP, SO I KEEP MY SKETCHES.

AS I'M DOING THESE DRAWINGS, I SOMETIMES GET A BETTER OVERALL IDEA OF THE CHARACTER, SO IT ALSO SERVES AS A CHARACTER DESIGN STEP.

Lots of manga artists make the same facial expressions as the character they're drawing. We are playing the role.

"I LOVE YOU KAI-KUN ..."

"WHAT?"

HEHEHE...

IT'S THE SAME AS ACTING. BECOME THE CHARACTER WHEN YOU DRAW IT!

THAT'S CREEPY ...

FACE
53

Anne
sketches.

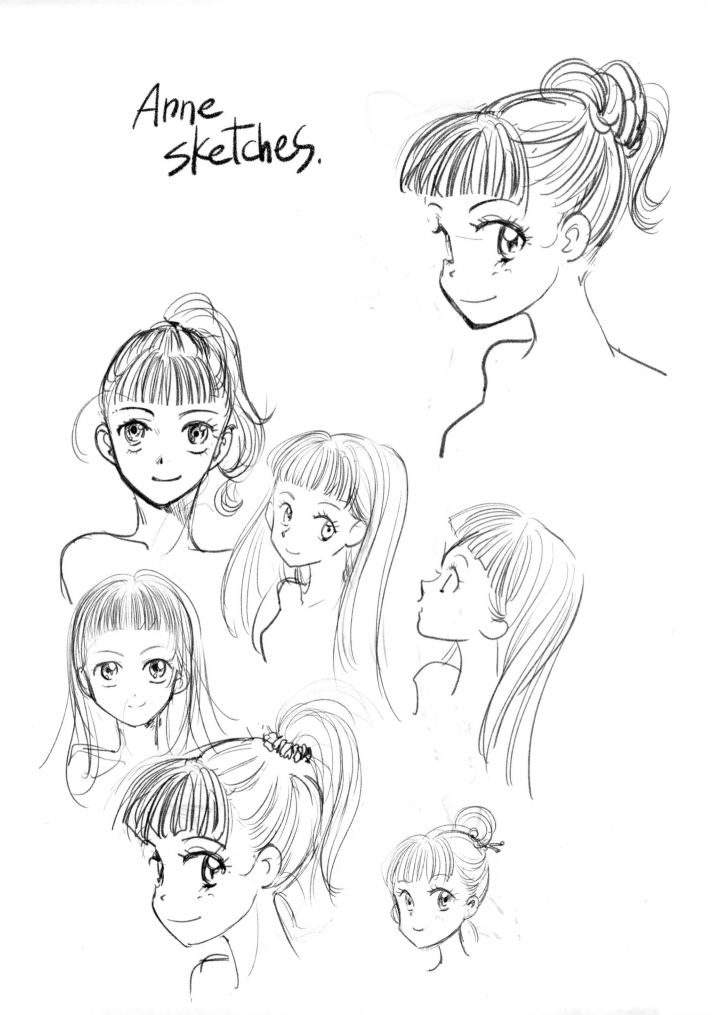

BODY

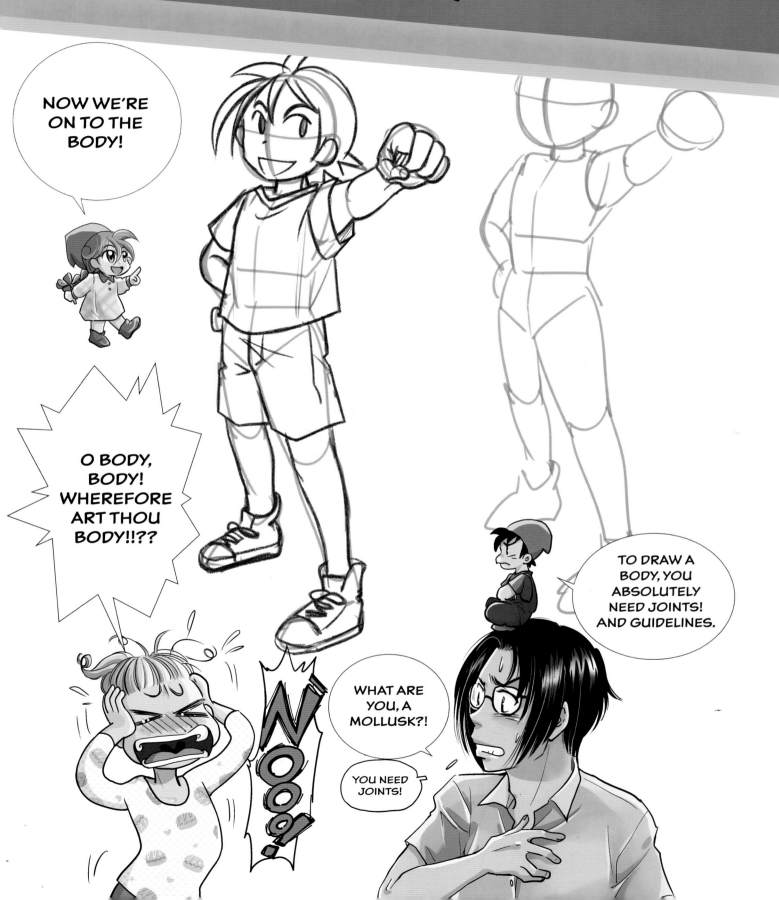

OVERALL STRUCTURE

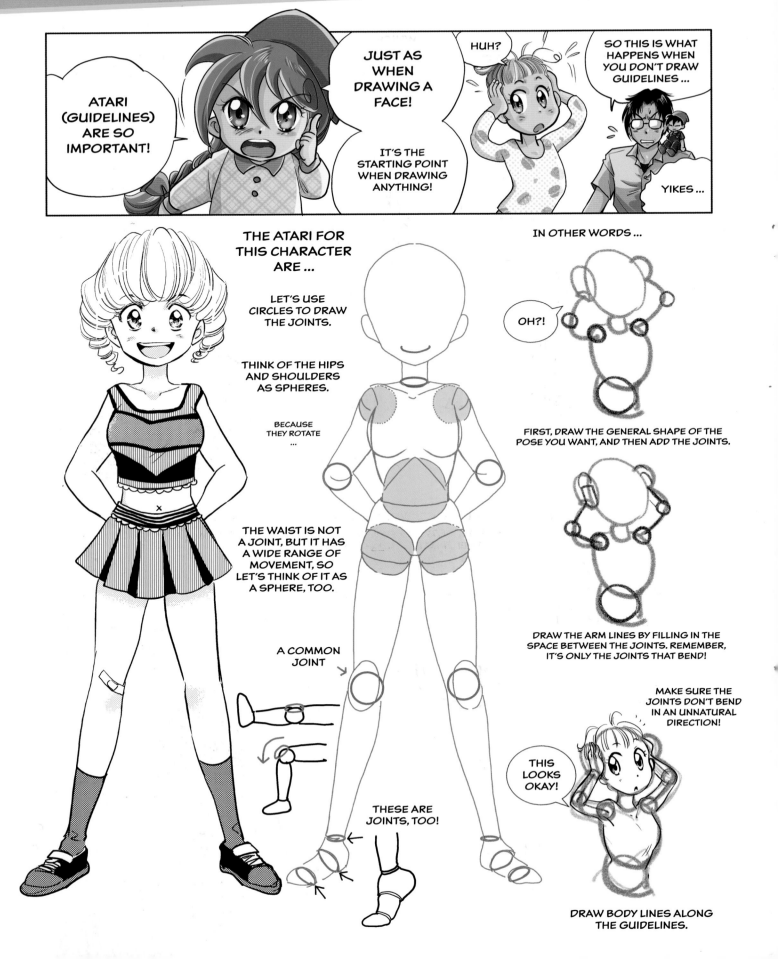

ATARI (GUIDELINES) ARE SO IMPORTANT!

JUST AS WHEN DRAWING A FACE!

IT'S THE STARTING POINT WHEN DRAWING ANYTHING!

HUH?

SO THIS IS WHAT HAPPENS WHEN YOU DON'T DRAW GUIDELINES ...

YIKES ...

THE ATARI FOR THIS CHARACTER ARE ...

LET'S USE CIRCLES TO DRAW THE JOINTS.

THINK OF THE HIPS AND SHOULDERS AS SPHERES.

BECAUSE THEY ROTATE ...

THE WAIST IS NOT A JOINT, BUT IT HAS A WIDE RANGE OF MOVEMENT, SO LET'S THINK OF IT AS A SPHERE, TOO.

A COMMON JOINT

THESE ARE JOINTS, TOO!

IN OTHER WORDS ...

OH?!

FIRST, DRAW THE GENERAL SHAPE OF THE POSE YOU WANT, AND THEN ADD THE JOINTS.

DRAW THE ARM LINES BY FILLING IN THE SPACE BETWEEN THE JOINTS. REMEMBER, IT'S ONLY THE JOINTS THAT BEND!

MAKE SURE THE JOINTS DON'T BEND IN AN UNNATURAL DIRECTION!

THIS LOOKS OKAY!

DRAW BODY LINES ALONG THE GUIDELINES.

DRAWING ATARI

THERE ARE MANY WAYS TO DRAW ATARI, BUT THE PURPOSE IS ALWAYS THE SAME: TO ASSEMBLE A NATURAL POSE IN YOUR MIND BY PAYING ATTENTION TO THE SKELETAL FRAME AND JOINTS.

WHICH ONE SHOULD I CHOOSE?

THE METHODS TAUGHT IN SCHOOLS AND BOOKS HAVE BEEN WELL THOUGHT OUT, SO YOU SHOULD JUST USE ONE THAT WORKS FOR YOU.

BUT DON'T SKIP IT!

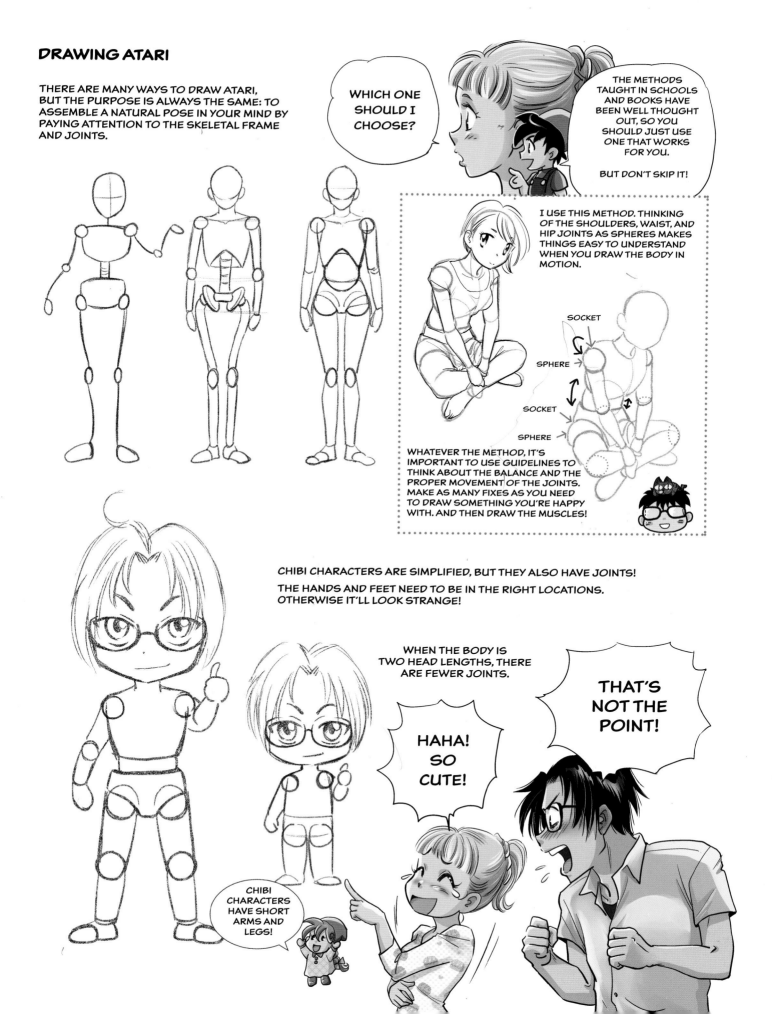

I USE THIS METHOD. THINKING OF THE SHOULDERS, WAIST, AND HIP JOINTS AS SPHERES MAKES THINGS EASY TO UNDERSTAND WHEN YOU DRAW THE BODY IN MOTION.

SOCKET

SPHERE

SOCKET

SPHERE

WHATEVER THE METHOD, IT'S IMPORTANT TO USE GUIDELINES TO THINK ABOUT THE BALANCE AND THE PROPER MOVEMENT OF THE JOINTS. MAKE AS MANY FIXES AS YOU NEED TO DRAW SOMETHING YOU'RE HAPPY WITH. AND THEN DRAW THE MUSCLES!

CHIBI CHARACTERS ARE SIMPLIFIED, BUT THEY ALSO HAVE JOINTS!

THE HANDS AND FEET NEED TO BE IN THE RIGHT LOCATIONS. OTHERWISE IT'LL LOOK STRANGE!

WHEN THE BODY IS TWO HEAD LENGTHS, THERE ARE FEWER JOINTS.

HAHA! SO CUTE!

THAT'S NOT THE POINT!

CHIBI CHARACTERS HAVE SHORT ARMS AND LEGS!

FACING FRONT

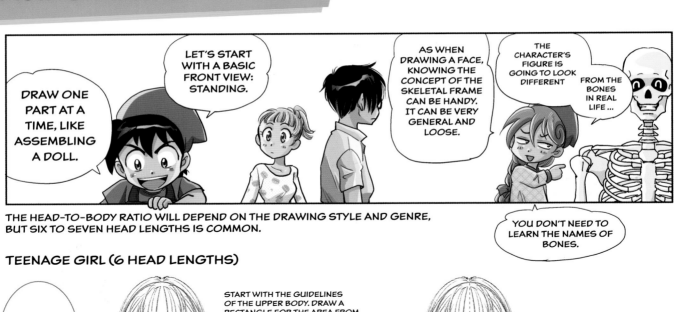

THE HEAD-TO-BODY RATIO WILL DEPEND ON THE DRAWING STYLE AND GENRE, BUT SIX TO SEVEN HEAD LENGTHS IS COMMON.

YOU DON'T NEED TO LEARN THE NAMES OF BONES.

TEENAGE GIRL (6 HEAD LENGTHS)

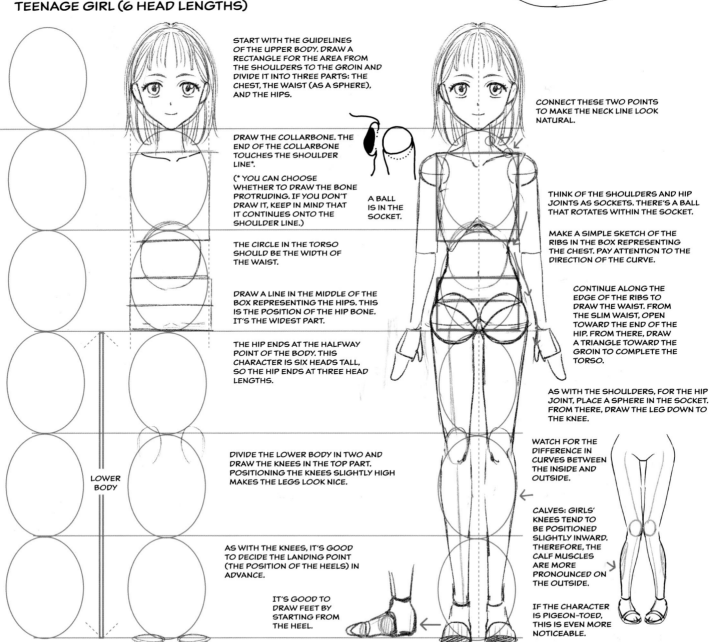

START WITH THE GUIDELINES OF THE UPPER BODY. DRAW A RECTANGLE FOR THE AREA FROM THE SHOULDERS TO THE GROIN AND DIVIDE IT INTO THREE PARTS: THE CHEST, THE WAIST (AS A SPHERE), AND THE HIPS.

DRAW THE COLLARBONE. THE END OF THE COLLARBONE TOUCHES THE SHOULDER LINE*.

(* YOU CAN CHOOSE WHETHER TO DRAW THE BONE PROTRUDING. IF YOU DON'T DRAW IT, KEEP IN MIND THAT IT CONTINUES ONTO THE SHOULDER LINE.)

A BALL IS IN THE SOCKET.

THE CIRCLE IN THE TORSO SHOULD BE THE WIDTH OF THE WAIST.

DRAW A LINE IN THE MIDDLE OF THE BOX REPRESENTING THE HIPS. THIS IS THE POSITION OF THE HIP BONE. IT'S THE WIDEST PART.

THE HIP ENDS AT THE HALFWAY POINT OF THE BODY. THIS CHARACTER IS SIX HEADS TALL, SO THE HIP ENDS AT THREE HEAD LENGTHS.

LOWER BODY

DIVIDE THE LOWER BODY IN TWO AND DRAW THE KNEES IN THE TOP PART. POSITIONING THE KNEES SLIGHTLY HIGH MAKES THE LEGS LOOK NICE.

AS WITH THE KNEES, IT'S GOOD TO DECIDE THE LANDING POINT (THE POSITION OF THE HEELS) IN ADVANCE.

IT'S GOOD TO DRAW FEET BY STARTING FROM THE HEEL.

CONNECT THESE TWO POINTS TO MAKE THE NECK LINE LOOK NATURAL.

THINK OF THE SHOULDERS AND HIP JOINTS AS SOCKETS. THERE'S A BALL THAT ROTATES WITHIN THE SOCKET.

MAKE A SIMPLE SKETCH OF THE RIBS IN THE BOX REPRESENTING THE CHEST. PAY ATTENTION TO THE DIRECTION OF THE CURVE.

CONTINUE ALONG THE EDGE OF THE RIBS TO DRAW THE WAIST. FROM THE SLIM WAIST, OPEN TOWARD THE END OF THE HIP. FROM THERE, DRAW A TRIANGLE TOWARD THE GROIN TO COMPLETE THE TORSO.

AS WITH THE SHOULDERS, FOR THE HIP JOINT, PLACE A SPHERE IN THE SOCKET. FROM THERE, DRAW THE LEG DOWN TO THE KNEE.

WATCH FOR THE DIFFERENCE IN CURVES BETWEEN THE INSIDE AND OUTSIDE.

CALVES: GIRLS' KNEES TEND TO BE POSITIONED SLIGHTLY INWARD. THEREFORE, THE CALF MUSCLES ARE MORE PRONOUNCED ON THE OUTSIDE.

IF THE CHARACTER IS PIGEON-TOED, THIS IS EVEN MORE NOTICEABLE.

OK NO

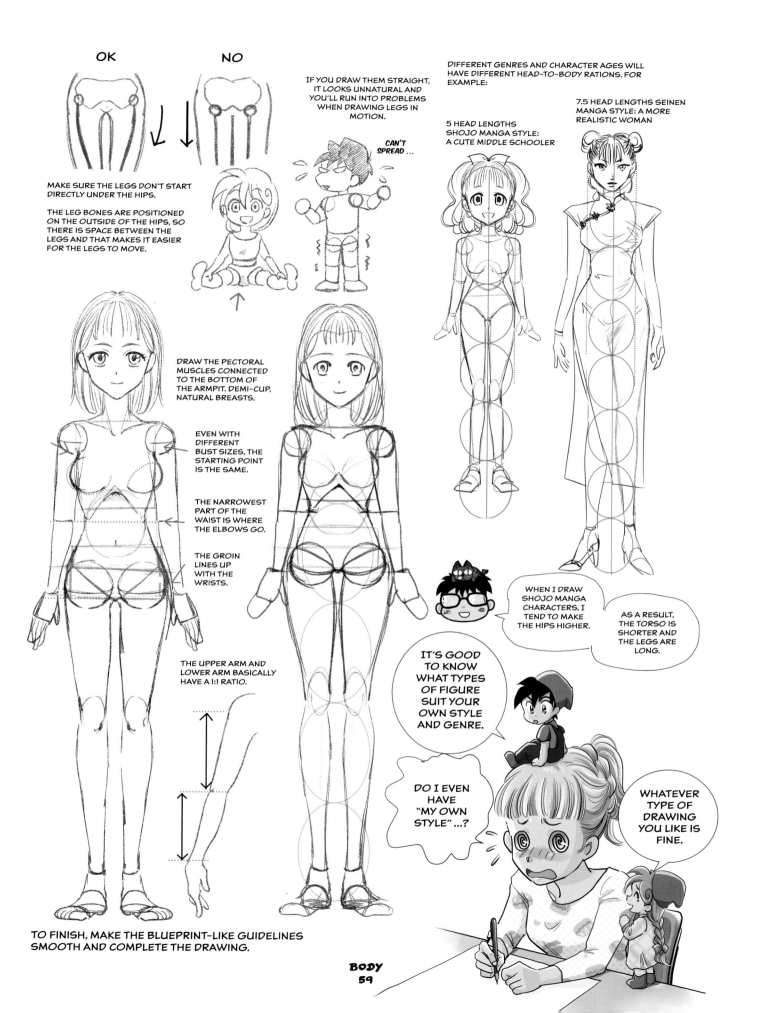

IF YOU DRAW THEM STRAIGHT, IT LOOKS UNNATURAL AND YOU'LL RUN INTO PROBLEMS WHEN DRAWING LEGS IN MOTION.

CAN'T SPREAD ...

DIFFERENT GENRES AND CHARACTER AGES WILL HAVE DIFFERENT HEAD-TO-BODY RATIONS. FOR EXAMPLE:

5 HEAD LENGTHS SHOJO MANGA STYLE: A CUTE MIDDLE SCHOOLER

7.5 HEAD LENGTHS SEINEN MANGA STYLE: A MORE REALISTIC WOMAN

MAKE SURE THE LEGS DON'T START DIRECTLY UNDER THE HIPS.

THE LEG BONES ARE POSITIONED ON THE OUTSIDE OF THE HIPS, SO THERE IS SPACE BETWEEN THE LEGS AND THAT MAKES IT EASIER FOR THE LEGS TO MOVE.

DRAW THE PECTORAL MUSCLES CONNECTED TO THE BOTTOM OF THE ARMPIT. DEMI-CUP, NATURAL BREASTS.

EVEN WITH DIFFERENT BUST SIZES, THE STARTING POINT IS THE SAME.

THE NARROWEST PART OF THE WAIST IS WHERE THE ELBOWS GO.

THE GROIN LINES UP WITH THE WRISTS.

THE UPPER ARM AND LOWER ARM BASICALLY HAVE A 1:1 RATIO.

WHEN I DRAW SHOJO MANGA CHARACTERS, I TEND TO MAKE THE HIPS HIGHER.

AS A RESULT, THE TORSO IS SHORTER AND THE LEGS ARE LONG.

IT'S GOOD TO KNOW WHAT TYPES OF FIGURE SUIT YOUR OWN STYLE AND GENRE.

DO I EVEN HAVE "MY OWN STYLE" ...?

WHATEVER TYPE OF DRAWING YOU LIKE IS FINE.

TO FINISH, MAKE THE BLUEPRINT-LIKE GUIDELINES SMOOTH AND COMPLETE THE DRAWING.

BODY
59

TEENAGE BOY (6.5 HEAD LENGTHS)

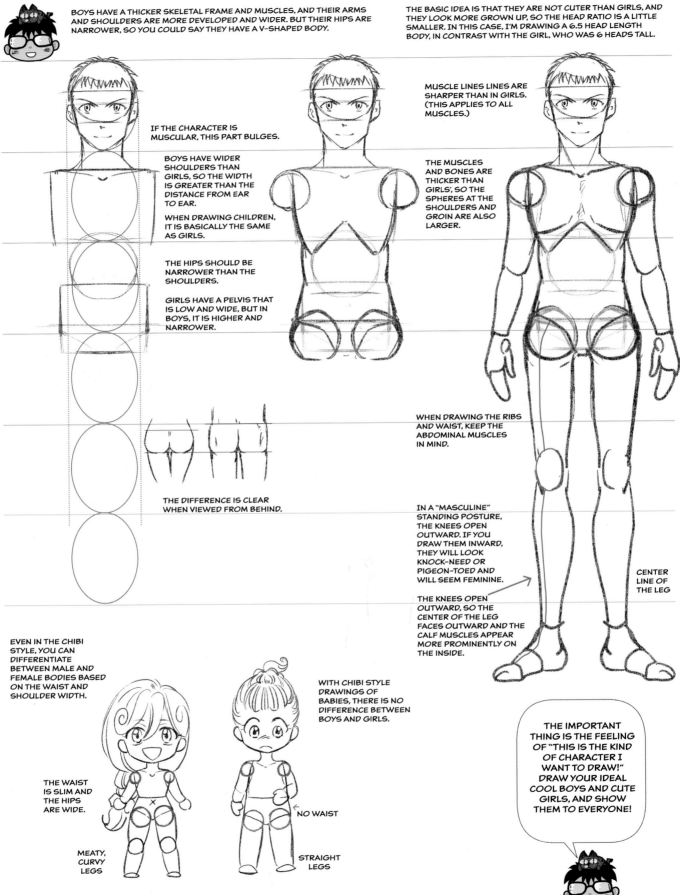

BOYS HAVE A THICKER SKELETAL FRAME AND MUSCLES, AND THEIR ARMS AND SHOULDERS ARE MORE DEVELOPED AND WIDER. BUT THEIR HIPS ARE NARROWER, SO YOU COULD SAY THEY HAVE A V-SHAPED BODY.

THE BASIC IDEA IS THAT THEY ARE NOT CUTER THAN GIRLS, AND THEY LOOK MORE GROWN UP, SO THE HEAD RATIO IS A LITTLE SMALLER. IN THIS CASE, I'M DRAWING A 6.5 HEAD LENGTH BODY, IN CONTRAST WITH THE GIRL, WHO WAS 6 HEADS TALL.

IF THE CHARACTER IS MUSCULAR, THIS PART BULGES.

BOYS HAVE WIDER SHOULDERS THAN GIRLS, SO THE WIDTH IS GREATER THAN THE DISTANCE FROM EAR TO EAR.

WHEN DRAWING CHILDREN, IT IS BASICALLY THE SAME AS GIRLS.

THE HIPS SHOULD BE NARROWER THAN THE SHOULDERS.

GIRLS HAVE A PELVIS THAT IS LOW AND WIDE, BUT IN BOYS, IT IS HIGHER AND NARROWER.

THE DIFFERENCE IS CLEAR WHEN VIEWED FROM BEHIND.

MUSCLE LINES LINES ARE SHARPER THAN IN GIRLS. (THIS APPLIES TO ALL MUSCLES.)

THE MUSCLES AND BONES ARE THICKER THAN GIRLS', SO THE SPHERES AT THE SHOULDERS AND GROIN ARE ALSO LARGER.

WHEN DRAWING THE RIBS AND WAIST, KEEP THE ABDOMINAL MUSCLES IN MIND.

IN A "MASCULINE" STANDING POSTURE, THE KNEES OPEN OUTWARD. IF YOU DRAW THEM INWARD, THEY WILL LOOK KNOCK-NEED OR PIGEON-TOED AND WILL SEEM FEMININE.

THE KNEES OPEN OUTWARD, SO THE CENTER OF THE LEG FACES OUTWARD AND THE CALF MUSCLES APPEAR MORE PROMINENTLY ON THE INSIDE.

CENTER LINE OF THE LEG

EVEN IN THE CHIBI STYLE, YOU CAN DIFFERENTIATE BETWEEN MALE AND FEMALE BODIES BASED ON THE WAIST AND SHOULDER WIDTH.

WITH CHIBI STYLE DRAWINGS OF BABIES, THERE IS NO DIFFERENCE BETWEEN BOYS AND GIRLS.

THE WAIST IS SLIM AND THE HIPS ARE WIDE.

MEATY, CURVY LEGS

NO WAIST

STRAIGHT LEGS

THE IMPORTANT THING IS THE FEELING OF "THIS IS THE KIND OF CHARACTER I WANT TO DRAW!" DRAW YOUR IDEAL COOL BOYS AND CUTE GIRLS, AND SHOW THEM TO EVERYONE!

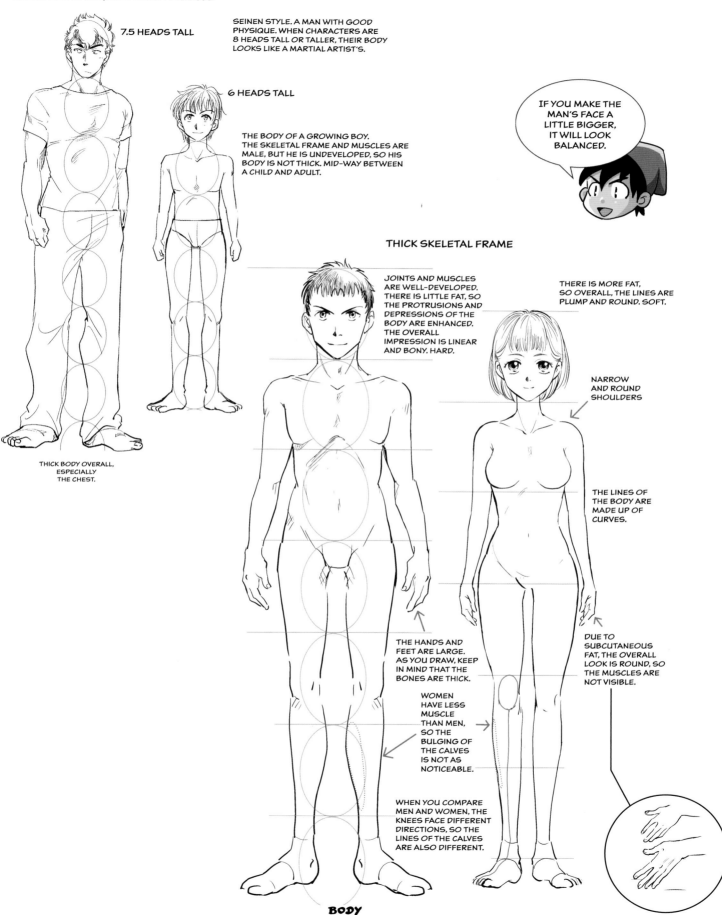

SLENDER FRAME, NOT MUCH MUSCLE

7.5 HEADS TALL

SEINEN STYLE. A MAN WITH GOOD PHYSIQUE. WHEN CHARACTERS ARE 8 HEADS TALL OR TALLER, THEIR BODY LOOKS LIKE A MARTIAL ARTIST'S.

6 HEADS TALL

THE BODY OF A GROWING BOY. THE SKELETAL FRAME AND MUSCLES ARE MALE, BUT HE IS UNDEVELOPED, SO HIS BODY IS NOT THICK. MID-WAY BETWEEN A CHILD AND ADULT.

IF YOU MAKE THE MAN'S FACE A LITTLE BIGGER, IT WILL LOOK BALANCED.

THICK SKELETAL FRAME

JOINTS AND MUSCLES ARE WELL-DEVELOPED. THERE IS LITTLE FAT, SO THE PROTRUSIONS AND DEPRESSIONS OF THE BODY ARE ENHANCED. THE OVERALL IMPRESSION IS LINEAR AND BONY. HARD.

THERE IS MORE FAT, SO OVERALL, THE LINES ARE PLUMP AND ROUND. SOFT.

NARROW AND ROUND SHOULDERS

THE LINES OF THE BODY ARE MADE UP OF CURVES.

THICK BODY OVERALL, ESPECIALLY THE CHEST.

THE HANDS AND FEET ARE LARGE. AS YOU DRAW, KEEP IN MIND THAT THE BONES ARE THICK.

DUE TO SUBCUTANEOUS FAT, THE OVERALL LOOK IS ROUND, SO THE MUSCLES ARE NOT VISIBLE.

WOMEN HAVE LESS MUSCLE THAN MEN, SO THE BULGING OF THE CALVES IS NOT AS NOTICEABLE.

WHEN YOU COMPARE MEN AND WOMEN, THE KNEES FACE DIFFERENT DIRECTIONS, SO THE LINES OF THE CALVES ARE ALSO DIFFERENT.

BODY
61

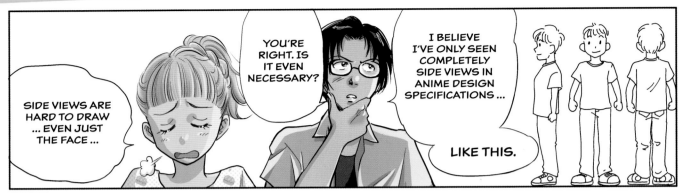

ATARI OF THE TORSO

THE COMPLETELY SIDE VIEW ANGLE IS UNNATURAL, SO YOU MIGHT NOT DRAW IT MUCH IN MANGA, BUT LET'S PRACTICE IT TO UNDERSTAND THE STRUCTURE!

THINK ABOUT THE OVERALL FIGURE, DECIDE THE POSITION OF THE HEAD, AND DRAW THE CENTER OF GRAVITY LINE. IN A FRONT VIEW, IT GOES IN THE MIDDLE OF THE BODY, BUT IN THIS CASE, IT GOES IN THE MIDDLE OF THE NECK.

PUT SPHERES IN THE SHOULDERS AND GROIN, AND THEN DRAW THE BUTTOCKS AND LEGS. AS EXPLAINED IN THE FACES SECTION, ALWAYS THINK ABOUT THE SIDE AND FRONT SURFACES.

THE CENTER OF GRAVITY IS A STRAIGHT LINE, BUT THE BODY AXIS FORMS AN "S" SHAPE THAT STARTS FROM THE CURVE OF THE BACKBONE, TO MAINTAIN BALANCE. WHEN STANDING STRAIGHT WITH THE CHEST HELD OUT, THE LOWER ABDOMEN PROTRUDES FORWARD AND THE BACK AND CALVES ARE PULLED BACK.

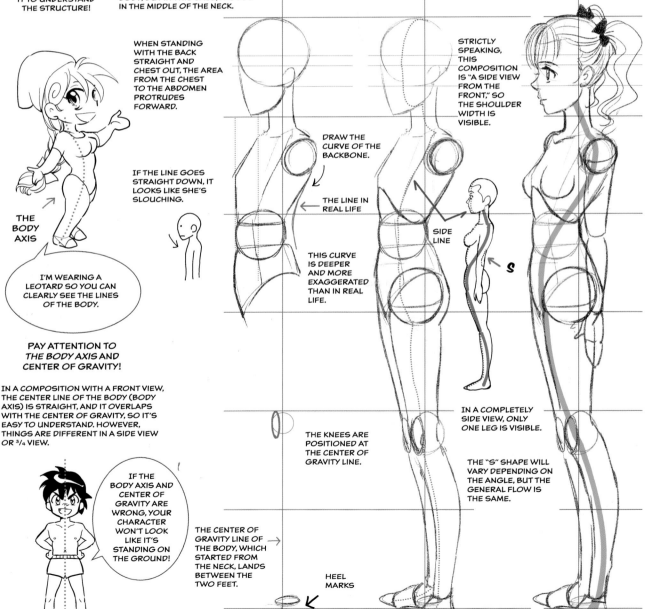

WHEN STANDING WITH THE BACK STRAIGHT AND CHEST OUT, THE AREA FROM THE CHEST TO THE ABDOMEN PROTRUDES FORWARD.

IF THE LINE GOES STRAIGHT DOWN, IT LOOKS LIKE SHE'S SLOUCHING.

DRAW THE CURVE OF THE BACKBONE.

THE LINE IN REAL LIFE

THIS CURVE IS DEEPER AND MORE EXAGGERATED THAN IN REAL LIFE.

STRICTLY SPEAKING, THIS COMPOSITION IS "A SIDE VIEW FROM THE FRONT," SO THE SHOULDER WIDTH IS VISIBLE.

SIDE LINE

S

THE BODY AXIS

I'M WEARING A LEOTARD SO YOU CAN CLEARLY SEE THE LINES OF THE BODY.

PAY ATTENTION TO *THE BODY AXIS AND CENTER OF GRAVITY!*

IN A COMPOSITION WITH A FRONT VIEW, THE CENTER LINE OF THE BODY (BODY AXIS) IS STRAIGHT, AND IT OVERLAPS WITH THE CENTER OF GRAVITY, SO IT'S EASY TO UNDERSTAND. HOWEVER, THINGS ARE DIFFERENT IN A SIDE VIEW OR ¾ VIEW.

IF THE BODY AXIS AND CENTER OF GRAVITY ARE WRONG, YOUR CHARACTER WON'T LOOK LIKE IT'S STANDING ON THE GROUND!

THE KNEES ARE POSITIONED AT THE CENTER OF GRAVITY LINE.

IN A COMPLETELY SIDE VIEW, ONLY ONE LEG IS VISIBLE.

THE "S" SHAPE WILL VARY DEPENDING ON THE ANGLE, BUT THE GENERAL FLOW IS THE SAME.

THE CENTER OF GRAVITY LINE OF THE BODY, WHICH STARTED FROM THE NECK, LANDS BETWEEN THE TWO FEET.

HEEL MARKS

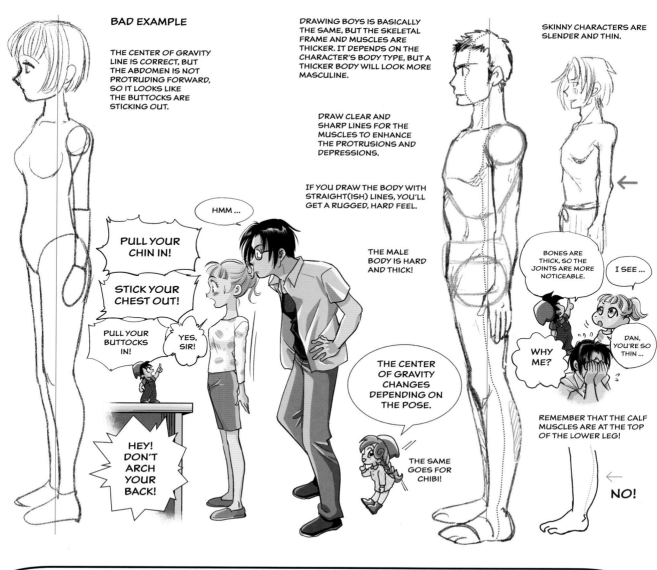

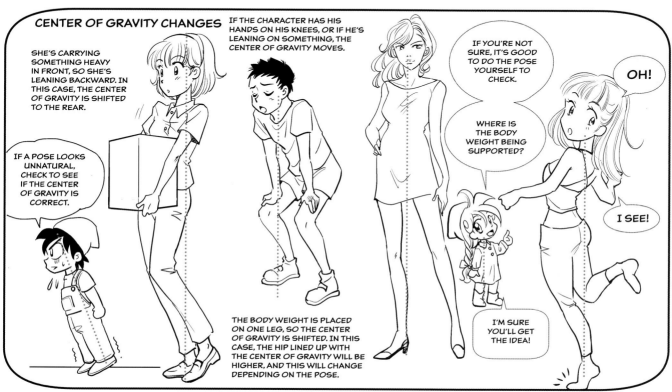

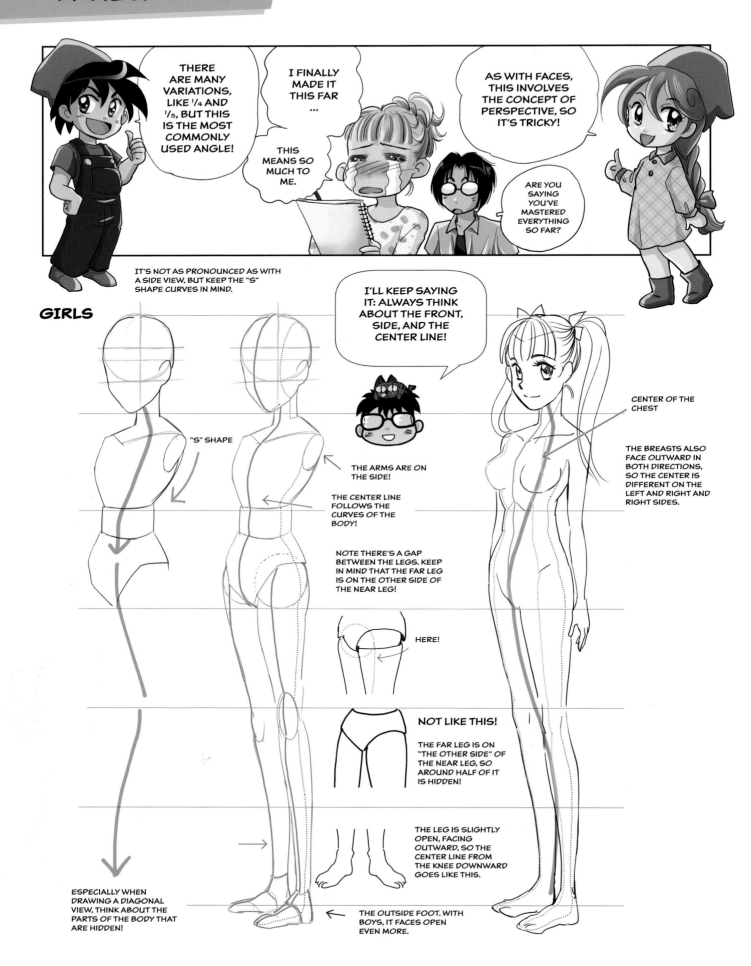

THERE ARE MANY VARIATIONS, LIKE ¹/₄ AND ¹/₅, BUT THIS IS THE MOST COMMONLY USED ANGLE!

I FINALLY MADE IT THIS FAR ...

THIS MEANS SO MUCH TO ME.

AS WITH FACES, THIS INVOLVES THE CONCEPT OF PERSPECTIVE, SO IT'S TRICKY!

ARE YOU SAYING YOU'VE MASTERED EVERYTHING SO FAR?

IT'S NOT AS PRONOUNCED AS WITH A SIDE VIEW, BUT KEEP THE "S" SHAPE CURVES IN MIND.

GIRLS

I'LL KEEP SAYING IT: ALWAYS THINK ABOUT THE FRONT, SIDE, AND THE CENTER LINE!

"S" SHAPE

THE ARMS ARE ON THE SIDE!

THE CENTER LINE FOLLOWS THE CURVES OF THE BODY!

NOTE THERE'S A GAP BETWEEN THE LEGS. KEEP IN MIND THAT THE FAR LEG IS ON THE OTHER SIDE OF THE NEAR LEG!

HERE!

NOT LIKE THIS!

THE FAR LEG IS ON "THE OTHER SIDE" OF THE NEAR LEG, SO AROUND HALF OF IT IS HIDDEN!

CENTER OF THE CHEST

THE BREASTS ALSO FACE OUTWARD IN BOTH DIRECTIONS, SO THE CENTER IS DIFFERENT ON THE LEFT AND RIGHT AND RIGHT SIDES.

THE LEG IS SLIGHTLY OPEN, FACING OUTWARD, SO THE CENTER LINE FROM THE KNEE DOWNWARD GOES LIKE THIS.

ESPECIALLY WHEN DRAWING A DIAGONAL VIEW, THINK ABOUT THE PARTS OF THE BODY THAT ARE HIDDEN!

THE OUTSIDE FOOT. WITH BOYS, IT FACES OPEN EVEN MORE.

BOYS

THE DIFFERENCES OF EACH PART ARE THE SAME AS WHEN DRAWING FRONT VIEWS AND SIDE VIEWS.

BOYS ARE HORIZONTALLY THICK, SO IT SHOULD BE EASIER TO VISUALIZE THE SIDE SURFACE AND FRONT SURFACE.

KEEP IN MIND THAT THE HAND ALSO HAS A MAIN SURFACE (BACK OF THE HAND) AND A SIDE SURFACE.

MAIN SURFACE (SIDE)

BACK SURFACE

MAIN SURFACE (FRONT)

BACK OF THE HAND

SIDE

THE SAME APPLIES TO THE LEGS. MEN'S KNEES FACE MORE OUTWARD THAN WOMEN'S SO PAY ATTENTION TO THE POSITION OF THE KNEES.

YASUHIKO-DACHI (THE YASUHIKO POSE)

HAVE YOU EVER SEEN THIS STANDING POSE? IT'S AN EXAGGERATED "S" SHAPE WITH THE HIPS PUSHED FORWARD WHILE LEANING BACK. IN REAL LIFE, IT WOULD BE HARD TO KEEP YOUR BALANCE.

IT'S A UNIQUE POSE CREATED BY THE FIRST GUNDAM CHARACTER DESIGNER, MR. YOSHIKAZU YASUHIKO. IT WAS WILDLY POPULAR AND CAME TO BE KNOWN AS THE "YASUHIKO POSE."

MANY ARTISTS USE THIS POSE WITH VARYING DEGREES OF EXAGGERATION.

YOU'RE RIGHT, IT'S QUITE EXTREME ...

THE STOMACH STICKS OUT AND THE CHEST BECOMES FLAT, BUT IN MANGA IT LOOKS COOL.

HMM ...

NORMAL STANDING POSTURE WOULD LOOK LIKE THIS.

DOESN'T IT NEED TO BE ACCURATE?

WE'RE NOT DRAWING REALISTIC BODIES, SO ...

IT DOESN'T LOOK IMPRESSIVE WHEN A CHIBI CHARACTER DOES IT ...

AS LONG AS IT LOOKS COOL, IT'S OKAY!

HAHAHA

stretch

YEAH ...

HANDS

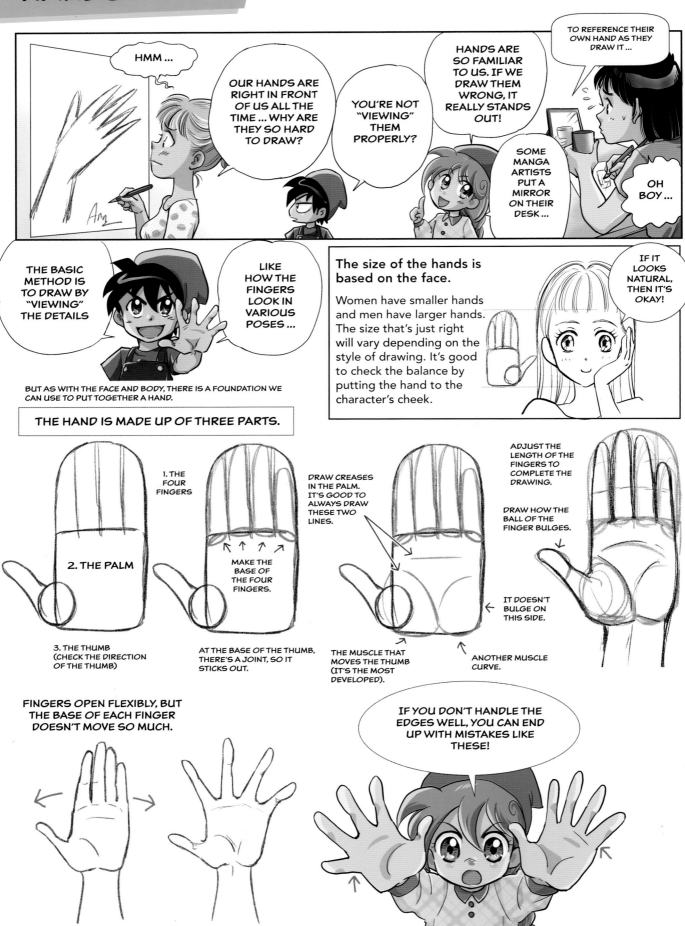

HMM ...

OUR HANDS ARE RIGHT IN FRONT OF US ALL THE TIME ... WHY ARE THEY SO HARD TO DRAW?

YOU'RE NOT "VIEWING" THEM PROPERLY?

HANDS ARE SO FAMILIAR TO US. IF WE DRAW THEM WRONG, IT REALLY STANDS OUT!

SOME MANGA ARTISTS PUT A MIRROR ON THEIR DESK ...

TO REFERENCE THEIR OWN HAND AS THEY DRAW IT ...

OH BOY ...

THE BASIC METHOD IS TO DRAW BY "VIEWING" THE DETAILS

LIKE HOW THE FINGERS LOOK IN VARIOUS POSES ...

BUT AS WITH THE FACE AND BODY, THERE IS A FOUNDATION WE CAN USE TO PUT TOGETHER A HAND.

The size of the hands is based on the face.

Women have smaller hands and men have larger hands. The size that's just right will vary depending on the style of drawing. It's good to check the balance by putting the hand to the character's cheek.

IF IT LOOKS NATURAL, THEN IT'S OKAY!

THE HAND IS MADE UP OF THREE PARTS.

1. THE FOUR FINGERS

2. THE PALM

3. THE THUMB (CHECK THE DIRECTION OF THE THUMB)

MAKE THE BASE OF THE FOUR FINGERS.

AT THE BASE OF THE THUMB, THERE'S A JOINT, SO IT STICKS OUT.

DRAW CREASES IN THE PALM. IT'S GOOD TO ALWAYS DRAW THESE TWO LINES.

THE MUSCLE THAT MOVES THE THUMB (IT'S THE MOST DEVELOPED).

ANOTHER MUSCLE CURVE.

IT DOESN'T BULGE ON THIS SIDE.

ADJUST THE LENGTH OF THE FINGERS TO COMPLETE THE DRAWING.

DRAW HOW THE BALL OF THE FINGER BULGES.

FINGERS OPEN FLEXIBLY, BUT THE BASE OF EACH FINGER DOESN'T MOVE SO MUCH.

IF YOU DON'T HANDLE THE EDGES WELL, YOU CAN END UP WITH MISTAKES LIKE THESE!

DRAW FROM BOTH ENDS TO MAINTAIN GOOD BALANCE.

DRAWING A FIST

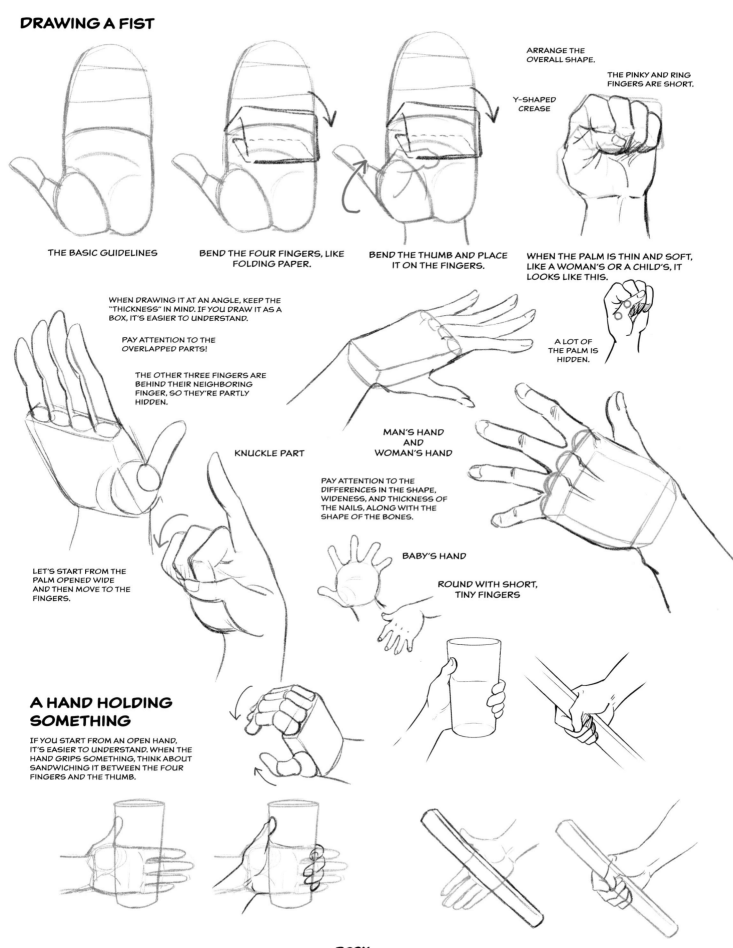

THE BASIC GUIDELINES

BEND THE FOUR FINGERS, LIKE FOLDING PAPER.

BEND THE THUMB AND PLACE IT ON THE FINGERS.

ARRANGE THE OVERALL SHAPE.

Y-SHAPED CREASE

THE PINKY AND RING FINGERS ARE SHORT.

WHEN THE PALM IS THIN AND SOFT, LIKE A WOMAN'S OR A CHILD'S, IT LOOKS LIKE THIS.

A LOT OF THE PALM IS HIDDEN.

WHEN DRAWING IT AT AN ANGLE, KEEP THE "THICKNESS" IN MIND. IF YOU DRAW IT AS A BOX, IT'S EASIER TO UNDERSTAND.

PAY ATTENTION TO THE OVERLAPPED PARTS!

THE OTHER THREE FINGERS ARE BEHIND THEIR NEIGHBORING FINGER, SO THEY'RE PARTLY HIDDEN.

KNUCKLE PART

MAN'S HAND
AND
WOMAN'S HAND

PAY ATTENTION TO THE DIFFERENCES IN THE SHAPE, WIDENESS, AND THICKNESS OF THE NAILS, ALONG WITH THE SHAPE OF THE BONES.

LET'S START FROM THE PALM OPENED WIDE AND THEN MOVE TO THE FINGERS.

BABY'S HAND

ROUND WITH SHORT, TINY FINGERS

A HAND HOLDING SOMETHING

IF YOU START FROM AN OPEN HAND, IT'S EASIER TO UNDERSTAND. WHEN THE HAND GRIPS SOMETHING, THINK ABOUT SANDWICHING IT BETWEEN THE FOUR FINGERS AND THE THUMB.

FEET

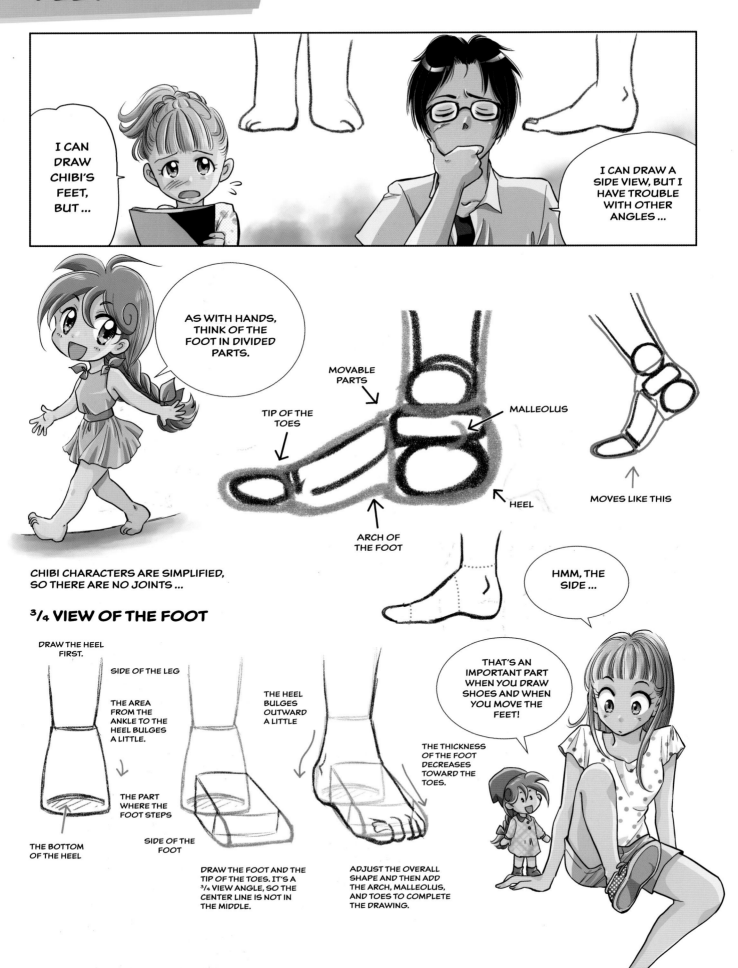

I CAN DRAW CHIBI'S FEET, BUT ...

I CAN DRAW A SIDE VIEW, BUT I HAVE TROUBLE WITH OTHER ANGLES ...

AS WITH HANDS, THINK OF THE FOOT IN DIVIDED PARTS.

MOVABLE PARTS

TIP OF THE TOES

MALLEOLUS

HEEL

ARCH OF THE FOOT

MOVES LIKE THIS

CHIBI CHARACTERS ARE SIMPLIFIED, SO THERE ARE NO JOINTS ...

HMM, THE SIDE ...

THAT'S AN IMPORTANT PART WHEN YOU DRAW SHOES AND WHEN YOU MOVE THE FEET!

¾ VIEW OF THE FOOT

DRAW THE HEEL FIRST.

SIDE OF THE LEG

THE AREA FROM THE ANKLE TO THE HEEL BULGES A LITTLE.

THE PART WHERE THE FOOT STEPS

THE BOTTOM OF THE HEEL

SIDE OF THE FOOT

DRAW THE FOOT AND THE TIP OF THE TOES. IT'S A ¾ VIEW ANGLE, SO THE CENTER LINE IS NOT IN THE MIDDLE.

THE HEEL BULGES OUTWARD A LITTLE

ADJUST THE OVERALL SHAPE AND THEN ADD THE ARCH, MALLEOLUS, AND TOES TO COMPLETE THE DRAWING.

THE THICKNESS OF THE FOOT DECREASES TOWARD THE TOES.

SHOES

IF YOU DRAW THE FOOT FIRST AND THEN "PUT A SHOE ON," YOU'LL HAVE A BELIEVABLE DRAWING.

PAY ATTENTION TO THE DIFFERENT CURVES!

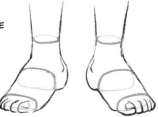

LEG (VERTICAL CYLINDER)

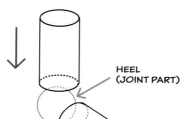

HEEL (JOINT PART)

FOOT (HORIZONTAL CYLINDER)

STILETTO HEELS

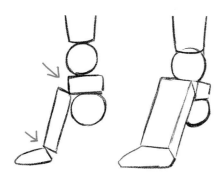

LIKE STANDING ON TIPTOES. HAVE A CLEAR UNDERSTANDING OF THE MOVABLE PARTS.

HIGH HEELS AND PUMPS FIT CLOSELY ALONG THE SHAPE OF THE FOOT.

THE PARTS ON THE GROUND

THERE IS SOME ROOM AT THE TIP OF THE TOES.

³/₄ VIEW

PAY ATTENTION TO THE CURVE OF THE FOOT.

SNEAKERS

CURVE OF THE FOOT

CENTER LINE

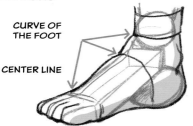

SIDE

LACES OF SNEAKERS DRAW THE CENTER OF THE "X"S ALONG THE CENTER LINE ON THE TOP OF THE FOOT.

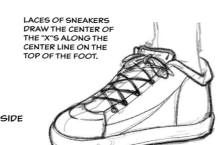

THICK AND STRAIGHT SHOE SOLE

SNEAKERS HAVE FLAT SOLES, SO THE HEEL IS ON THE GROUND.

THESE SHOES ARE TIED WITH LACES, SO THE CENTER OF THE FOOT IS CLOSE TO THE CENTER OF THE SHOE.

SNEAKERS LOOK REALISTIC WHEN THE WHOLE THING IS DRAWN THICK, AND NOT JUST THE SOLE. COMPARED TO OTHER SHOES, SNEAKERS COVER A LOT OF THE FOOT.

LOAFERS

CURVE OF THE FOOT

CENTER LINE

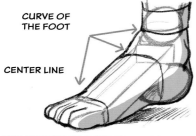

THIS SHOE HAS SOME EXTRA ROOM INSIDE, SO THE CENTER OF THE SHOE IS SLIGHTLY OFFSET FROM THE CENTER OF THE FOOT.

CENTER OF THE SHOE

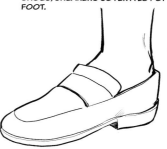

THIS SHOE HAS AN ELEVATED HEEL, SO RAISE THE HEEL A LITTLE.

DRAW THE SOLE OF THE SHOE, ADD THE ELEVATED HEEL, AND THEN DRAW THE SHOE ALONG THE SHAPE OF THE FOOT.

MAKE SURE THE CURVE OF THE FOOT/LEG AND THE CURVE OF THE SHOE ALWAYS MATCHES.

ALWAYS PAY ATTENTION TO THE FRONT AND SIDE SURFACES AND THE CENTER LINE, WHETHER YOU'RE DRAWING A FACE, BODY, HAND, OR FOOT!

BODY
69

EXPRESSING AGE

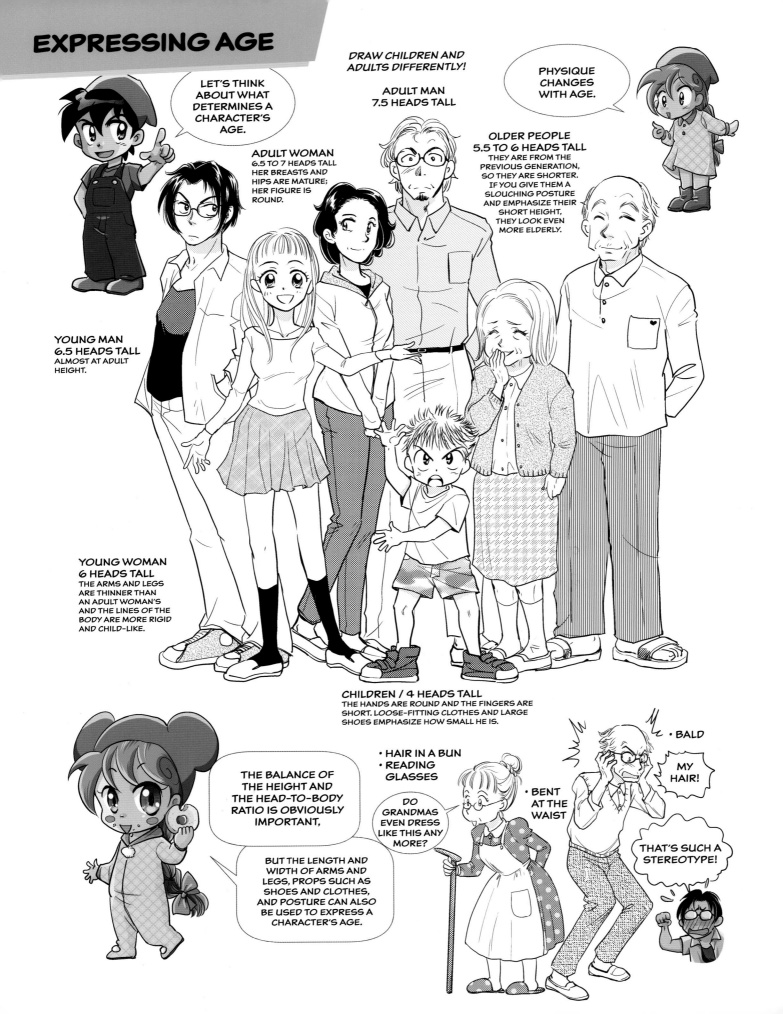

DRAW CHILDREN AND ADULTS DIFFERENTLY!

LET'S THINK ABOUT WHAT DETERMINES A CHARACTER'S AGE.

PHYSIQUE CHANGES WITH AGE.

ADULT MAN
7.5 HEADS TALL

ADULT WOMAN
6.5 TO 7 HEADS TALL
HER BREASTS AND HIPS ARE MATURE; HER FIGURE IS ROUND.

OLDER PEOPLE
5.5 TO 6 HEADS TALL
THEY ARE FROM THE PREVIOUS GENERATION, SO THEY ARE SHORTER. IF YOU GIVE THEM A SLOUCHING POSTURE AND EMPHASIZE THEIR SHORT HEIGHT, THEY LOOK EVEN MORE ELDERLY.

YOUNG MAN
6.5 HEADS TALL
ALMOST AT ADULT HEIGHT.

YOUNG WOMAN
6 HEADS TALL
THE ARMS AND LEGS ARE THINNER THAN AN ADULT WOMAN'S AND THE LINES OF THE BODY ARE MORE RIGID AND CHILD-LIKE.

CHILDREN / 4 HEADS TALL
THE HANDS ARE ROUND AND THE FINGERS ARE SHORT. LOOSE-FITTING CLOTHES AND LARGE SHOES EMPHASIZE HOW SMALL HE IS.

THE BALANCE OF THE HEIGHT AND THE HEAD-TO-BODY RATIO IS OBVIOUSLY IMPORTANT,

BUT THE LENGTH AND WIDTH OF ARMS AND LEGS, PROPS SUCH AS SHOES AND CLOTHES, AND POSTURE CAN ALSO BE USED TO EXPRESS A CHARACTER'S AGE.

DO GRANDMAS EVEN DRESS LIKE THIS ANY MORE?

• HAIR IN A BUN
• READING GLASSES

• BENT AT THE WAIST

• BALD

MY HAIR!

THAT'S SUCH A STEREOTYPE!

BASIC CHANGES IN FIGURE

THE UPPER BODY AND LOWER BODY HAVE A 1:1 RATIO STARTING AROUND AGE 14. THE POSITION OF THE HIPS RELATIVE TO THE WHOLE BODY RISES AS THE AGE INCREASES.

MANGA CHARACTERS

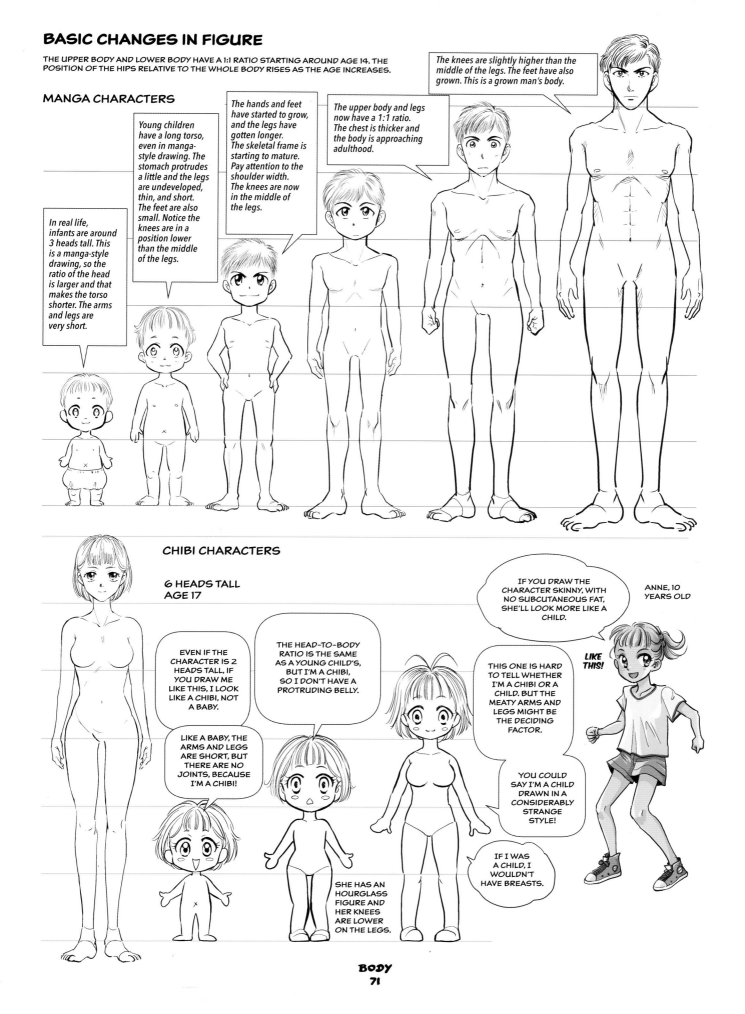

The knees are slightly higher than the middle of the legs. The feet have also grown. This is a grown man's body.

The hands and feet have started to grow, and the legs have gotten longer. The skeletal frame is starting to mature. Pay attention to the shoulder width. The knees are now in the middle of the legs.

The upper body and legs now have a 1:1 ratio. The chest is thicker and the body is approaching adulthood.

Young children have a long torso, even in manga-style drawing. The stomach protrudes a little and the legs are undeveloped, thin, and short. The feet are also small. Notice the knees are in a position lower than the middle of the legs.

In real life, infants are around 3 heads tall. This is a manga-style drawing, so the ratio of the head is larger and that makes the torso shorter. The arms and legs are very short.

CHIBI CHARACTERS

6 HEADS TALL
AGE 17

IF YOU DRAW THE CHARACTER SKINNY, WITH NO SUBCUTANEOUS FAT, SHE'LL LOOK MORE LIKE A CHILD.

ANNE, 10 YEARS OLD

EVEN IF THE CHARACTER IS 2 HEADS TALL, IF YOU DRAW ME LIKE THIS, I LOOK LIKE A CHIBI, NOT A BABY.

THE HEAD-TO-BODY RATIO IS THE SAME AS A YOUNG CHILD'S, BUT I'M A CHIBI, SO I DON'T HAVE A PROTRUDING BELLY.

THIS ONE IS HARD TO TELL WHETHER I'M A CHIBI OR A CHILD. BUT THE MEATY ARMS AND LEGS MIGHT BE THE DECIDING FACTOR.

LIKE THIS!

LIKE A BABY, THE ARMS AND LEGS ARE SHORT, BUT THERE ARE NO JOINTS, BECAUSE I'M A CHIBI!

YOU COULD SAY I'M A CHILD DRAWN IN A CONSIDERABLY STRANGE STYLE!

SHE HAS AN HOURGLASS FIGURE AND HER KNEES ARE LOWER ON THE LEGS.

IF I WAS A CHILD, I WOULDN'T HAVE BREASTS.

BODY TYPE VARIATIONS

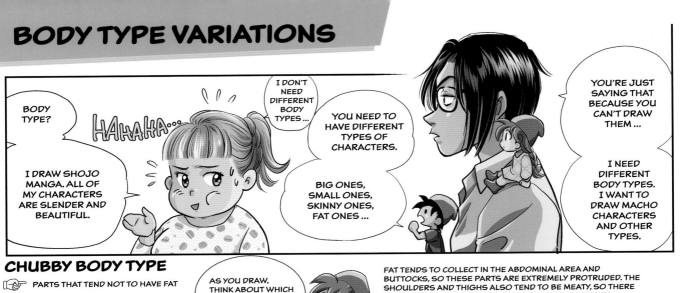

BODY TYPE?

HAHAHA...

I DRAW SHOJO MANGA. ALL OF MY CHARACTERS ARE SLENDER AND BEAUTIFUL.

I DON'T NEED DIFFERENT BODY TYPES...

YOU NEED TO HAVE DIFFERENT TYPES OF CHARACTERS.

BIG ONES, SMALL ONES, SKINNY ONES, FAT ONES...

YOU'RE JUST SAYING THAT BECAUSE YOU CAN'T DRAW THEM...

I NEED DIFFERENT BODY TYPES. I WANT TO DRAW MACHO CHARACTERS AND OTHER TYPES.

CHUBBY BODY TYPE

☞ PARTS THAT TEND NOT TO HAVE FAT

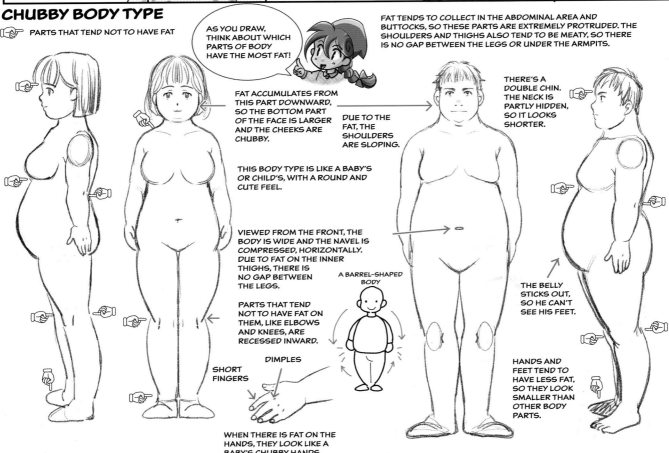

AS YOU DRAW, THINK ABOUT WHICH PARTS OF BODY HAVE THE MOST FAT!

FAT TENDS TO COLLECT IN THE ABDOMINAL AREA AND BUTTOCKS, SO THESE PARTS ARE EXTREMELY PROTRUDED. THE SHOULDERS AND THIGHS ALSO TEND TO BE MEATY, SO THERE IS NO GAP BETWEEN THE LEGS OR UNDER THE ARMPITS.

FAT ACCUMULATES FROM THIS PART DOWNWARD, SO THE BOTTOM PART OF THE FACE IS LARGER AND THE CHEEKS ARE CHUBBY.

DUE TO THE FAT, THE SHOULDERS ARE SLOPING.

THERE'S A DOUBLE CHIN. THE NECK IS PARTLY HIDDEN, SO IT LOOKS SHORTER.

THIS BODY TYPE IS LIKE A BABY'S OR CHILD'S, WITH A ROUND AND CUTE FEEL.

VIEWED FROM THE FRONT, THE BODY IS WIDE AND THE NAVEL IS COMPRESSED, HORIZONTALLY. DUE TO FAT ON THE INNER THIGHS, THERE IS NO GAP BETWEEN THE LEGS.

A BARREL-SHAPED BODY

PARTS THAT TEND NOT TO HAVE FAT ON THEM, LIKE ELBOWS AND KNEES, ARE RECESSED INWARD.

DIMPLES

SHORT FINGERS

WHEN THERE IS FAT ON THE HANDS, THEY LOOK LIKE A BABY'S CHUBBY HANDS.

THE BELLY STICKS OUT, SO HE CAN'T SEE HIS FEET.

HANDS AND FEET TEND TO HAVE LESS FAT, SO THEY LOOK SMALLER THAN OTHER BODY PARTS.

CUTE, ROUND, CHUBBY CHARACTERS

IN MANGA, WHEN DRAWING A DISTINCTIVE BODY TYPE, IT'S COMMON TO EXAGGERATE.

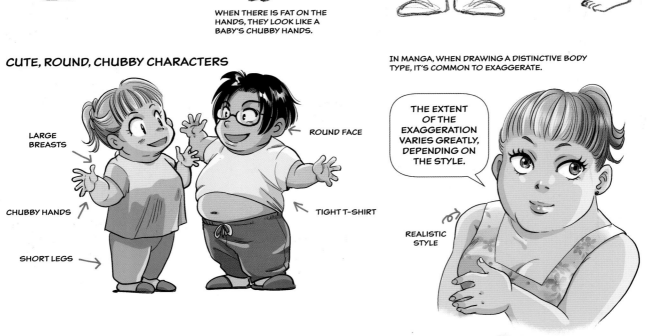

LARGE BREASTS

CHUBBY HANDS

SHORT LEGS

ROUND FACE

TIGHT T-SHIRT

THE EXTENT OF THE EXAGGERATION VARIES GREATLY, DEPENDING ON THE STYLE.

REALISTIC STYLE

SCRAWNY BODY TYPE

THINK OF THIS AS THE OPPOSITE OF THE CHUBBY BODY TYPE. THERE IS VERY LITTLE MUSCLE AND THE LINES OF THE BODY ARE FLAT.

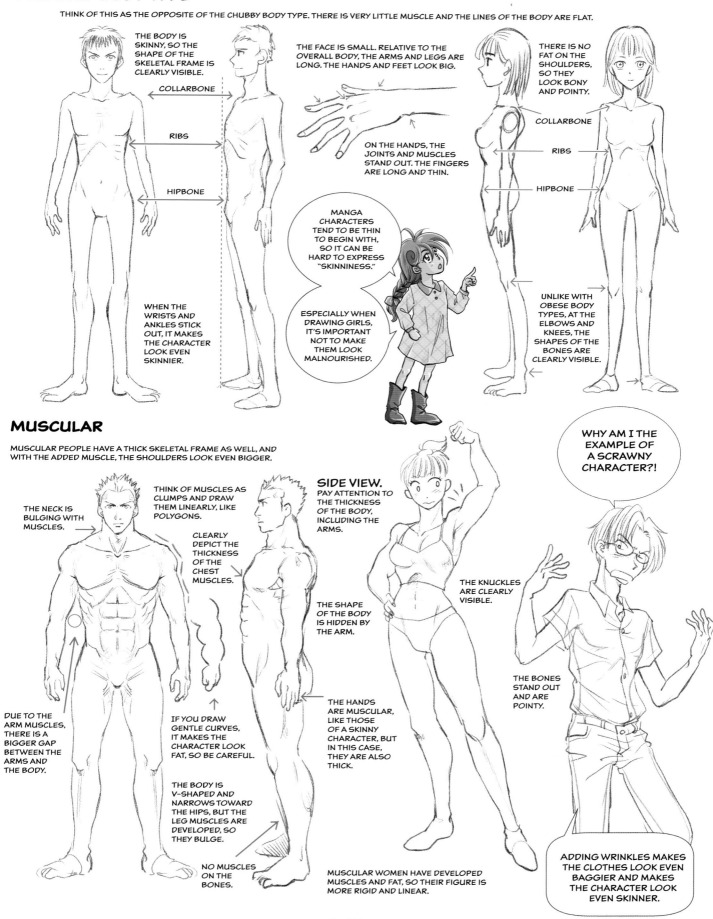

THE BODY IS SKINNY, SO THE SHAPE OF THE SKELETAL FRAME IS CLEARLY VISIBLE.

COLLARBONE

RIBS

HIPBONE

WHEN THE WRISTS AND ANKLES STICK OUT, IT MAKES THE CHARACTER LOOK EVEN SKINNIER.

THE FACE IS SMALL. RELATIVE TO THE OVERALL BODY, THE ARMS AND LEGS ARE LONG. THE HANDS AND FEET LOOK BIG.

ON THE HANDS, THE JOINTS AND MUSCLES STAND OUT. THE FINGERS ARE LONG AND THIN.

MANGA CHARACTERS TEND TO BE THIN TO BEGIN WITH, SO IT CAN BE HARD TO EXPRESS "SKINNINESS."

ESPECIALLY WHEN DRAWING GIRLS, IT'S IMPORTANT NOT TO MAKE THEM LOOK MALNOURISHED.

THERE IS NO FAT ON THE SHOULDERS, SO THEY LOOK BONY AND POINTY.

COLLARBONE

RIBS

HIPBONE

UNLIKE WITH OBESE BODY TYPES, AT THE ELBOWS AND KNEES, THE SHAPES OF THE BONES ARE CLEARLY VISIBLE.

MUSCULAR

MUSCULAR PEOPLE HAVE A THICK SKELETAL FRAME AS WELL, AND WITH THE ADDED MUSCLE, THE SHOULDERS LOOK EVEN BIGGER.

THE NECK IS BULGING WITH MUSCLES.

THINK OF MUSCLES AS CLUMPS AND DRAW THEM LINEARLY, LIKE POLYGONS.

CLEARLY DEPICT THE THICKNESS OF THE CHEST MUSCLES.

DUE TO THE ARM MUSCLES, THERE IS A BIGGER GAP BETWEEN THE ARMS AND THE BODY.

IF YOU DRAW GENTLE CURVES, IT MAKES THE CHARACTER LOOK FAT, SO BE CAREFUL.

THE BODY IS V-SHAPED AND NARROWS TOWARD THE HIPS, BUT THE LEG MUSCLES ARE DEVELOPED, SO THEY BULGE.

NO MUSCLES ON THE BONES.

SIDE VIEW. PAY ATTENTION TO THE THICKNESS OF THE BODY, INCLUDING THE ARMS.

THE SHAPE OF THE BODY IS HIDDEN BY THE ARM.

THE HANDS ARE MUSCULAR, LIKE THOSE OF A SKINNY CHARACTER, BUT IN THIS CASE, THEY ARE ALSO THICK.

THE KNUCKLES ARE CLEARLY VISIBLE.

MUSCULAR WOMEN HAVE DEVELOPED MUSCLES AND FAT, SO THEIR FIGURE IS MORE RIGID AND LINEAR.

WHY AM I THE EXAMPLE OF A SCRAWNY CHARACTER?!

THE BONES STAND OUT AND ARE POINTY.

ADDING WRINKLES MAKES THE CLOTHES LOOK EVEN BAGGIER AND MAKES THE CHARACTER LOOK EVEN SKINNER.

LOW ANGLE AND BIRD'S-EYE VIEW

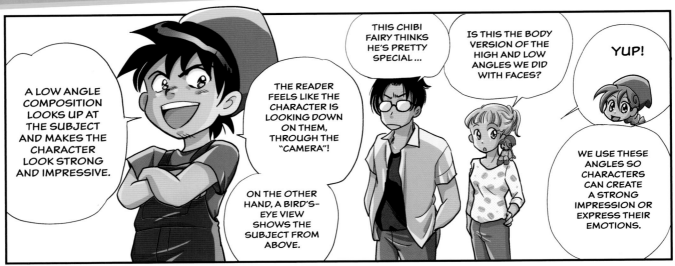

A LOW ANGLE COMPOSITION LOOKS UP AT THE SUBJECT AND MAKES THE CHARACTER LOOK STRONG AND IMPRESSIVE.

THE READER FEELS LIKE THE CHARACTER IS LOOKING DOWN ON THEM, THROUGH THE "CAMERA"!

ON THE OTHER HAND, A BIRD'S-EYE VIEW SHOWS THE SUBJECT FROM ABOVE.

THIS CHIBI FAIRY THINKS HE'S PRETTY SPECIAL ...

IS THIS THE BODY VERSION OF THE HIGH AND LOW ANGLES WE DID WITH FACES?

YUP!

WE USE THESE ANGLES SO CHARACTERS CAN CREATE A STRONG IMPRESSION OR EXPRESS THEIR EMOTIONS.

LOW ANGLE

LOOKING UP AT AN ANGLE FROM BELOW

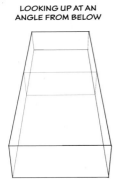

BIRD'S-EYE VIEW

LOOKING DOWN AT AN ANGLE FROM ABOVE

VANISHING POINT

THE VANISHING POINT (PERSPECTIVE DRAWING) IS IMPORTANT FOR BACKGROUNDS, AND WHEN DRAWING CHARACTERS IN 3D!

THE POINT WHERE TWO DIAGONALS CROSS IS THE BISECTION POINT.

THE SPLIT LINE CAN BE USED AS REFERENCE FOR THE RATIO OF THE PROPORTION.

LET'S ADD A CHARACTER

FOR BOTH THE LOW ANGLE AND THE BIRD'S-EYE VIEW, THE CONCEPT OF A BOX IS IMPORTANT TO DRAW A THREE-DIMENSIONAL CHARACTER. MANGA CHARACTERS ARE 2D, BUT DON'T FORGET THEY HAVE "THICKNESS"!

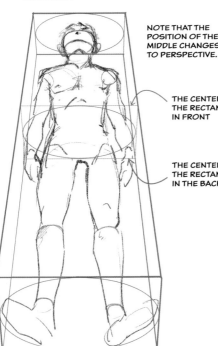

NOTE THAT THE POSITION OF THE MIDDLE CHANGES DUE TO PERSPECTIVE.

THE CENTER OF THE RECTANGLE IN FRONT

THE CENTER OF THE RECTANGLE IN THE BACK

EYE LEVEL: WHEN THE CAMERA IS AT THE HEIGHT OF A PERSON'S EYES.

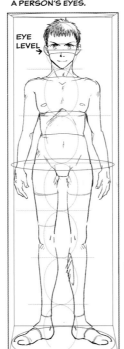

EYE LEVEL

CROSS SECTION

THINK ABOUT WHETHER THE OVALS REPRESENTING THE CROSS SECTIONS OF THE BODY IN THE BOX ARE FACING UPWARD AND DOWNWARD. KEEP THIS IN MIND WHEN DRAWING THE LINES OF THE BODY, TO MAKE THE BODY LOOK 3D.

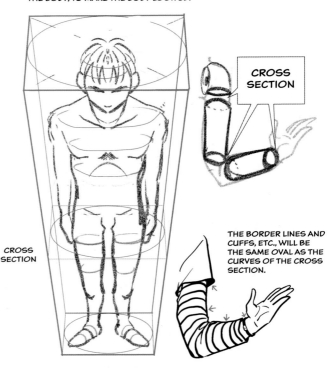

CROSS SECTION

THE BORDER LINES AND CUFFS, ETC., WILL BE THE SAME OVAL AS THE CURVES OF THE CROSS SECTION.

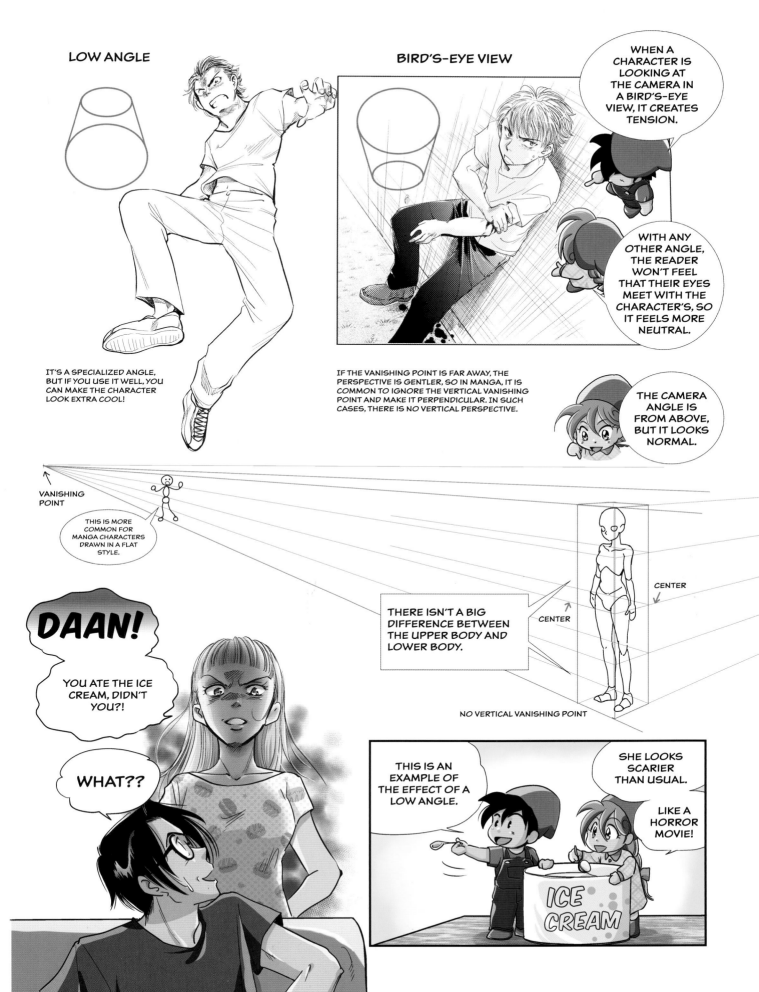

CHARACTERS IN MOTION

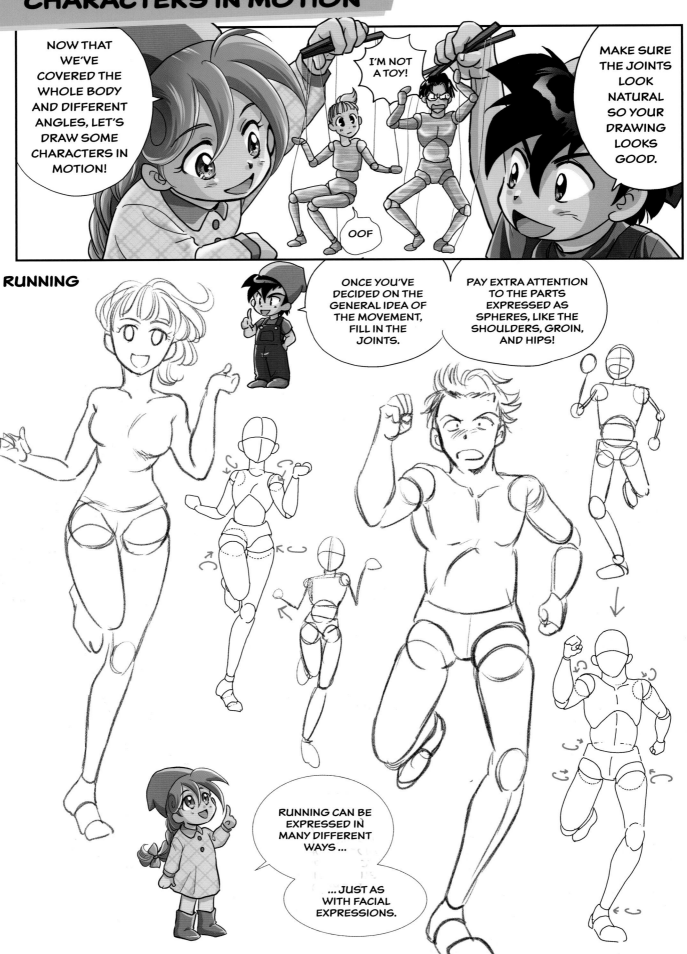

NOW THAT WE'VE COVERED THE WHOLE BODY AND DIFFERENT ANGLES, LET'S DRAW SOME CHARACTERS IN MOTION!

I'M NOT A TOY!

OOF

MAKE SURE THE JOINTS LOOK NATURAL SO YOUR DRAWING LOOKS GOOD.

RUNNING

ONCE YOU'VE DECIDED ON THE GENERAL IDEA OF THE MOVEMENT, FILL IN THE JOINTS.

PAY EXTRA ATTENTION TO THE PARTS EXPRESSED AS SPHERES, LIKE THE SHOULDERS, GROIN, AND HIPS!

RUNNING CAN BE EXPRESSED IN MANY DIFFERENT WAYS ...

... JUST AS WITH FACIAL EXPRESSIONS.

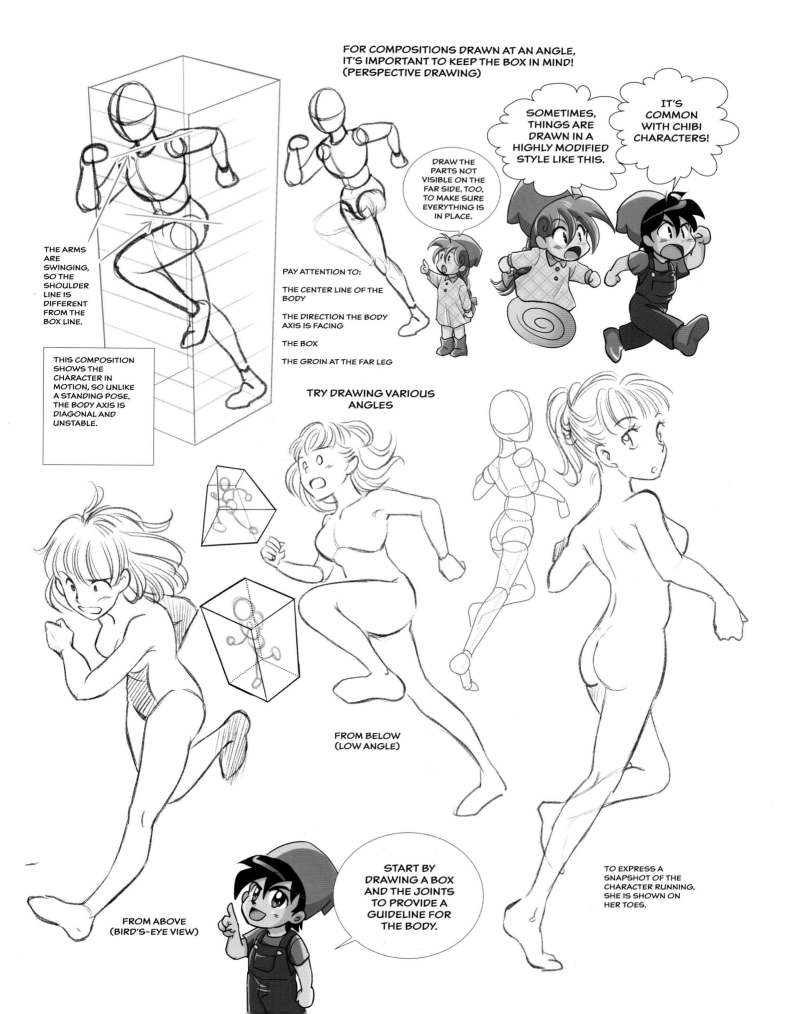

FOR COMPOSITIONS DRAWN AT AN ANGLE, IT'S IMPORTANT TO KEEP THE BOX IN MIND! (PERSPECTIVE DRAWING)

SOMETIMES, THINGS ARE DRAWN IN A HIGHLY MODIFIED STYLE LIKE THIS.

IT'S COMMON WITH CHIBI CHARACTERS!

DRAW THE PARTS NOT VISIBLE ON THE FAR SIDE, TOO, TO MAKE SURE EVERYTHING IS IN PLACE.

THE ARMS ARE SWINGING, SO THE SHOULDER LINE IS DIFFERENT FROM THE BOX LINE.

THIS COMPOSITION SHOWS THE CHARACTER IN MOTION, SO UNLIKE A STANDING POSE, THE BODY AXIS IS DIAGONAL AND UNSTABLE.

PAY ATTENTION TO:

THE CENTER LINE OF THE BODY

THE DIRECTION THE BODY AXIS IS FACING

THE BOX

THE GROIN AT THE FAR LEG

TRY DRAWING VARIOUS ANGLES

FROM BELOW (LOW ANGLE)

FROM ABOVE (BIRD'S-EYE VIEW)

START BY DRAWING A BOX AND THE JOINTS TO PROVIDE A GUIDELINE FOR THE BODY.

TO EXPRESS A SNAPSHOT OF THE CHARACTER RUNNING, SHE IS SHOWN ON HER TOES.

OTHER POSES

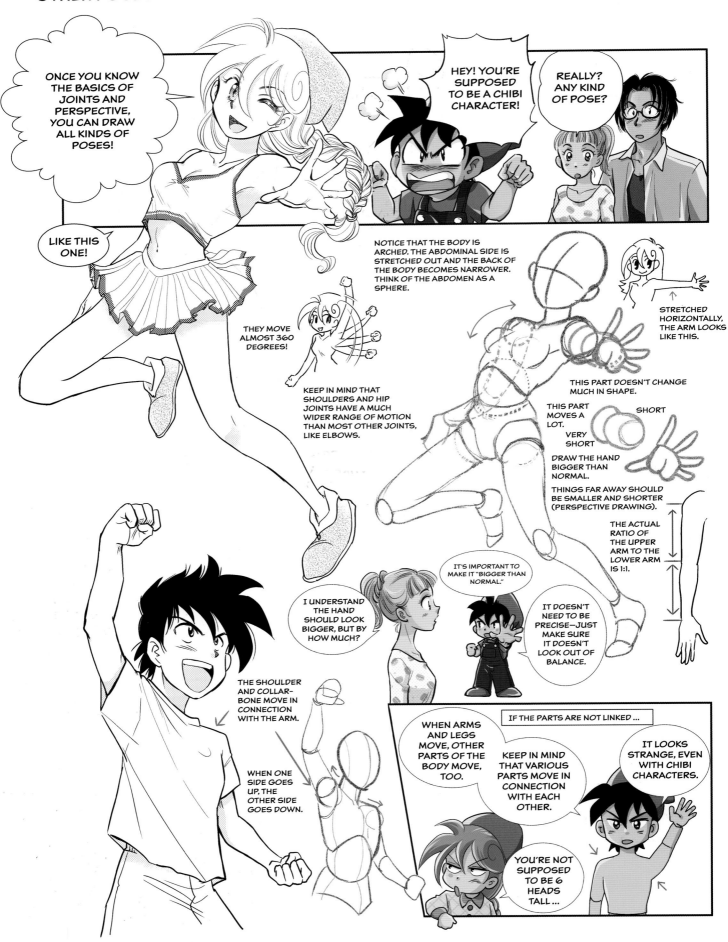

ONCE YOU KNOW THE BASICS OF JOINTS AND PERSPECTIVE, YOU CAN DRAW ALL KINDS OF POSES!

HEY! YOU'RE SUPPOSED TO BE A CHIBI CHARACTER!

REALLY? ANY KIND OF POSE?

LIKE THIS ONE!

THEY MOVE ALMOST 360 DEGREES!

KEEP IN MIND THAT SHOULDERS AND HIP JOINTS HAVE A MUCH WIDER RANGE OF MOTION THAN MOST OTHER JOINTS, LIKE ELBOWS.

NOTICE THAT THE BODY IS ARCHED. THE ABDOMINAL SIDE IS STRETCHED OUT AND THE BACK OF THE BODY BECOMES NARROWER. THINK OF THE ABDOMEN AS A SPHERE.

STRETCHED HORIZONTALLY, THE ARM LOOKS LIKE THIS.

THIS PART DOESN'T CHANGE MUCH IN SHAPE.

THIS PART MOVES A LOT.

SHORT

VERY SHORT

DRAW THE HAND BIGGER THAN NORMAL.

THINGS FAR AWAY SHOULD BE SMALLER AND SHORTER (PERSPECTIVE DRAWING).

THE ACTUAL RATIO OF THE UPPER ARM TO THE LOWER ARM IS 1:1.

IT'S IMPORTANT TO MAKE IT "BIGGER THAN NORMAL."

I UNDERSTAND THE HAND SHOULD LOOK BIGGER, BUT BY HOW MUCH?

IT DOESN'T NEED TO BE PRECISE—JUST MAKE SURE IT DOESN'T LOOK OUT OF BALANCE.

THE SHOULDER AND COLLAR-BONE MOVE IN CONNECTION WITH THE ARM.

WHEN ONE SIDE GOES UP, THE OTHER SIDE GOES DOWN.

WHEN ARMS AND LEGS MOVE, OTHER PARTS OF THE BODY MOVE, TOO.

KEEP IN MIND THAT VARIOUS PARTS MOVE IN CONNECTION WITH EACH OTHER.

IF THE PARTS ARE NOT LINKED ...

IT LOOKS STRANGE, EVEN WITH CHIBI CHARACTERS.

YOU'RE NOT SUPPOSED TO BE 6 HEADS TALL ...

IF YOU'RE STRUGGLING WITH THIS, START WITH A STANDING POSE AND ADD SOME SIMPLE MOVEMENT!

PAY ATTENTION TO HOW THE JOINTS MOVE. IT'S GOOD TO DO THE MOVEMENTS YOURSELF TO UNDERSTAND HOW THEY WORK!

IT'S ALSO GOOD TO REFERENCE MANGA AND PHOTOS TO GET THE HANG OF DRAWING GUIDELINES!

YOU CAN DRAW RIGHT ON YOUR REFERENCE MATERIAL TO MAKE SURE YOU UNDERSTAND THE STRUCTURE.

I SEE ... THIS PART MOVES LIKE THIS!

DON'T JUST COPY THE LINES. UNDERSTAND THE ENTIRE STRUCTURE AS YOU DRAW!

WOW! I DIDN'T THINK COPYING WOULD MAKE ME BETTER AT DRAWING.

OF COURSE!

EVEN PROFESSIONAL MANGA ARTISTS STARTED OUT BY COPYING!

DRAWING MULTIPLE CHARACTERS

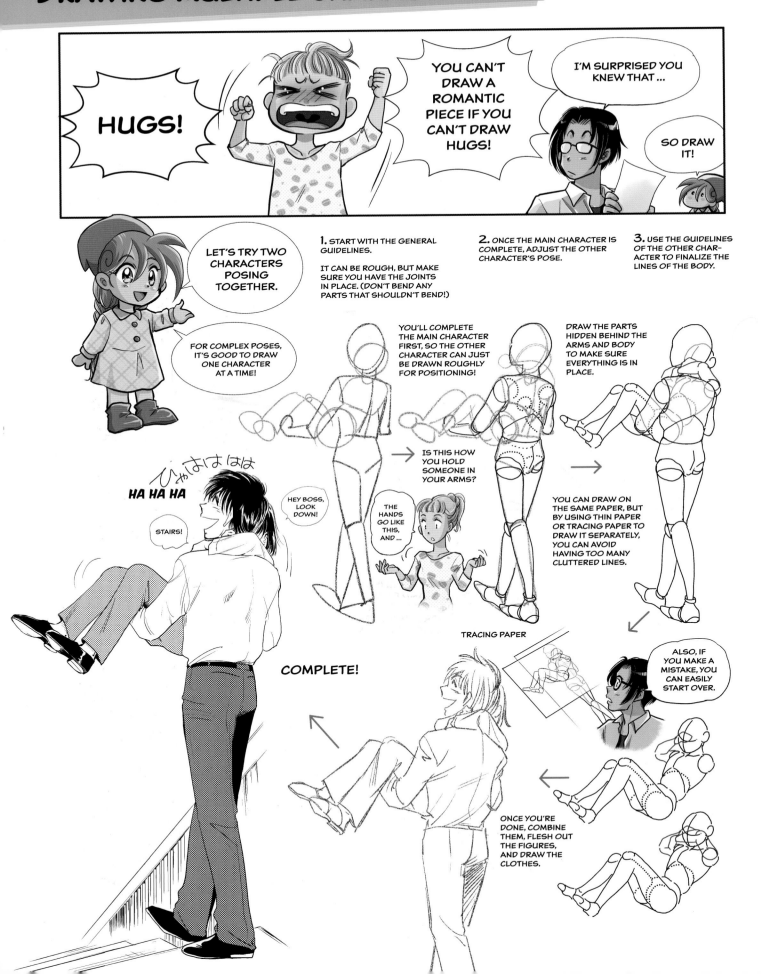

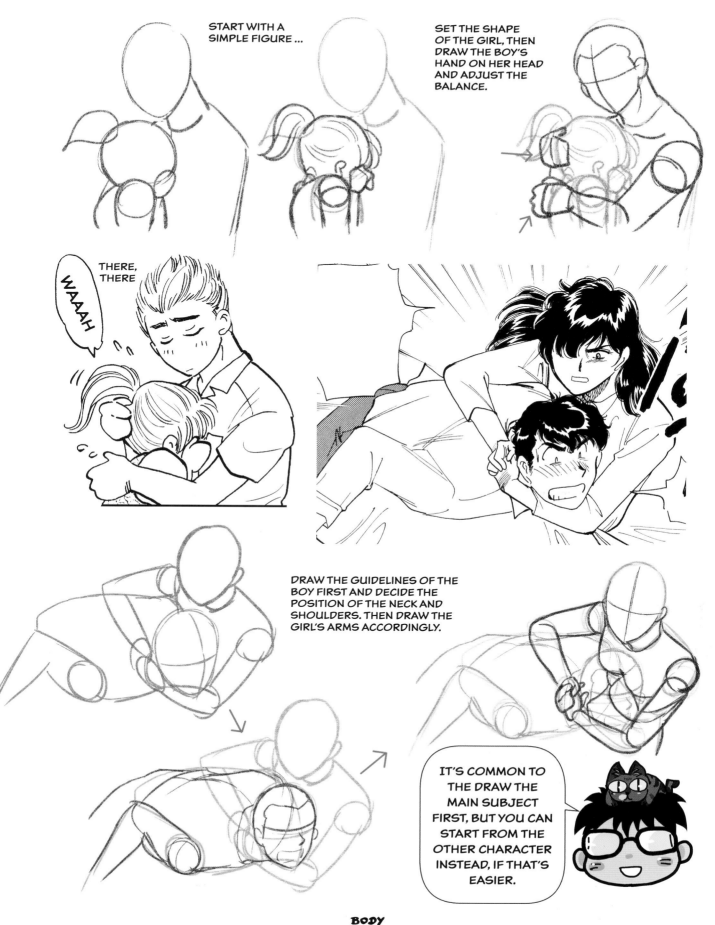

START WITH A SIMPLE FIGURE ...

SET THE SHAPE OF THE GIRL, THEN DRAW THE BOY'S HAND ON HER HEAD AND ADJUST THE BALANCE.

WAAAH

THERE, THERE

DRAW THE GUIDELINES OF THE BOY FIRST AND DECIDE THE POSITION OF THE NECK AND SHOULDERS. THEN DRAW THE GIRL'S ARMS ACCORDINGLY.

IT'S COMMON TO THE DRAW THE MAIN SUBJECT FIRST, BUT YOU CAN START FROM THE OTHER CHARACTER INSTEAD, IF THAT'S EASIER.

BODY
81

SITTING

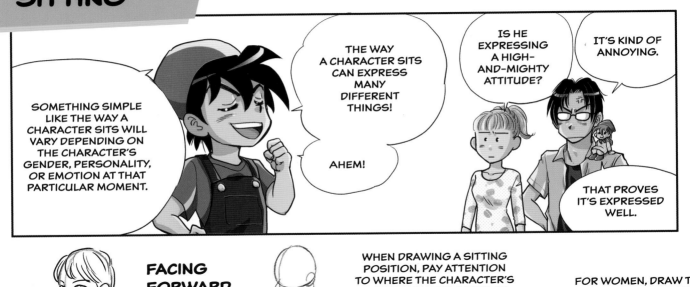

SOMETHING SIMPLE LIKE THE WAY A CHARACTER SITS WILL VARY DEPENDING ON THE CHARACTER'S GENDER, PERSONALITY, OR EMOTION AT THAT PARTICULAR MOMENT.

THE WAY A CHARACTER SITS CAN EXPRESS MANY DIFFERENT THINGS!

AHEM!

IS HE EXPRESSING A HIGH-AND-MIGHTY ATTITUDE?

IT'S KIND OF ANNOYING.

THAT PROVES IT'S EXPRESSED WELL.

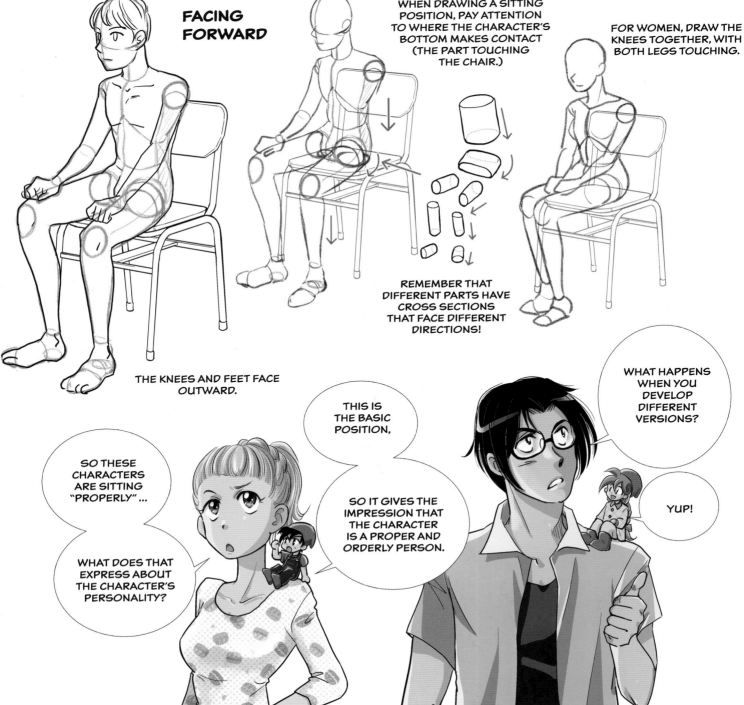

FACING FORWARD

WHEN DRAWING A SITTING POSITION, PAY ATTENTION TO WHERE THE CHARACTER'S BOTTOM MAKES CONTACT (THE PART TOUCHING THE CHAIR.)

FOR WOMEN, DRAW THE KNEES TOGETHER, WITH BOTH LEGS TOUCHING.

THE KNEES AND FEET FACE OUTWARD.

REMEMBER THAT DIFFERENT PARTS HAVE CROSS SECTIONS THAT FACE DIFFERENT DIRECTIONS!

SO THESE CHARACTERS ARE SITTING "PROPERLY" ...

WHAT DOES THAT EXPRESS ABOUT THE CHARACTER'S PERSONALITY?

THIS IS THE BASIC POSITION,

SO IT GIVES THE IMPRESSION THAT THE CHARACTER IS A PROPER AND ORDERLY PERSON.

WHAT HAPPENS WHEN YOU DEVELOP DIFFERENT VERSIONS?

YUP!

LEANING

A SCARY GUY SITTING LIKE A DELINQUENT ...

... LEANING WAY BACK IN THE CHAIR, STICKING HIS HIPS OUT.

BOYS OFTEN SIT LIKE THIS, BUT WHEN A GIRL DOES IT, SHE LENDS A BOYISH, LIVELY, AND EASYGOING IMPRESSION.

LEANING FORWARD

DUE TO PERSPECTIVE, THE LEFT AND RIGHT LEGS HAVE DIFFERENT LENGTHS.

WHEN A WOMAN IN A SKIRT SITS LIKE THIS, THE POSE EXPRESSES SEXINESS.

CROSS-LEGGED

AN EXAMPLE OF A TYPICAL MASCULINE POSE IS SITTING CROSS-LEGGED. THE BACK IS ROUNDED AND THE CHARACTER LEANS FORWARD.

AGAIN, DUE TO PERSPECTIVE, THERE IS A CLEAR DIFFERENCE IN THE LENGTHS OF THE LEFT AND RIGHT LEGS.

THE LEFT THIGH SITS ON THE RIGHT KNEE AND THE RIGHT LEG DISAPPEARS ON THE OTHER SIDE.

YOU SAID IT'S MASCULINE, BUT I SIT CROSS-LEGGED, TOO ...

THERE ARE TYPICAL MASCULINE AND FEMININE POSES, BUT BY USING THEM FOR THE OPPOSITE SEX, YOU CAN EXPRESS THE CHARACTER'S PERSONALITY!

EXPRESSIONS WITH THE BODY

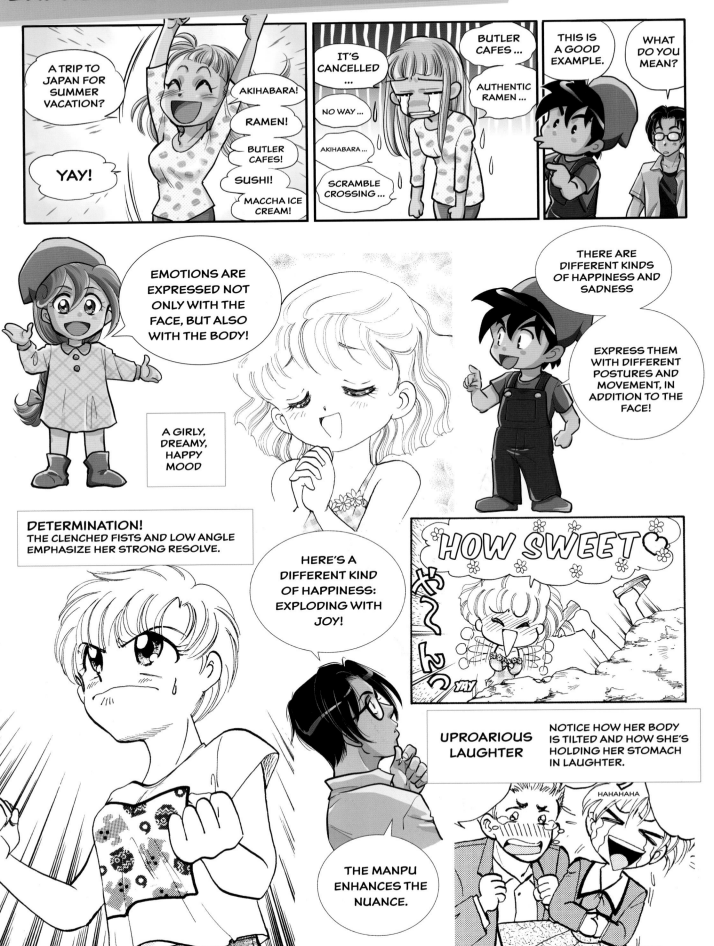

NO I'M NOT!

ANGER AND LAUGHTER ARE OUTWARD EMOTIONS. THEY EXPLODE!

THE ARMS AND LEGS MOVE A LOT.

VERTICAL FLOW LINES, SWEAT, MUSCLES, CLENCHED FISTS, AND BULGING VEINS ALL EXPRESS RAGE.

SHIVER

SHIVER

SHIVER

ON THE OTHER HAND, FEAR AND SADNESS ARE OFTEN EXPRESSED WITH STATIC, INTROSPECTIVE POSES.

CHEER UP ... YOU CAN GO ON YOUR OWN WHEN YOU'RE OLDER.

THE BIRD'S-EYE VIEW IS OFTEN USED TO EMPHASIZE A CHARACTER'S SENSE OF ISOLATION.

HACHIKO ... SHIBUYA ...

SIGH

BODY
85

DRAWING CLOTHES

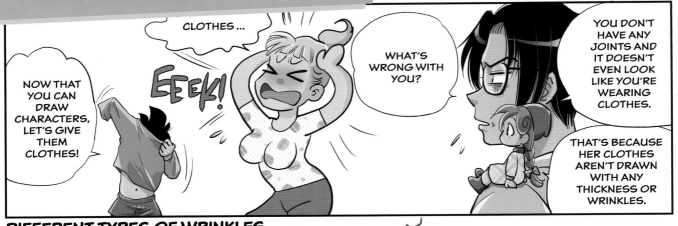

DIFFERENT TYPES OF WRINKLES

WRINKLES FORM WHEN FABRIC IS EITHER STRETCHED OR LOOSENED.

BULGING WRINKLES

WRINKLES THAT START FROM A BULGING PART.

FROM THE BULGING OF A GIVEN POINT

STRETCHING WRINKLES

BULGING (PUSHED UP)

STRETCHING

WRINKLES START FROM THE HIGHEST PART OF A BULGE AND THEN FLOW DOWNWARD.

STRETCHING

BULGING (PUSHED UP)

THE WRINKLES START AROUND HERE (BOTTOM PART OF THE SPHERE)

BENDING WRINKLES

WRINKLES FORM IN THE CENTER OF A BENT PART AND SPREAD OUTWARD

BULGING WRINKLE

CONTRACTED (EXCESS PART)

STRETCHED (TAUT PART, A TYPE OF BULGING WRINKLE)

BUNCHED WRINKLES

WRINKLES FORMED AT A FIXED POINT, LIKE A BUTTON (STRETCHING).

SAGGING WRINKLES

WRINKLES THAT SAG AND THEN FLOW HORIZONTALLY, LIKE WITH SKIRTS.

GRAVITY PULLS THE LOOSE PARTS DOWN AND DIAGONAL CURVED LINES ARE FORMED.

DIAGONAL LINE

BULGING + SAGGING

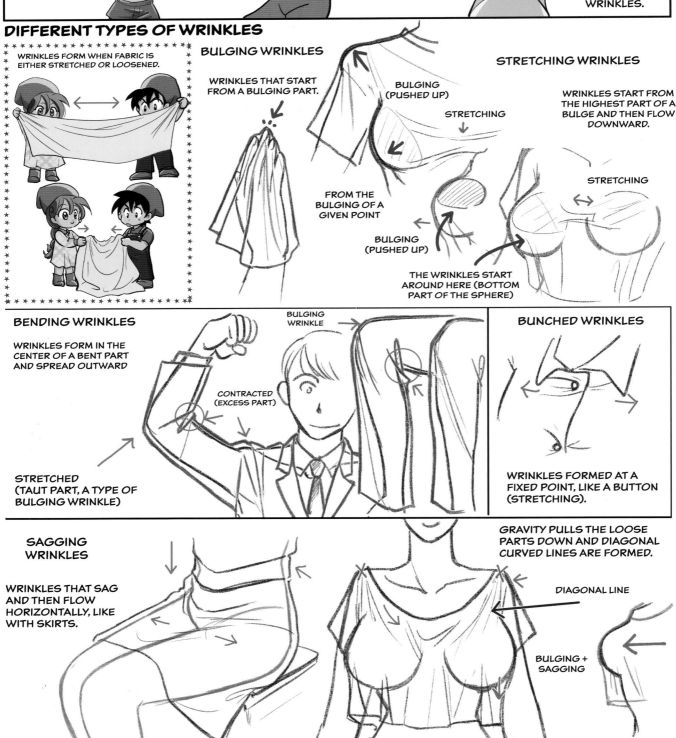

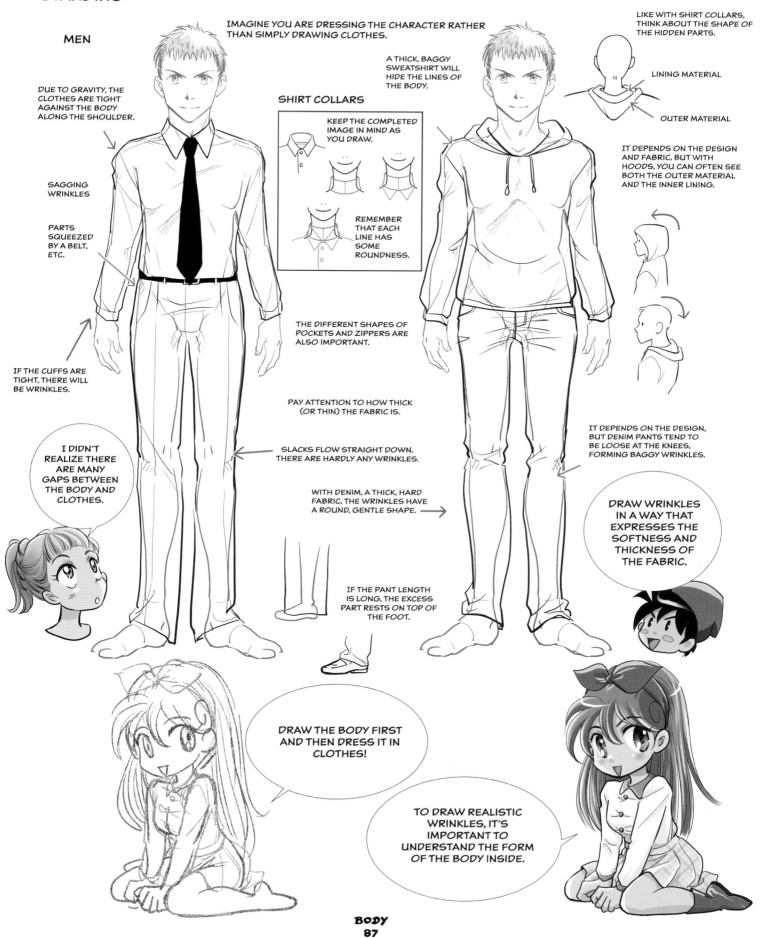

MEN

IMAGINE YOU ARE DRESSING THE CHARACTER RATHER THAN SIMPLY DRAWING CLOTHES.

DUE TO GRAVITY, THE CLOTHES ARE TIGHT AGAINST THE BODY ALONG THE SHOULDER.

A THICK, BAGGY SWEATSHIRT WILL HIDE THE LINES OF THE BODY.

SHIRT COLLARS

KEEP THE COMPLETED IMAGE IN MIND AS YOU DRAW.

REMEMBER THAT EACH LINE HAS SOME ROUNDNESS.

SAGGING WRINKLES

PARTS SQUEEZED BY A BELT, ETC.

IF THE CUFFS ARE TIGHT, THERE WILL BE WRINKLES.

I DIDN'T REALIZE THERE ARE MANY GAPS BETWEEN THE BODY AND CLOTHES.

THE DIFFERENT SHAPES OF POCKETS AND ZIPPERS ARE ALSO IMPORTANT.

PAY ATTENTION TO HOW THICK (OR THIN) THE FABRIC IS.

SLACKS FLOW STRAIGHT DOWN. THERE ARE HARDLY ANY WRINKLES.

WITH DENIM, A THICK, HARD FABRIC, THE WRINKLES HAVE A ROUND, GENTLE SHAPE.

IF THE PANT LENGTH IS LONG, THE EXCESS PART RESTS ON TOP OF THE FOOT.

LIKE WITH SHIRT COLLARS, THINK ABOUT THE SHAPE OF THE HIDDEN PARTS.

LINING MATERIAL

OUTER MATERIAL

IT DEPENDS ON THE DESIGN AND FABRIC, BUT WITH HOODS, YOU CAN OFTEN SEE BOTH THE OUTER MATERIAL AND THE INNER LINING.

IT DEPENDS ON THE DESIGN, BUT DENIM PANTS TEND TO BE LOOSE AT THE KNEES, FORMING BAGGY WRINKLES.

DRAW WRINKLES IN A WAY THAT EXPRESSES THE SOFTNESS AND THICKNESS OF THE FABRIC.

DRAW THE BODY FIRST AND THEN DRESS IT IN CLOTHES!

TO DRAW REALISTIC WRINKLES, IT'S IMPORTANT TO UNDERSTAND THE FORM OF THE BODY INSIDE.

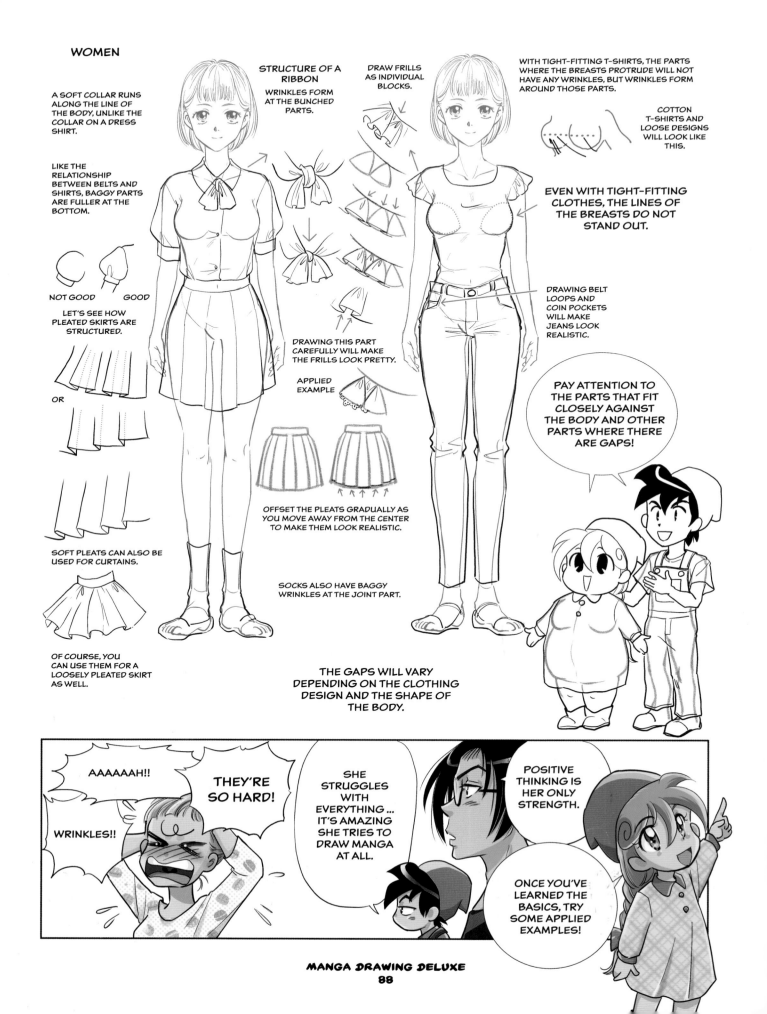

WOMEN

A SOFT COLLAR RUNS ALONG THE LINE OF THE BODY, UNLIKE THE COLLAR ON A DRESS SHIRT.

LIKE THE RELATIONSHIP BETWEEN BELTS AND SHIRTS, BAGGY PARTS ARE FULLER AT THE BOTTOM.

NOT GOOD GOOD

LET'S SEE HOW PLEATED SKIRTS ARE STRUCTURED.

OR

SOFT PLEATS CAN ALSO BE USED FOR CURTAINS.

OF COURSE, YOU CAN USE THEM FOR A LOOSELY PLEATED SKIRT AS WELL.

STRUCTURE OF A RIBBON
WRINKLES FORM AT THE BUNCHED PARTS.

DRAW FRILLS AS INDIVIDUAL BLOCKS.

DRAWING THIS PART CAREFULLY WILL MAKE THE FRILLS LOOK PRETTY.

APPLIED EXAMPLE

OFFSET THE PLEATS GRADUALLY AS YOU MOVE AWAY FROM THE CENTER TO MAKE THEM LOOK REALISTIC.

SOCKS ALSO HAVE BAGGY WRINKLES AT THE JOINT PART.

THE GAPS WILL VARY DEPENDING ON THE CLOTHING DESIGN AND THE SHAPE OF THE BODY.

WITH TIGHT-FITTING T-SHIRTS, THE PARTS WHERE THE BREASTS PROTRUDE WILL NOT HAVE ANY WRINKLES, BUT WRINKLES FORM AROUND THOSE PARTS.

COTTON T-SHIRTS AND LOOSE DESIGNS WILL LOOK LIKE THIS.

EVEN WITH TIGHT-FITTING CLOTHES, THE LINES OF THE BREASTS DO NOT STAND OUT.

DRAWING BELT LOOPS AND COIN POCKETS WILL MAKE JEANS LOOK REALISTIC.

PAY ATTENTION TO THE PARTS THAT FIT CLOSELY AGAINST THE BODY AND OTHER PARTS WHERE THERE ARE GAPS!

AAAAAAH!!

WRINKLES!!

THEY'RE SO HARD!

SHE STRUGGLES WITH EVERYTHING ... IT'S AMAZING SHE TRIES TO DRAW MANGA AT ALL.

POSITIVE THINKING IS HER ONLY STRENGTH.

ONCE YOU'VE LEARNED THE BASICS, TRY SOME APPLIED EXAMPLES!

OTHER POSES

COLLAR

WHEN THEY'RE AT AN ANGLE

WOW! A JAPANESE SCHOOL UNIFORM!

PAY ATTENTION TO THE PARTS NOT VISIBLE (DOTTED LINES). TRY DRAWING COLLARS AT DIFFERENT ANGLES AND COLLARS THAT ARE UNBUTTONED.

RAISE YOUR ARMS! HIGHER!!

SHEESH

WHY AM I WEARING PLAIN JEANS AND A T-SHIRT ...?

WRINKLES THAT START FROM A BULGING PART

WRINKLES THAT START FROM A BULGING PART

BUNCHED WRINKLES

BAGGY WRINKLES

BAGGY WRINKLES

BULGING WRINKLES FORMED ON THE OPPOSITE SIDE FROM THE DIRECTION FORCE IS BEING APPLIED.

THESE PARTS RISE AS THE SHOULDERS ARE RAISED (BUNCHED WRINKLES). THE SHOULDERS ARE RAISED, SO BULGING WRINKLES AND BAGGY WRINKLES COMBINE TO FORM DIAGONAL LINES.

THIS IS A BAGGY SHIRT, SO SAGGING WRINKLES ARE FORMED.

MOVEMENT OF PLEATS

BAGGY WRINKLES FORM AT PARTS THAT MOVE A LOT, LIKE JOINTS.

BENDING WRINKLES

HIS LEGS ARE OPEN, SO THE PANT FABRIC IS STRETCHED IN THE DIRECTION OF THE ARROWS.

THE STRETCHED KNEE SIDE AND THE CONTRACTED INNER SIDE HAVE DIFFERENT LENGTHS, SO THE HEM LINE POINTS UP, DIAGONALLY.

SWAYING CURTAINS ARE ALSO LIKE THIS!

LONG SHORT

DRAW DIFFERENT TYPES OF WRINKLES, FROM REALISTIC TO SIMPLE, TO MATCH THE ART STYLE.

THERE ARE MANY WAYS TO DRAW WRINKLES IN AN EXAGGERATED STYLE, SO STUDY HOW YOUR FAVORITE ARTISTS DRAW WRINKLES.

IN EVERYDAY SITUATIONS, IT'S GOOD TO OBSERVE HOW CLOTHES LOOK AND HOW WRINKLES ARE FORMED!

DRAWING HEROES AND HEROINES

THINK OF A SUITABLE HAIRSTYLE AND COSTUME FOR A PROTAGONIST.

AND A CHARACTER PROFILE, TOO!

A CHARACTER PROFILE?

I THOUGHT CHARACTER DESIGN ONLY MEANT A FACE AND COSTUME.

THE CHARACTER'S PERSONALITY AND BACKGROUND DETERMINE THEIR FACIAL EXPRESSION, CLOTHES, HAIRSTYLE, AND MORE.

YOU CAN ALSO DRAW THE CHARACTER FIRST AND GIVE THEM A PROFILE LATER.

CHARACTER PROFILES

BEAUTIFUL, SMART, STRONG, 17 YEARS OLD

CONFIDENT AND SPEAKS HER MIND. TOUGH ON OTHERS, BUT ALSO EXPECTS A LOT FROM HERSELF. PROPER AND UPSTANDING.

A DAUGHTER OF NOBILITY. SHE DOESN'T THINK ALL PEOPLE ARE EQUAL, BUT SHE BELIEVES IT'S HER RESPONSIBILITY TO PROTECT THE WEAK.

HATES BEING PROTECTED OR SAVED BY BOYS. COMPETITIVE AND WORKS EXTREMELY HARD.

#1 IN ACADEMICS AND MARTIAL ARTS, AND PROUD OF IT. HER DAYS ARE FILLED WITH TRAINING AND COMPETITIONS. HER GOAL IS TO BE A ROYAL GUARD.

HER LONG HAIR GETS IN THE WAY DURING BATTLES, BUT SHE WON'T CUT IT SHORT.

SHE HATES LOSING TO BOYS, BUT SHE COULD NEVER HAVE A BOYFRIEND WHO WASN'T STRONGER THAN HER.

WITH SUCH A CONTRADICTORY VIEW ON BOYS, SHE DOESN'T HAVE A BOYFRIEND.

IN SOME WAYS, SHE'S STILL A YOUNG GIRL. HER BOOTS HAVE A CUTE PATTERN ON THEM. SHE THINKS FINE DETAILS ARE THE KEY TO FASHION.

IN THIS WORLD, PEOPLE HAVE A RING SOMEWHERE ON THEIR BODY AND THAT SERVES AS THEIR ID.

TATTOOS INDICATE SOCIAL STATUS.

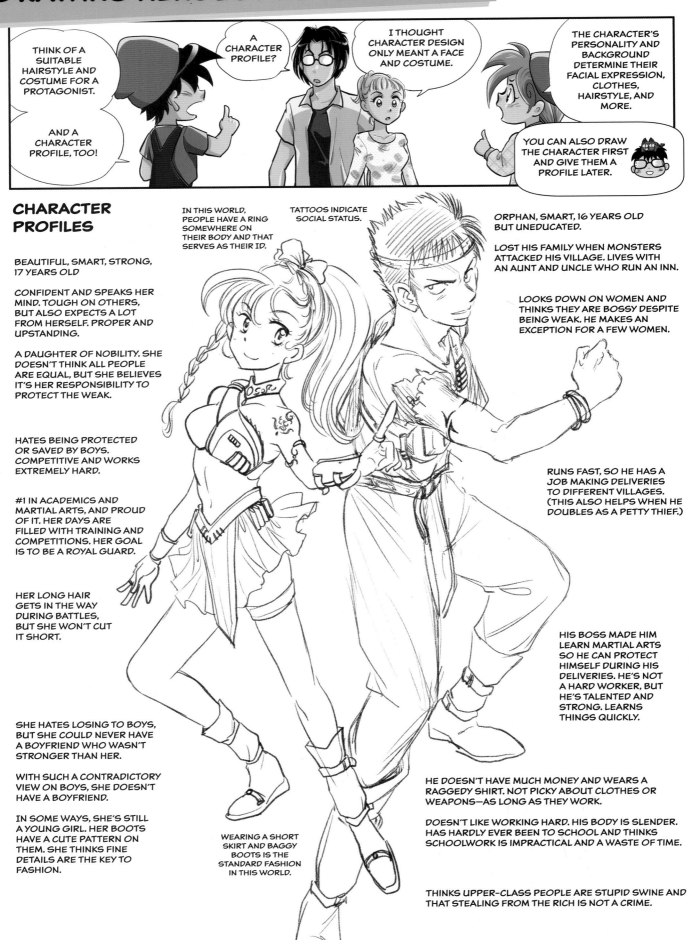

WEARING A SHORT SKIRT AND BAGGY BOOTS IS THE STANDARD FASHION IN THIS WORLD.

ORPHAN, SMART, 16 YEARS OLD BUT UNEDUCATED.

LOST HIS FAMILY WHEN MONSTERS ATTACKED HIS VILLAGE. LIVES WITH AN AUNT AND UNCLE WHO RUN AN INN.

LOOKS DOWN ON WOMEN AND THINKS THEY ARE BOSSY DESPITE BEING WEAK. HE MAKES AN EXCEPTION FOR A FEW WOMEN.

RUNS FAST, SO HE HAS A JOB MAKING DELIVERIES TO DIFFERENT VILLAGES. (THIS ALSO HELPS WHEN HE DOUBLES AS A PETTY THIEF.)

HIS BOSS MADE HIM LEARN MARTIAL ARTS SO HE CAN PROTECT HIMSELF DURING HIS DELIVERIES. HE'S NOT A HARD WORKER, BUT HE'S TALENTED AND STRONG. LEARNS THINGS QUICKLY.

HE DOESN'T HAVE MUCH MONEY AND WEARS A RAGGEDY SHIRT. NOT PICKY ABOUT CLOTHES OR WEAPONS—AS LONG AS THEY WORK.

DOESN'T LIKE WORKING HARD. HIS BODY IS SLENDER. HAS HARDLY EVER BEEN TO SCHOOL AND THINKS SCHOOLWORK IS IMPRACTICAL AND A WASTE OF TIME.

THINKS UPPER-CLASS PEOPLE ARE STUPID SWINE AND THAT STEALING FROM THE RICH IS NOT A CRIME.

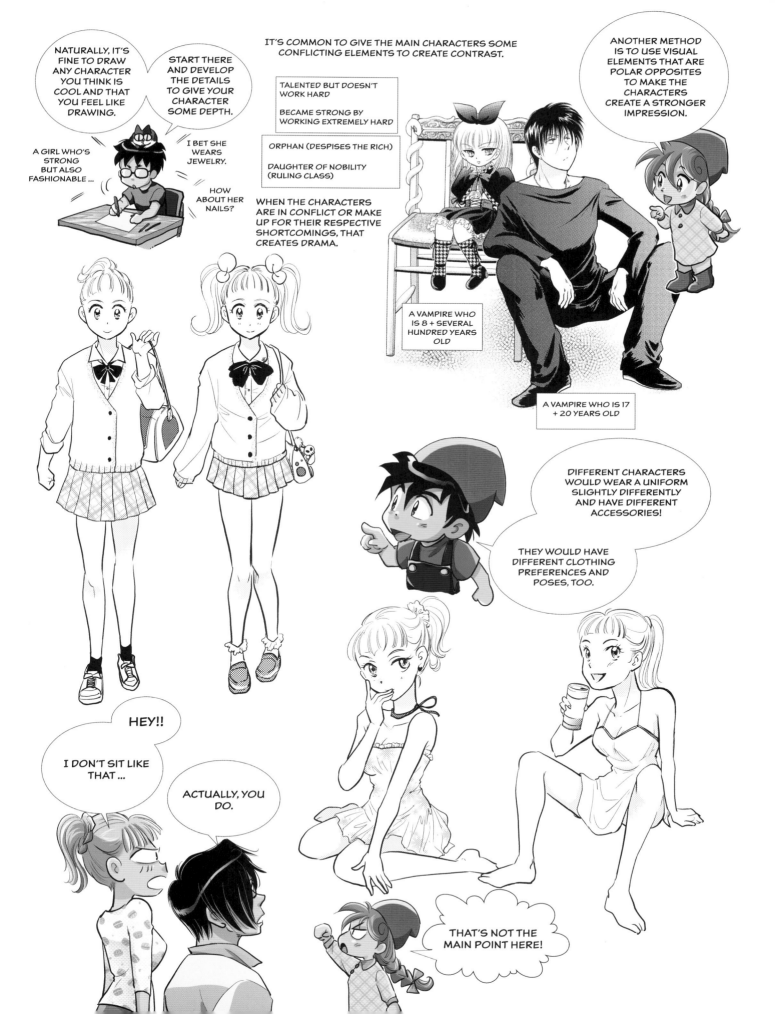

THE HERO AND HEROINE'S FRIENDS

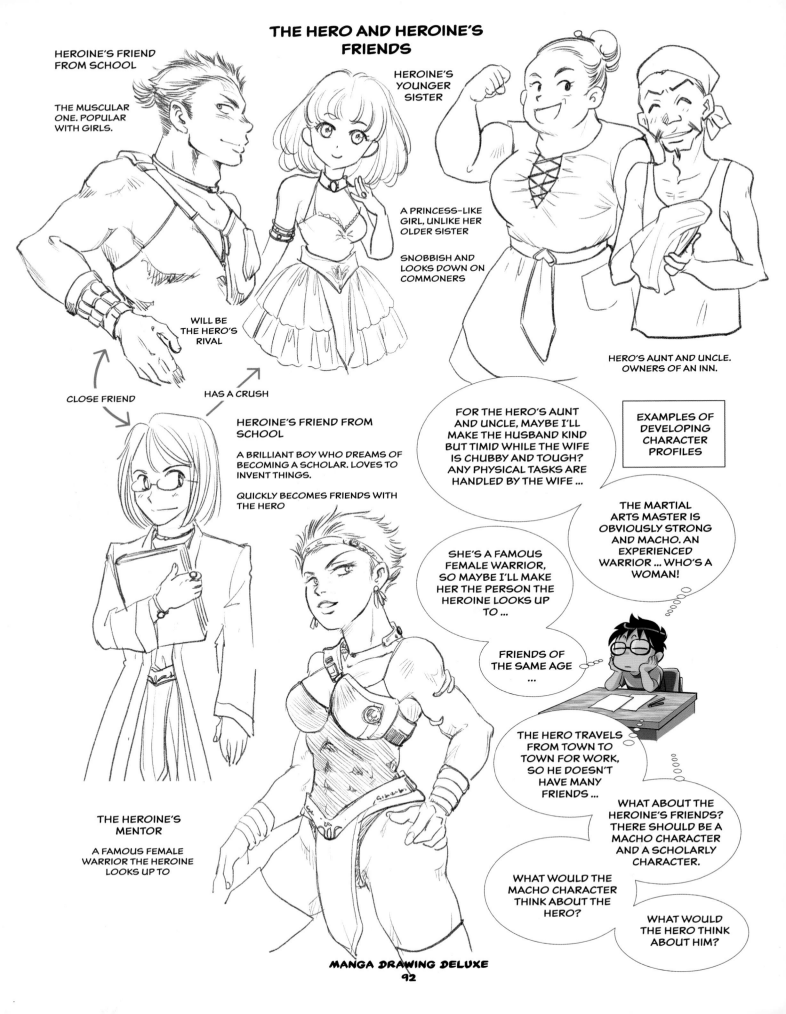

HEROINE'S FRIEND FROM SCHOOL

THE MUSCULAR ONE. POPULAR WITH GIRLS.

WILL BE THE HERO'S RIVAL

HEROINE'S YOUNGER SISTER

A PRINCESS-LIKE GIRL, UNLIKE HER OLDER SISTER

SNOBBISH AND LOOKS DOWN ON COMMONERS

HERO'S AUNT AND UNCLE. OWNERS OF AN INN.

CLOSE FRIEND

HAS A CRUSH

HEROINE'S FRIEND FROM SCHOOL

A BRILLIANT BOY WHO DREAMS OF BECOMING A SCHOLAR. LOVES TO INVENT THINGS.

QUICKLY BECOMES FRIENDS WITH THE HERO

THE HEROINE'S MENTOR

A FAMOUS FEMALE WARRIOR THE HEROINE LOOKS UP TO

FOR THE HERO'S AUNT AND UNCLE, MAYBE I'LL MAKE THE HUSBAND KIND BUT TIMID WHILE THE WIFE IS CHUBBY AND TOUGH? ANY PHYSICAL TASKS ARE HANDLED BY THE WIFE ...

EXAMPLES OF DEVELOPING CHARACTER PROFILES

THE MARTIAL ARTS MASTER IS OBVIOUSLY STRONG AND MACHO. AN EXPERIENCED WARRIOR ... WHO'S A WOMAN!

SHE'S A FAMOUS FEMALE WARRIOR, SO MAYBE I'LL MAKE HER THE PERSON THE HEROINE LOOKS UP TO ...

FRIENDS OF THE SAME AGE ...

THE HERO TRAVELS FROM TOWN TO TOWN FOR WORK, SO HE DOESN'T HAVE MANY FRIENDS ...

WHAT ABOUT THE HEROINE'S FRIENDS? THERE SHOULD BE A MACHO CHARACTER AND A SCHOLARLY CHARACTER.

WHAT WOULD THE MACHO CHARACTER THINK ABOUT THE HERO?

WHAT WOULD THE HERO THINK ABOUT HIM?

CHARACTER VARIATIONS

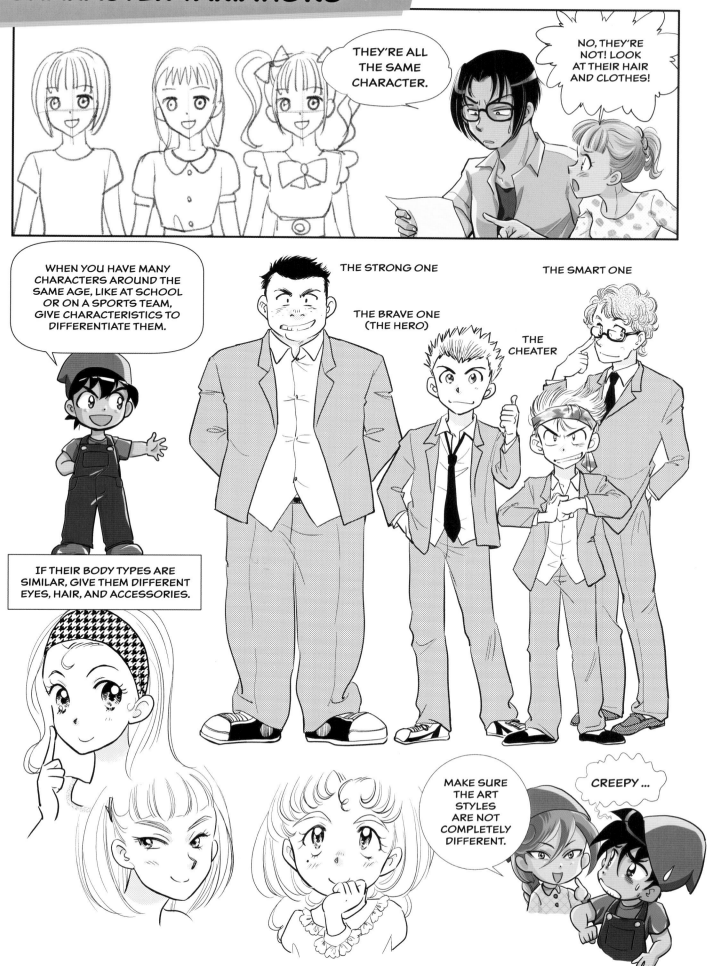

SKETCHING IN PENCIL

ROUGH PENCIL SKETCH (SHITAGAKI)

AS I MENTIONED IN THE INTRODUCTION, FIRST I DO A ROUGH SKETCH IN PENCIL AND THEN I INK OVER IT.

It depends on your preference, but B and B2 are common pencils.

If the lead is too hard, it damages the surface of the paper. If it's too soft, powder from the lead scatters and makes a mess on the page, so be careful!

MECHANICAL PENCIL

THICKER LEADS LIKE 0.8 TO 1.2 ARE USED FOR CHARACTERS.

0.3 IS FOR DETAILED PARTS SUCH AS BACKGROUNDS.

0.5 IS FOR EVERYTHING (CHARACTERS AND BACKGROUNDS).

USE PENCILS MEANT FOR DOING ART!

ERASER

USE A PLASTIC ERASER! JAPANESE ONES ARE GOOD.

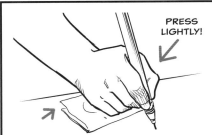

PRESS LIGHTLY!

PLACE A TISSUE ON THE PAPER TO PREVENT DISCOLORING IT WITH OIL FROM YOUR HAND.

I use B or HB (because the hardness varies depending on the manufacturer).
I tend to rub the paper with my hand (the pinky side) as I draw, and this often discolors the paper, so B2 is too dark. This is just a habit I have when drawing.

As such, I end up discoloring the paper so much that I have to go over the whole page with an eraser during the final step.

It's good to use an eraser that works by pressing lightly. If you press too hard, the paper can be damaged or bent!

OH!!

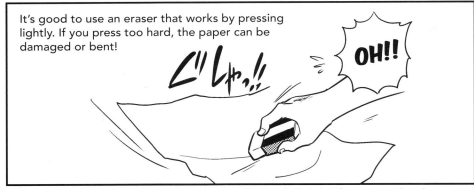

EVEN NOW, I SOMETIMES MAKE THIS MISTAKE.

ESPECIALLY AFTER INKING, WHEN I USE THE ERASER OVER THE WHOLE PAGE.

I TRY TO BE CAREFUL, BUT ...

For the reasons above, do the rough sketch lightly! If you press hard when you draw, you have to rub hard with the eraser, so the paper can be damaged or the ink can fade!

IF YOU GRIP HERE, YOU CAN DRAW LIGHTLY WITHOUT PRESSING TOO HARD.

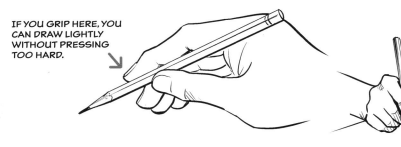

This is the best grip for expressing objects with shading, such as with a soft pencil or charcoal. However, in my case, I feel more comfortable drawing manga lines with the same grip I use for writing.

IT'S EASIER TO DRAW WHEN THE TIP OF THE INDEX FINGER IS CLOSER TO THE PAPER.

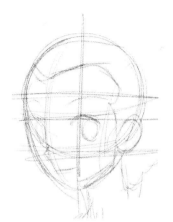

DRAW GUIDELINES
WITH A LIGHT TOUCH.

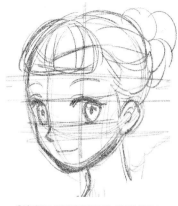

ON THE GUIDELINES, DRAW THE
FACE USING LIGHT LINES. WHEN
YOU FIND A LINE YOU LIKE, DRAW
IT A LITTLE DARKER TO MAKE IT
STAND OUT.

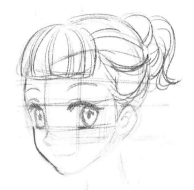

IF THERE ARE TOO MANY LINES CLUTTERING
THE DRAWING OR IF YOU WANT TO
MAKE CORRECTIONS FOR ANY OTHER
REASON, TAP LIGHTLY WITH AN ERASER TO
MAKE THE LINES LIGHTER AND DRAW
THE PROPER LINE ON TOP OF IT.
(YOU DON'T NEED TO ERASE IT COMPLETELY.)

IT'S DONE!

When you've decided on the actual line,
complete the sketch with a slightly darker line
to make it clear which lines you're going to ink.
If the original lines are too dark, or if there
are too many lines, tap them with an eraser to
make them lighter overall, and then draw
slightly darker lines on top.

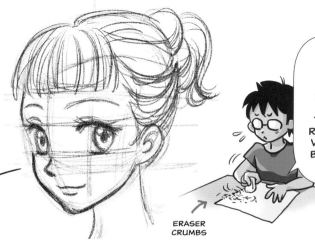

TAP TAP

ERASER
CRUMBS

DOING THIS
MAKES THE
ERASER ALL
BLACK, SO IT'S
IMPORTANT
TO CLEAN IT BY
RUBBING IT ON A
WHITE PAPER IN
BETWEEN USES.

CAUTION!

If the pencil lines are too dark when you're inking, the ink may not settle well, or it may be repelled.

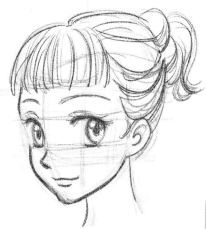

Some people draw guidelines
and rough sketches using
colored lead.

They don't turn the paper
black and, because you're
drawing black lines on top,
it's easier to see the actual
line!

However, compared to black lead, it's
harder to adjust the darkness by varying
pressure with colored lead, and tapping
with an eraser doesn't make the lines
much lighter. They're not ideal for
people who repeatedly draw over lines.

No matter how careful you are, drawing a rough sketch
will result in some degree of damage to the paper, so
many people use a lightbox to ink on a different paper.

THERE'S
NO NEED TO
ERASE THE
SKETCH LINES,
SO THE
INK DOESN'T
FADE.

IF YOU DRAW
TOO LIGHTLY,
IT'S HARD TO
SEE.

UNLESS YOU PRESS
HARD WITH THE
ERASER, IT JUST
CREATES A BIG
BLUR OF LIGHT
BLUE, SO YOU CAN'T
DISTINGUISH THE
INDIVIDUAL LINES.

I like to do inking
directly on the rough
sketch, but I do find
lightboxes useful.

I CHECK FOR
POOR BALANCE
FROM THE
REVERSE SIDE
AND MAKE
CORRECTIONS.

BODY
95

INKING

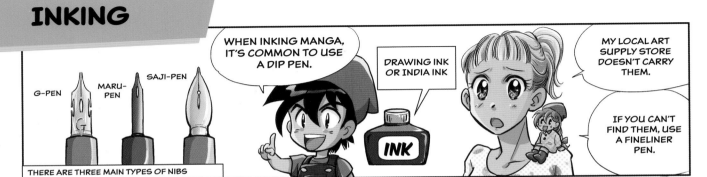

THERE ARE THREE MAIN TYPES OF NIBS

G-PEN MARU-PEN SAJI-PEN

WHEN INKING MANGA, IT'S COMMON TO USE A DIP PEN.

DRAWING INK OR INDIA INK

INK

MY LOCAL ART SUPPLY STORE DOESN'T CARRY THEM.

IF YOU CAN'T FIND THEM, USE A FINELINER PEN.

PENS

G: The most popular. Easy to control the thickness of the line by adjusting the pressure and/or angle. Can draw lines with a wide range of expression. Often used for character lines.

MARU: For drawing hard, thin lines. Can draw thicker lines, but the tip is sharp, so it tends to catch on paper. Often used for backgrounds, effects, and eyes and hair in shojo manga.

SAJI: For drawing soft, round lines. Doesn't provide much range in thickness, but it's smooth so it doesn't catch on paper. Used for everything from characters to backgrounds.

MOVE THE PEN VERTICALLY.

IF YOU MOVE THE PEN HORIZONTALLY, IT CATCHES ON THE PAPER.

SCRITCH!

IF YOU PRESS HARDER TO SPREAD THE NIB, YOU GET A THICKER LINE. IF YOU DRAW WITH A LIGHTER TOUCH, YOU GET A THINNER LINE.

IF YOU DRAW WITHOUT APPLYING MUCH PRESSURE, YOU CAN MOVE THE PEN IN ANY DIRECTION.

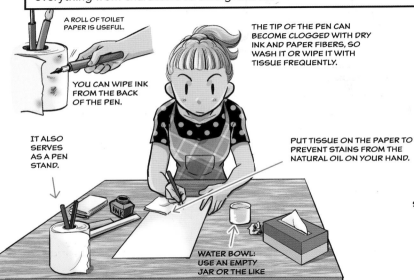

A ROLL OF TOILET PAPER IS USEFUL.

YOU CAN WIPE INK FROM THE BACK OF THE PEN.

IT ALSO SERVES AS A PEN STAND.

THE TIP OF THE PEN CAN BECOME CLOGGED WITH DRY INK AND PAPER FIBERS, SO WASH IT OR WIPE IT WITH TISSUE FREQUENTLY.

PUT TISSUE ON THE PAPER TO PREVENT STAINS FROM THE NATURAL OIL ON YOUR HAND.

WATER BOWL: USE AN EMPTY JAR OR THE LIKE

WHERE TO START

IF YOU'RE RIGHT-HANDED, STARTING FROM THE TOP LEFT WILL DECREASE THE RISK OF TOUCHING ANY WET INK, AND VICE VERSA IF YOU'RE LEFT-HANDED. THAT SAID, YOU'RE INKING YOUR SKETCH, SO YOU CAN ROTATE THE PAPER AS NEEDED.

IF YOU'RE HAVING TROUBLE USING THE PEN, TRY THESE EXERCISES:

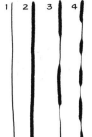

1 2 3 4

1. THIN SINGLE LINE

2. THICK SINGLE LINE THICKNESS (UNIFORM)

3. ALTERNATED (LONG)

4. ALTERNATED (SHORT)

WITHOUT APPLYING PRESSURE

PRESSURE APPLIED

STRONG GOING DOWN, LIGHT GOING UP

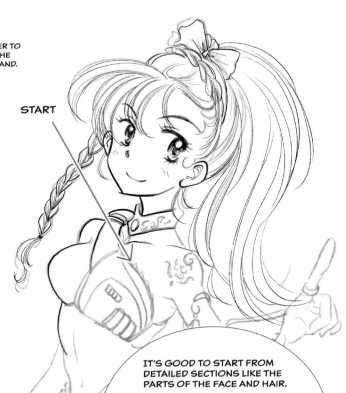

START

IT'S GOOD TO START FROM DETAILED SECTIONS LIKE THE PARTS OF THE FACE AND HAIR.

WHEN STARTING, YOU CAN PUT YOUR HAND ANYWHERE, SO YOU CAN FOCUS SOLELY ON INKING!

TYPES OF LINES

FOR HAIR, EYES, THIN FABRICS, AND THE LIKE, USE THIN LINES AND DRAW DELICATELY. MANY PEOPLE USE A MARU PEN FOR THESE.

ESPECIALLY FOR HAIR, WHEN YOU DRAW LIGHTLY WITH THIN LINES, YOU CAN MOVE THE PEN IN ANY DIRECTION, SO IT'S EASY.

THINK ABOUT THE FLOW OF BRAIDS AND FILL IN THE LINES OF THE HAIR— CAREFULLY.

BY ADDING THIN LINES THAT EXPRESS THICKNESS, YOU CAN CREATE TEXTURE.

THIS IS A THIN, SOFT FABRIC, SO USE A THIN, SINGLE LINE.

FOR THE THICK LEATHER BOOTS, USE FULLER LINES, INCLUDING FOR THE CREASES.

A COMMON METHOD IS TO DRAW THE MAIN LINES BOLDLY AND CLEARLY, WITH STRONG LINES DRAWN WITH RHYTHM. FOR INNER LINES (WRINKLES ON CLOTHES, MUSCLE LINES, SHADOWS, ETC.), USE THIN, SIMPLE LINES TO PROVIDE CONTRAST.

WHEN USING A FINELINER PEN, DRAW OVER YOUR LINES MULTIPLE TIMES TO ADD VARIOUS DEGREES OF THICKNESS, LIKE YOU GET WITH A DIP PEN. THAT WILL GIVE THEM AN AUTHENTIC MANGA-STYLE LOOK.

FOR THE SHINY PART OF HAIR, USE A CALLIGRAPHY PEN.

FOR MUSCLE LINES AND SHADOWS, USE THIN LINES.

DIFFERENT THICKNESSES IN LINES WILL EXPRESS TENSION AND FLOW IN MUSCLES AND JOINTS.

JOINTS ON FINGERS AND ARMS

CROSS HATCHING

THIN LINES FOR THE THICKNESS OF THE BELT

KAKEAMI

FOR SECTIONS YOU DON'T WANT TO FILL IN SOLIDLY, YOU CAN USE SCREENTONES, OR CROSS HATCHING.

SINGLE DOUBLE TRIPLE QUADRUPLE

GRADATION
EXPRESSED BY VARYING THE GAPS BETWEEN THE LINES.

NAWAGAKE (ROPE-LIKE PATTERN)

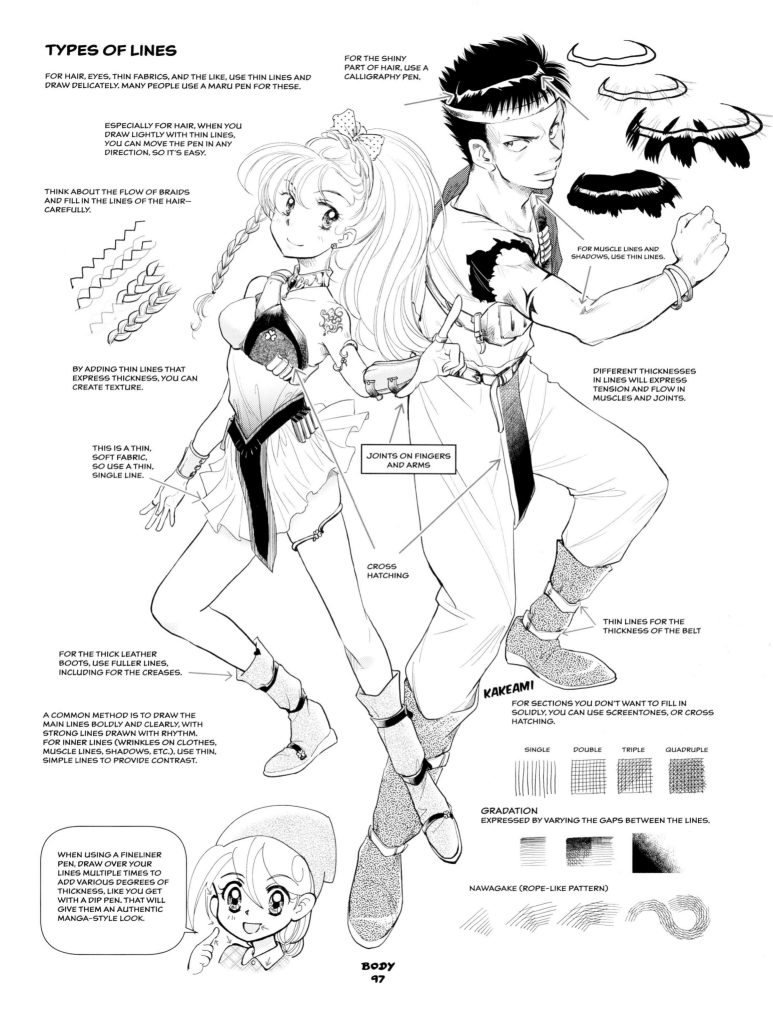

BODY
97

BACKGROUND

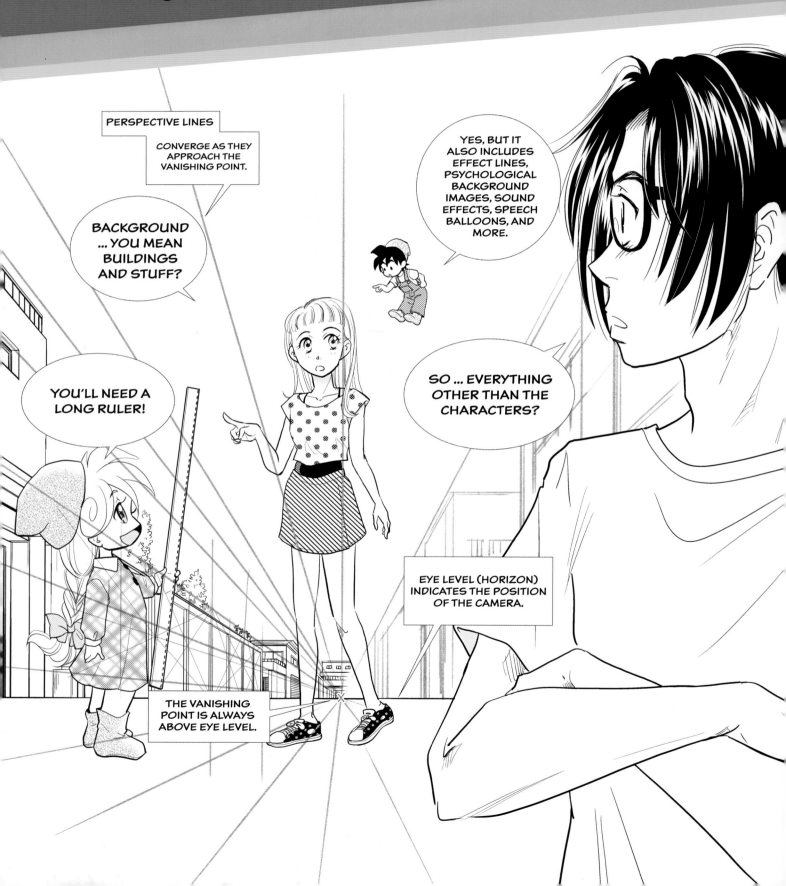

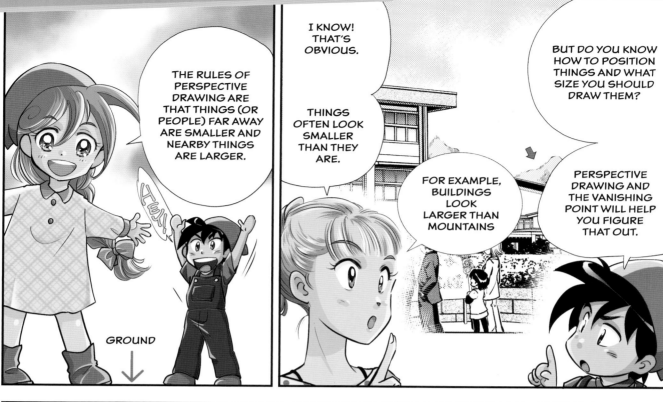

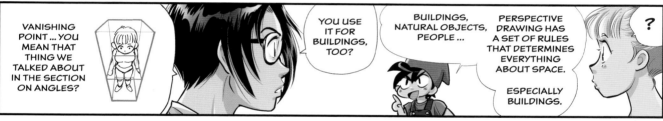

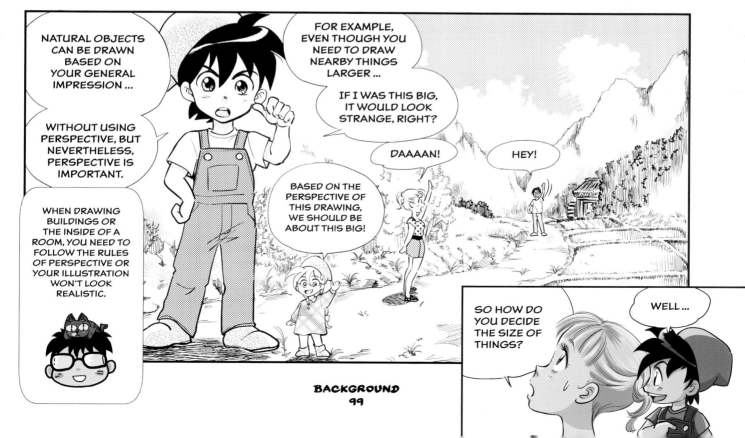

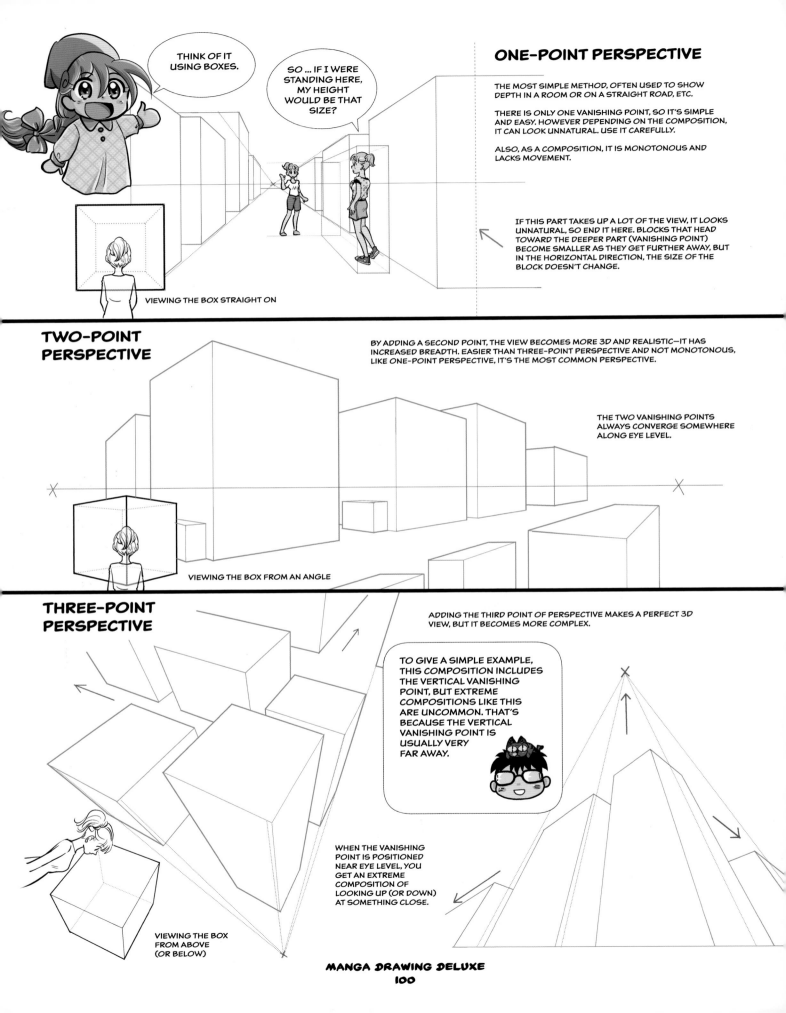

THINK OF IT USING BOXES.

SO ... IF I WERE STANDING HERE, MY HEIGHT WOULD BE THAT SIZE?

ONE-POINT PERSPECTIVE

THE MOST SIMPLE METHOD, OFTEN USED TO SHOW DEPTH IN A ROOM OR ON A STRAIGHT ROAD, ETC.

THERE IS ONLY ONE VANISHING POINT, SO IT'S SIMPLE AND EASY. HOWEVER DEPENDING ON THE COMPOSITION, IT CAN LOOK UNNATURAL. USE IT CAREFULLY.

ALSO, AS A COMPOSITION, IT IS MONOTONOUS AND LACKS MOVEMENT.

IF THIS PART TAKES UP A LOT OF THE VIEW, IT LOOKS UNNATURAL, SO END IT HERE. BLOCKS THAT HEAD TOWARD THE DEEPER PART (VANISHING POINT) BECOME SMALLER AS THEY GET FURTHER AWAY, BUT IN THE HORIZONTAL DIRECTION, THE SIZE OF THE BLOCK DOESN'T CHANGE.

VIEWING THE BOX STRAIGHT ON

TWO-POINT PERSPECTIVE

BY ADDING A SECOND POINT, THE VIEW BECOMES MORE 3D AND REALISTIC—IT HAS INCREASED BREADTH. EASIER THAN THREE-POINT PERSPECTIVE AND NOT MONOTONOUS, LIKE ONE-POINT PERSPECTIVE, IT'S THE MOST COMMON PERSPECTIVE.

THE TWO VANISHING POINTS ALWAYS CONVERGE SOMEWHERE ALONG EYE LEVEL.

VIEWING THE BOX FROM AN ANGLE

THREE-POINT PERSPECTIVE

ADDING THE THIRD POINT OF PERSPECTIVE MAKES A PERFECT 3D VIEW, BUT IT BECOMES MORE COMPLEX.

TO GIVE A SIMPLE EXAMPLE, THIS COMPOSITION INCLUDES THE VERTICAL VANISHING POINT, BUT EXTREME COMPOSITIONS LIKE THIS ARE UNCOMMON. THAT'S BECAUSE THE VERTICAL VANISHING POINT IS USUALLY VERY FAR AWAY.

WHEN THE VANISHING POINT IS POSITIONED NEAR EYE LEVEL, YOU GET AN EXTREME COMPOSITION OF LOOKING UP (OR DOWN) AT SOMETHING CLOSE.

VIEWING THE BOX FROM ABOVE (OR BELOW)

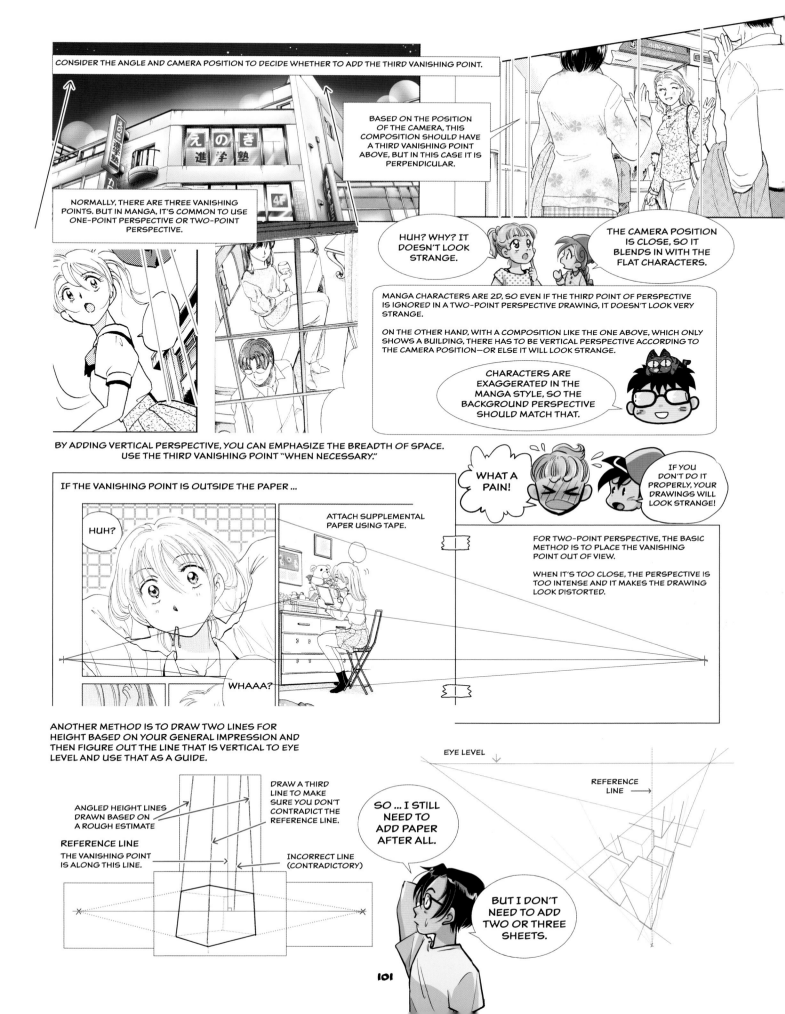

CONSIDER THE ANGLE AND CAMERA POSITION TO DECIDE WHETHER TO ADD THE THIRD VANISHING POINT.

BASED ON THE POSITION OF THE CAMERA, THIS COMPOSITION SHOULD HAVE A THIRD VANISHING POINT ABOVE, BUT IN THIS CASE IT IS PERPENDICULAR.

NORMALLY, THERE ARE THREE VANISHING POINTS. BUT IN MANGA, IT'S COMMON TO USE ONE-POINT PERSPECTIVE OR TWO-POINT PERSPECTIVE.

HUH? WHY? IT DOESN'T LOOK STRANGE.

THE CAMERA POSITION IS CLOSE, SO IT BLENDS IN WITH THE FLAT CHARACTERS.

MANGA CHARACTERS ARE 2D, SO EVEN IF THE THIRD POINT OF PERSPECTIVE IS IGNORED IN A TWO-POINT PERSPECTIVE DRAWING, IT DOESN'T LOOK VERY STRANGE.

ON THE OTHER HAND, WITH A COMPOSITION LIKE THE ONE ABOVE, WHICH ONLY SHOWS A BUILDING, THERE HAS TO BE VERTICAL PERSPECTIVE ACCORDING TO THE CAMERA POSITION—OR ELSE IT WILL LOOK STRANGE.

CHARACTERS ARE EXAGGERATED IN THE MANGA STYLE, SO THE BACKGROUND PERSPECTIVE SHOULD MATCH THAT.

BY ADDING VERTICAL PERSPECTIVE, YOU CAN EMPHASIZE THE BREADTH OF SPACE. USE THE THIRD VANISHING POINT "WHEN NECESSARY."

WHAT A PAIN!

IF YOU DON'T DO IT PROPERLY, YOUR DRAWINGS WILL LOOK STRANGE!

IF THE VANISHING POINT IS OUTSIDE THE PAPER ...

HUH?

ATTACH SUPPLEMENTAL PAPER USING TAPE.

WHAAA?

FOR TWO-POINT PERSPECTIVE, THE BASIC METHOD IS TO PLACE THE VANISHING POINT OUT OF VIEW.

WHEN IT'S TOO CLOSE, THE PERSPECTIVE IS TOO INTENSE AND IT MAKES THE DRAWING LOOK DISTORTED.

ANOTHER METHOD IS TO DRAW TWO LINES FOR HEIGHT BASED ON YOUR GENERAL IMPRESSION AND THEN FIGURE OUT THE LINE THAT IS VERTICAL TO EYE LEVEL AND USE THAT AS A GUIDE.

EYE LEVEL

REFERENCE LINE

DRAW A THIRD LINE TO MAKE SURE YOU DON'T CONTRADICT THE REFERENCE LINE.

ANGLED HEIGHT LINES DRAWN BASED ON A ROUGH ESTIMATE

REFERENCE LINE
THE VANISHING POINT IS ALONG THIS LINE.

INCORRECT LINE (CONTRADICTORY)

SO ... I STILL NEED TO ADD PAPER AFTER ALL.

BUT I DON'T NEED TO ADD TWO OR THREE SHEETS.

CREATING PERSPECTIVE

LET'S BREAK IT DOWN.

THIS IS A METHOD OF APPLYING PERSPECTIVE TO SQUARES DIVIDED INTO EQUAL SIZES (SUCH AS WINDOWS).

WHAT?! YOU DON'T JUST DO IT RANDOMLY?

WHAT?! THE LENGTHS ARE DIFFERENT?

OF COURSE!

BACKGROUNDS ARE SERIOUS STUFF!

CONNECT THE DIAGONALS

DRAW A PERPENDICULAR LINE FROM THE INTERSECTION.

BY REPEATING THIS, YOU CAN KEEP DIVIDING SPACES.

EVEN WITH PERSPECTIVE, THE PRINCIPLE IS THE SAME.

THEY GET SMALLER AT THE SAME RATIO, SO IT LOOKS NATURAL.

YOU CAN DIVIDE SPACES IN TWO WITHOUT USING A RULER! SO CONVENIENT!!

IF YOUR LINES ARE CONNECTED PROPERLY, THESE PARTS WILL BE STACKED VERTICALLY.

DIVIDING IN THREE (VARIATION OF DIVIDING IN TWO)

WHAT IS THIS? GEOMETRY?!

I HATE DIAGRAMS!

I HATE MATH!

LET'S USE A PRACTICAL EXAMPLE! WE'LL DRAW A LIBRARY SCENE USING TWO-POINT PERSPECTIVE!

DRAW A BOX TO OUTLINE THE BASIC SHAPE.

ADD PERSPECTIVE TO MAKE IT LOOK 3D. IT DOESN'T HAVE TO BE PRECISE.

ONCE YOU KNOW THIS, YOU'LL BE ABLE TO DRAW ALL KINDS OF THINGS!

KEEP AT IT!

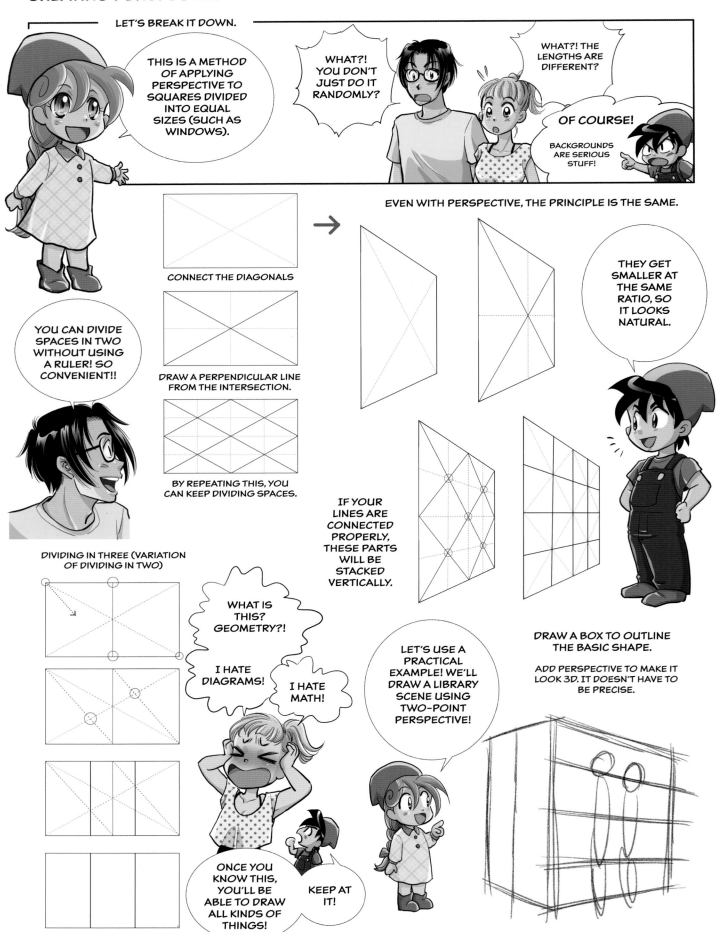

DETERMINE THE VANISHING POINT ACCORDING TO THE GUIDELINES.

HORIZONTAL LINE (EYE LEVEL)

THE TWO VANISHING POINTS SHOULD FALL ON THE SAME LINE. NATURALLY, THEY WON'T LINE UP EXACTLY, SO SPLIT THE DIFFERENCE.

IT'S A SIMPLE FOUR-SHELF BOOKCASE, SO DIVIDE INTO TWO, TWICE.

THICKNESS OF THE TOP BOARD

WE NEED TO DRAW TWO BOOKCASES THAT ARE BACK-TO-BACK, SO WE'LL DIVIDE THE SIDE SURFACE IN TWO.

IN THIS DESIGN, THE BOTTOM BOARD IS THICKER.

LET'S PUT A POSTER ON THE SIDE OF EACH BOOKCASE. DRAW THE CENTER LINE OF THE DEPTH OF THE BOOKCASE TO USE FOR POSITIONING.

CEILING SIDE

DRAW THE THICKNESS OF EACH SHELF

THICKNESS OF THE BOOKCASE

THICKNESS OF THE BOARD

TO MINIMIZE ERROR FROM MISALIGNMENT, USE THIS SMALL SQUARE PART TO DETERMINE THE CENTER LINE.

FLOOR SIDE

FOR THE SHELVES ABOVE EYE LEVEL, THE CEILING SIDE IS VISIBLE, AND FOR THOSE BELOW EYE LEVEL, THE FLOOR SIDE IS VISIBLE.

VANISHING POINT OF THE BOOK

VANISHING POINT OF THE BOOK

DRAW GUIDELINES FOR THE CHARACTERS. THE GIRL STANDING CLOSER IS REMOVING A BOOK THAT'S DIAGONAL AND SMALL. DRAW IT BY FEEL RATHER THAN USING A VANISHING POINT.

INK THE CHARACTERS BEFORE DRAWING THE BOOKCASE DETAILS TO AVOID HAVING TOO MANY CLUTTERED LINES AND TO PREVENT MISTAKES LIKE ERASING THE CHARACTER SKETCHES.

TO THE VANISHING POINT

THIS PART IS DONE BY FEEL, SO IT'S NOT PRECISE, BUT USE THREE-POINT PERSPECTIVE TO MAKE IT LOOK LIKE SHE'S REMOVING A BOOK.

THE POSTERS SHOULD BE DRAWN IN PERSPECTIVE. NOT JUST THEIR SHAPE, BUT ALSO THE TEXT AND IMAGES ON THEM.

FINISH SKETCHING THE DETAILS OF THE BOOKCASE, SUCH AS THE BOOKS. INK THEM, ERASE PENCIL MARKS, FILL IN ANY SOLID AREAS, AND THEN MAKE CORRECTIONS.

DRAW BOOKS OF VARIOUS SIZES AND THICKNESSES.

THE BOOKS ON THE SHELVES BELOW EYE LEVEL ARE AT AN ANGLE THAT SHOWS THEIR TOPS.

ADD SCREENTONE AND ...

YOU'RE DONE!

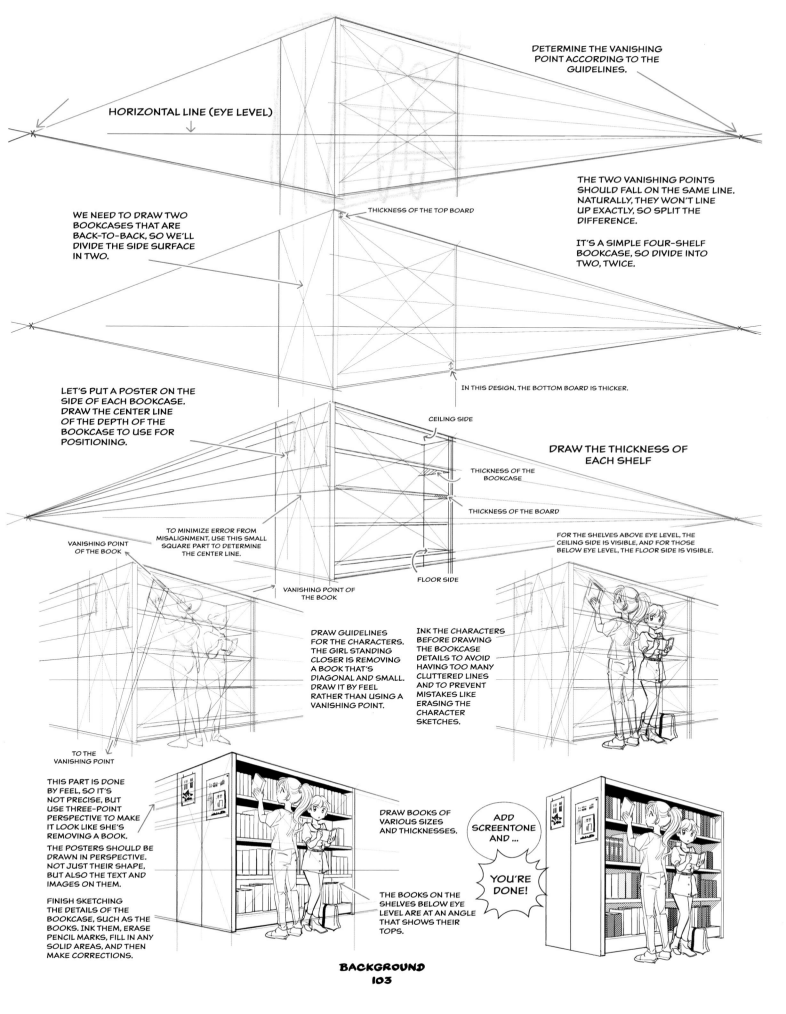

BACKGROUND
103

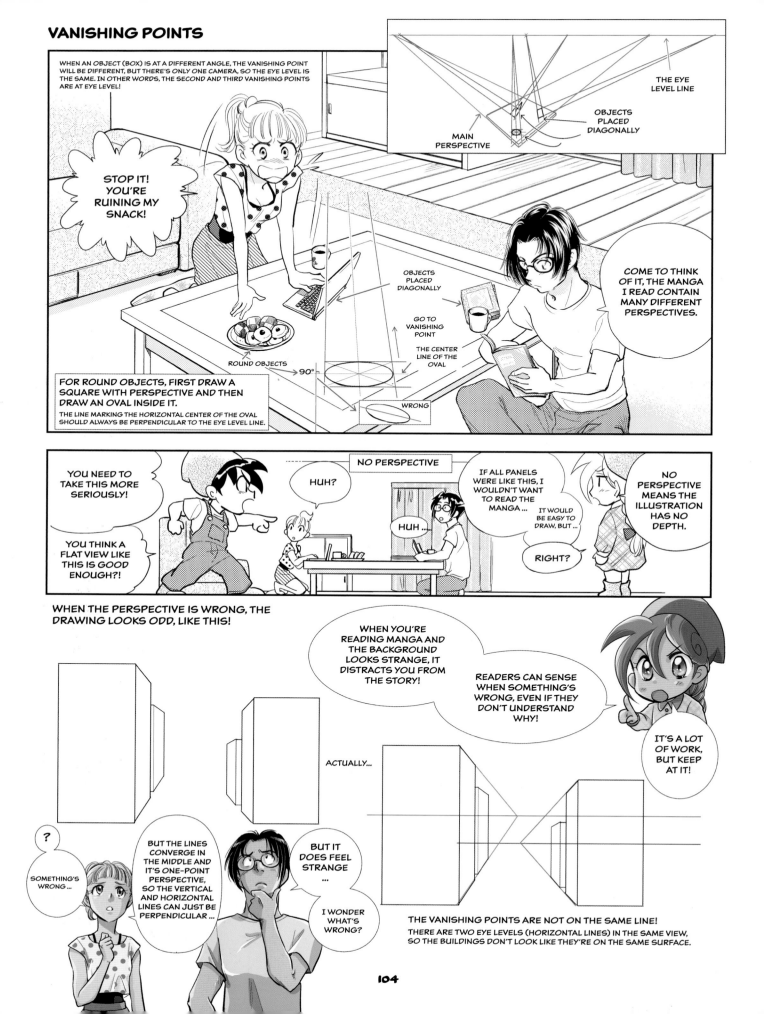

DRAWING CHARACTERS AT DIFFERENT LEVELS

THE SAME APPLIES WHEN DRAWING CHARACTERS.

THE RUNNING CAT IS ON A DIFFERENT EYE LEVEL AND PERSPECTIVE, SO IT DOESN'T LOOK LIKE IT'S IN THE SAME SPACE AS THE CHARACTERS.

WHEN PUTTING MULTIPLE CHARACTERS IS THE SAME SPACE, CHECK WHERE THEY'RE STANDING BEFORE YOU START DRAWING THEM.

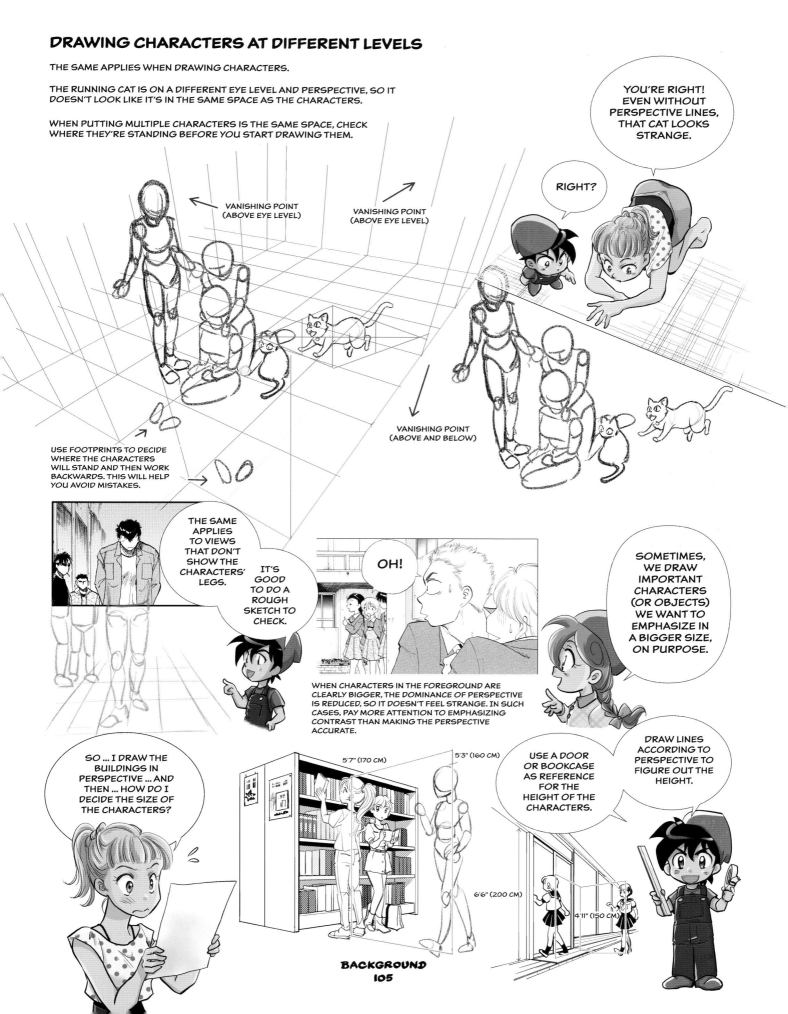

VANISHING POINT (ABOVE EYE LEVEL)

VANISHING POINT (ABOVE EYE LEVEL)

VANISHING POINT (ABOVE AND BELOW)

YOU'RE RIGHT! EVEN WITHOUT PERSPECTIVE LINES, THAT CAT LOOKS STRANGE.

RIGHT?

USE FOOTPRINTS TO DECIDE WHERE THE CHARACTERS WILL STAND AND THEN WORK BACKWARDS. THIS WILL HELP YOU AVOID MISTAKES.

THE SAME APPLIES TO VIEWS THAT DON'T SHOW THE CHARACTERS' LEGS.

IT'S GOOD TO DO A ROUGH SKETCH TO CHECK.

OH!

WHEN CHARACTERS IN THE FOREGROUND ARE CLEARLY BIGGER, THE DOMINANCE OF PERSPECTIVE IS REDUCED, SO IT DOESN'T FEEL STRANGE. IN SUCH CASES, PAY MORE ATTENTION TO EMPHASIZING CONTRAST THAN MAKING THE PERSPECTIVE ACCURATE.

SOMETIMES, WE DRAW IMPORTANT CHARACTERS (OR OBJECTS) WE WANT TO EMPHASIZE IN A BIGGER SIZE, ON PURPOSE.

SO ... I DRAW THE BUILDINGS IN PERSPECTIVE ... AND THEN ... HOW DO I DECIDE THE SIZE OF THE CHARACTERS?

DRAW LINES ACCORDING TO PERSPECTIVE TO FIGURE OUT THE HEIGHT.

USE A DOOR OR BOOKCASE AS REFERENCE FOR THE HEIGHT OF THE CHARACTERS.

5'7" (170 CM)

5'3" (160 CM)

6'6" (200 CM)

4'11" (150 CM)

BACKGROUND
105

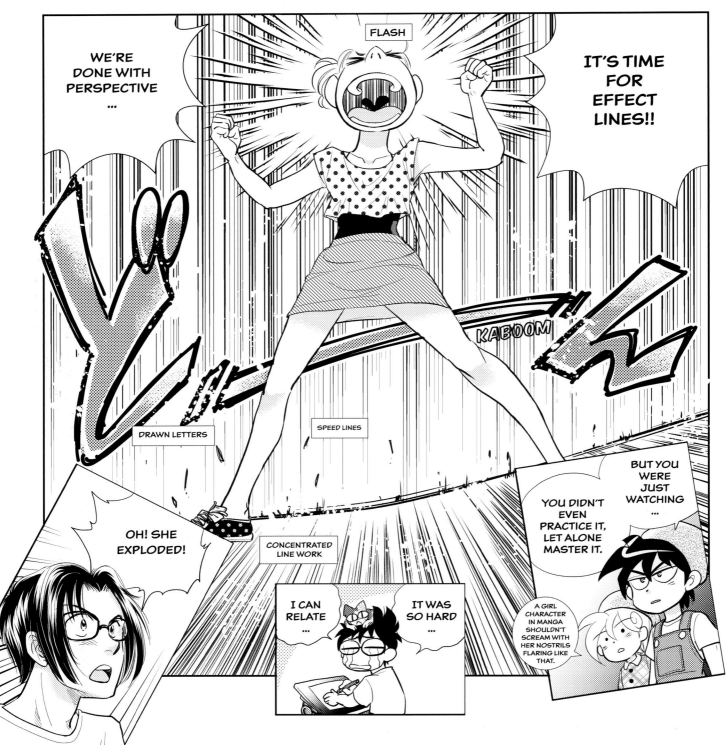

CONCENTRATED LINEWORK

SO YOU CAN SEE THAT THERE ARE MANY EFFECTS AND TECHNIQUES IN MANGA. CONCENTRATED LINE WORK IS PROBABLY THE MOST DAZZLING ONE OF THEM ALL.

CONCENTRATED LINE WORK IS DRAWN WITH A DIP PEN, WHICH ALLOWS YOU TO ADJUST THE THICKNESS OF THE LINE BASED ON HOW MUCH PRESSURE YOU APPLY.

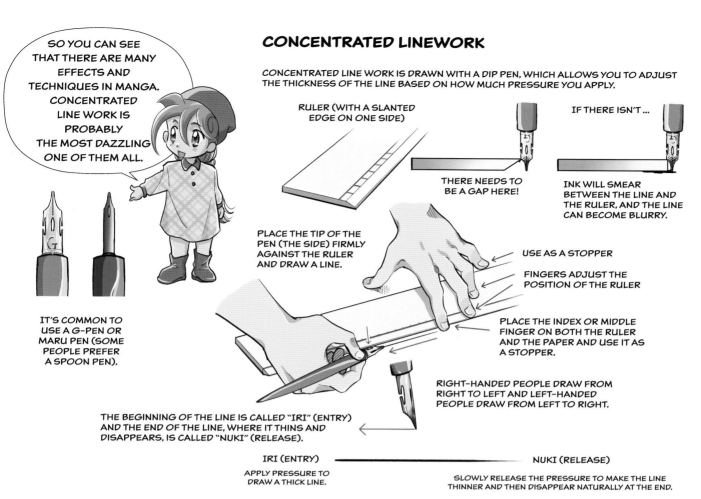

IT'S COMMON TO USE A G-PEN OR MARU PEN (SOME PEOPLE PREFER A SPOON PEN).

RULER (WITH A SLANTED EDGE ON ONE SIDE)

THERE NEEDS TO BE A GAP HERE!

IF THERE ISN'T …

INK WILL SMEAR BETWEEN THE LINE AND THE RULER, AND THE LINE CAN BECOME BLURRY.

PLACE THE TIP OF THE PEN (THE SIDE) FIRMLY AGAINST THE RULER AND DRAW A LINE.

USE AS A STOPPER

FINGERS ADJUST THE POSITION OF THE RULER

PLACE THE INDEX OR MIDDLE FINGER ON BOTH THE RULER AND THE PAPER AND USE IT AS A STOPPER.

RIGHT-HANDED PEOPLE DRAW FROM RIGHT TO LEFT AND LEFT-HANDED PEOPLE DRAW FROM LEFT TO RIGHT.

THE BEGINNING OF THE LINE IS CALLED "IRI" (ENTRY) AND THE END OF THE LINE, WHERE IT THINS AND DISAPPEARS, IS CALLED "NUKI" (RELEASE).

IRI (ENTRY) ———————————— NUKI (RELEASE)

APPLY PRESSURE TO DRAW A THICK LINE.

SLOWLY RELEASE THE PRESSURE TO MAKE THE LINE THINNER AND THEN DISAPPEAR NATURALLY AT THE END.

THE BASICS OF CONCENTRATED LINE WORK

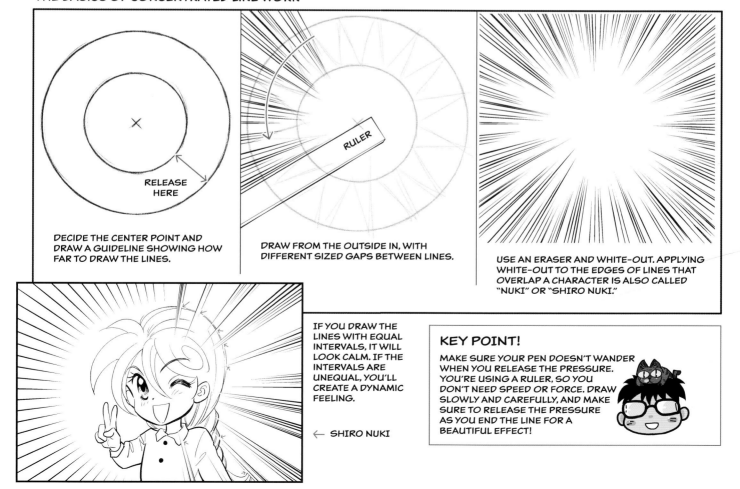

RELEASE HERE

DECIDE THE CENTER POINT AND DRAW A GUIDELINE SHOWING HOW FAR TO DRAW THE LINES.

RULER

DRAW FROM THE OUTSIDE IN, WITH DIFFERENT SIZED GAPS BETWEEN LINES.

USE AN ERASER AND WHITE-OUT. APPLYING WHITE-OUT TO THE EDGES OF LINES THAT OVERLAP A CHARACTER IS ALSO CALLED "NUKI" OR "SHIRO NUKI."

IF YOU DRAW THE LINES WITH EQUAL INTERVALS, IT WILL LOOK CALM. IF THE INTERVALS ARE UNEQUAL, YOU'LL CREATE A DYNAMIC FEELING.

← SHIRO NUKI

KEY POINT!

MAKE SURE YOUR PEN DOESN'T WANDER WHEN YOU RELEASE THE PRESSURE. YOU'RE USING A RULER, SO YOU DON'T NEED SPEED OR FORCE. DRAW SLOWLY AND CAREFULLY, AND MAKE SURE TO RELEASE THE PRESSURE AS YOU END THE LINE FOR A BEAUTIFUL EFFECT!

BETA FLASH

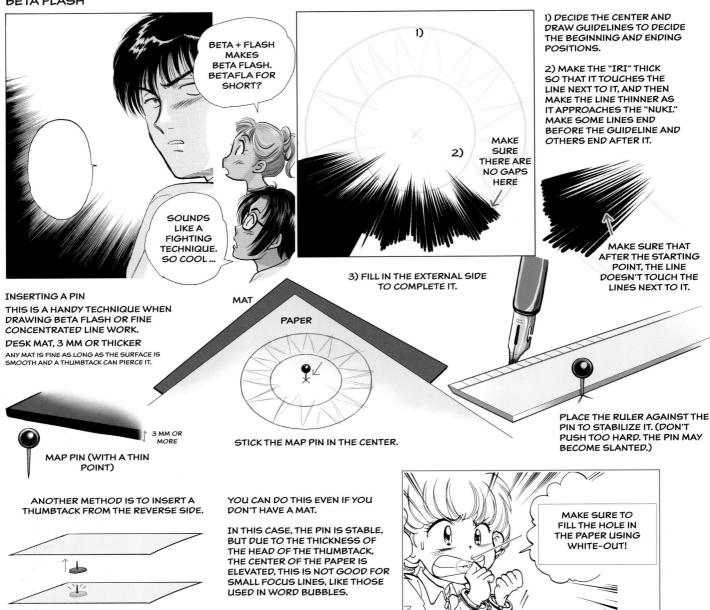

BETA + FLASH MAKES BETA FLASH. BETAFLA FOR SHORT?

SOUNDS LIKE A FIGHTING TECHNIQUE. SO COOL ...

1) DECIDE THE CENTER AND DRAW GUIDELINES TO DECIDE THE BEGINNING AND ENDING POSITIONS.

2) MAKE THE "IRI" THICK SO THAT IT TOUCHES THE LINE NEXT TO IT, AND THEN MAKE THE LINE THINNER AS IT APPROACHES THE "NUKI." MAKE SOME LINES END BEFORE THE GUIDELINE AND OTHERS END AFTER IT.

MAKE SURE THERE ARE NO GAPS HERE

3) FILL IN THE EXTERNAL SIDE TO COMPLETE IT.

MAKE SURE THAT AFTER THE STARTING POINT, THE LINE DOESN'T TOUCH THE LINES NEXT TO IT.

INSERTING A PIN

THIS IS A HANDY TECHNIQUE WHEN DRAWING BETA FLASH OR FINE CONCENTRATED LINE WORK.

DESK MAT, 3 MM OR THICKER

ANY MAT IS FINE AS LONG AS THE SURFACE IS SMOOTH AND A THUMBTACK CAN PIERCE IT.

3 MM OR MORE

MAP PIN (WITH A THIN POINT)

MAT

PAPER

STICK THE MAP PIN IN THE CENTER.

PLACE THE RULER AGAINST THE PIN TO STABILIZE IT. (DON'T PUSH TOO HARD. THE PIN MAY BECOME SLANTED.)

ANOTHER METHOD IS TO INSERT A THUMBTACK FROM THE REVERSE SIDE.

YOU CAN DO THIS EVEN IF YOU DON'T HAVE A MAT.

IN THIS CASE, THE PIN IS STABLE, BUT DUE TO THE THICKNESS OF THE HEAD OF THE THUMBTACK, THE CENTER OF THE PAPER IS ELEVATED, THIS IS NOT GOOD FOR SMALL FOCUS LINES, LIKE THOSE USED IN WORD BUBBLES.

MAKE SURE TO FILL THE HOLE IN THE PAPER USING WHITE-OUT!

STICKING IN A PIN IS USEFUL FOR DRAWING CONCENTRATED LINEWORK BECAUSE IT ELIMINATES ANY CONCERN ABOUT MISALIGNMENT FROM THE CENTER AND YOU CAN FOCUS ON THE NUKI AT THE END OF EACH LINE.

HOWEVER, SOME ARTISTS DISLIKE THE FACT THAT IT CREATES A HOLE IN THE PAPER. IT IS NOT USED MUCH IN MANGA WITH LITTLE ACTION, WHERE THE CONCENTRATED LINEWORK DOESN'T NEED TO BE DYNAMIC, LIKE SHOJO MANGA.

VARIOUS TYPES OF CONCENTRATED LINEWORK

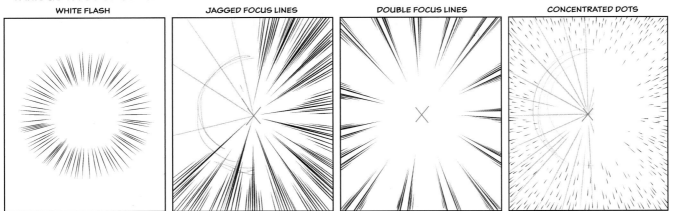

WHITE FLASH

JAGGED FOCUS LINES

DOUBLE FOCUS LINES

CONCENTRATED DOTS

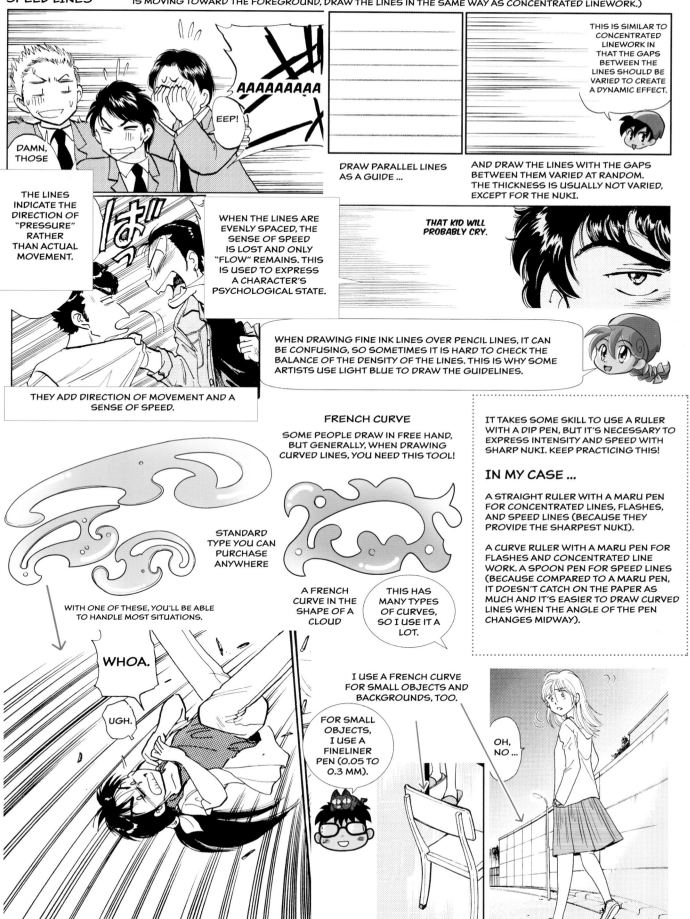

SPEED LINES

USE PARALLEL LINES TO EXPRESS THE FLOW OF MOVEMENT. (WHEN AT AN ANGLE, SUCH AS WHEN A CHARACTER IS MOVING TOWARD THE FOREGROUND, DRAW THE LINES IN THE SAME WAY AS CONCENTRATED LINEWORK.)

THIS IS SIMILAR TO CONCENTRATED LINEWORK IN THAT THE GAPS BETWEEN THE LINES SHOULD BE VARIED TO CREATE A DYNAMIC EFFECT.

DRAW PARALLEL LINES AS A GUIDE ...

AND DRAW THE LINES WITH THE GAPS BETWEEN THEM VARIED AT RANDOM. THE THICKNESS IS USUALLY NOT VARIED, EXCEPT FOR THE NUKI.

AAAAAAAAA

EEP!

DAMN, THOSE

THE LINES INDICATE THE DIRECTION OF "PRESSURE" RATHER THAN ACTUAL MOVEMENT.

WHEN THE LINES ARE EVENLY SPACED, THE SENSE OF SPEED IS LOST AND ONLY "FLOW" REMAINS. THIS IS USED TO EXPRESS A CHARACTER'S PSYCHOLOGICAL STATE.

THAT KID WILL PROBABLY CRY.

WHEN DRAWING FINE INK LINES OVER PENCIL LINES, IT CAN BE CONFUSING, SO SOMETIMES IT IS HARD TO CHECK THE BALANCE OF THE DENSITY OF THE LINES. THIS IS WHY SOME ARTISTS USE LIGHT BLUE TO DRAW THE GUIDELINES.

THEY ADD DIRECTION OF MOVEMENT AND A SENSE OF SPEED.

FRENCH CURVE

SOME PEOPLE DRAW IN FREE HAND, BUT GENERALLY, WHEN DRAWING CURVED LINES, YOU NEED THIS TOOL!

IT TAKES SOME SKILL TO USE A RULER WITH A DIP PEN, BUT IT'S NECESSARY TO EXPRESS INTENSITY AND SPEED WITH SHARP NUKI. KEEP PRACTICING THIS!

IN MY CASE ...

A STRAIGHT RULER WITH A MARU PEN FOR CONCENTRATED LINES, FLASHES, AND SPEED LINES (BECAUSE THEY PROVIDE THE SHARPEST NUKI).

A CURVE RULER WITH A MARU PEN FOR FLASHES AND CONCENTRATED LINE WORK. A SPOON PEN FOR SPEED LINES (BECAUSE COMPARED TO A MARU PEN, IT DOESN'T CATCH ON THE PAPER AS MUCH AND IT'S EASIER TO DRAW CURVED LINES WHEN THE ANGLE OF THE PEN CHANGES MIDWAY).

STANDARD TYPE YOU CAN PURCHASE ANYWHERE

A FRENCH CURVE IN THE SHAPE OF A CLOUD

THIS HAS MANY TYPES OF CURVES, SO I USE IT A LOT.

WITH ONE OF THESE, YOU'LL BE ABLE TO HANDLE MOST SITUATIONS.

WHOA.

UGH.

I USE A FRENCH CURVE FOR SMALL OBJECTS AND BACKGROUNDS, TOO.

FOR SMALL OBJECTS, I USE A FINELINER PEN (0.05 TO 0.3 MM).

OH, NO ...

PSYCHOLOGICAL EFFECTS

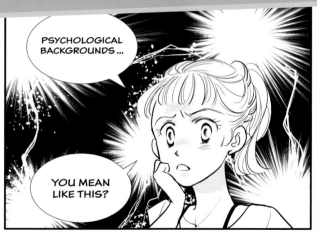

PSYCHOLOGICAL BACKGROUNDS ...

YOU MEAN LIKE THIS?

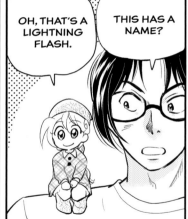

OH, THAT'S A LIGHTNING FLASH.

THIS HAS A NAME?

MANGA ARTISTS USE THE NAMES TO GIVE INSTRUCTIONS TO THEIR ASSISTANTS. BUT NAMES CAN DIFFER DEPENDING ON WHO'S USING THEM.

DRAW SOME CONCENTRATED DOTS HERE.

OKAY!

UNLIKE MOVIES, MANGA DON'T HAVE SOUND EFFECTS, SO PSYCHOLOGICAL BACKGROUNDS ARE ESSENTIAL FOR EXPRESSING A CHARACTER'S PSYCHOLOGICAL STATE AND THE MOOD OF A GIVEN SITUATION.

TAKE THIS TO HEART!

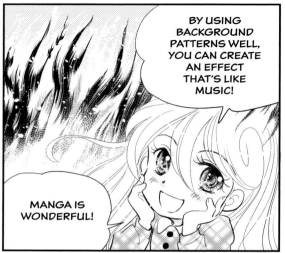

BY USING BACKGROUND PATTERNS WELL, YOU CAN CREATE AN EFFECT THAT'S LIKE MUSIC!

MANGA IS WONDERFUL!

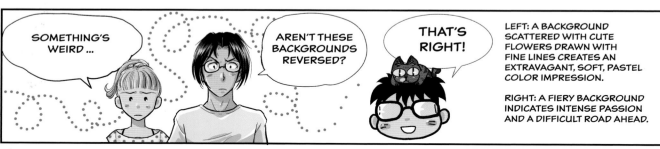

SOMETHING'S WEIRD ...

AREN'T THESE BACKGROUNDS REVERSED?

THAT'S RIGHT!

LEFT: A BACKGROUND SCATTERED WITH CUTE FLOWERS DRAWN WITH FINE LINES CREATES AN EXTRAVAGANT, SOFT, PASTEL COLOR IMPRESSION.

RIGHT: A FIERY BACKGROUND INDICATES INTENSE PASSION AND A DIFFICULT ROAD AHEAD.

Motion lines and concentrated linework indicate the direction of movement and the orientation of the camera. Furthermore, they can communicate intensity and the degree of speed, so paired with drawn letters, they provide the reader with a dynamic scene of presence and tension.

Meanwhile, psychological backgrounds have the effect of communicating the character's inner state. Using the wrong effect will not only ruin the scene, it can even communicate the wrong emotion. One of manga's most appealing elements is the range of vibrant facial expressions. A background that matches the situation can further enhance the effect of the character's expression.

YOU ...

YOU!

GRADATION

Gradation refers to a gradual change from light to dark. It can be used to imply a change in emotions, to indicate reminiscing, or, conversely, to isolate the character and give a sense that time has stopped.

The fact that he has various emotions beyond what he's saying can be sensed not only from his facial expression but also from the gradation in the background.

The flow of the gradation in the direction of the arrow shows that he is listening to a voice from the past as he goes back into his memories. ←

TONE COVERING A CHARACTER'S WHOLE BODY

THERE ARE MANY SCREENTONE VARIATIONS, SUCH AS CUT AND PASTED TO MATCH THE EXACT SHAPE, STICKING OUT A LITTLE, WITH BLURRED EDGES, OR MADE UP OF LARGER DOTS.

THERE ARE ALSO VARIOUS MEANINGS, DEPENDING ON THE CONTEXT.

A SOLID WHITE BACKGROUND COMBINED WITH THE USE OF SCREENTONE EMPHASIZES THE CHARACTER (NATURALLY, THE PANELS BEFORE AND AFTER THIS ONE HAVE BACKGROUNDS). THIS EXPRESSES THAT THE CHARACTER IS DEEPLY SHOCKED. HIS MIND HAS GONE BLANK.

↑ TOGETHER WITH HER SUGGESTIVE EXPRESSION AND GAZE, THE TONE INDICATES THAT WHAT THIS CHARACTER IS SAYING IS NOT WHAT SHE REALLY THINKS.

←

THE CHARACTER IN THE MIDDLE IS THE ONLY ONE NOT COVERED WITH TONE, SHOWING HE IS DIFFERENT AND FEELING ALIENATED.

FINELY DETAILED PATTERNS

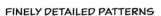

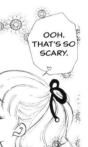

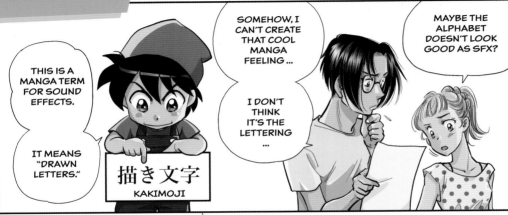

THIS IS A MANGA TERM FOR SOUND EFFECTS.

IT MEANS "DRAWN LETTERS."

描き文字
KAKIMOJI

SOMEHOW, I CAN'T CREATE THAT COOL MANGA FEELING ...

I DON'T THINK IT'S THE LETTERING ...

MAYBE THE ALPHABET DOESN'T LOOK GOOD AS SFX?

HMM, YOU MAY BE RIGHT ...

HUH?

WORDS CAN LOOK GOOD, TOO, BUT ENGLISH TENDS TO HAVE MORE LETTERS THAN JAPANESE, WHICH CREATES CHALLENGES.

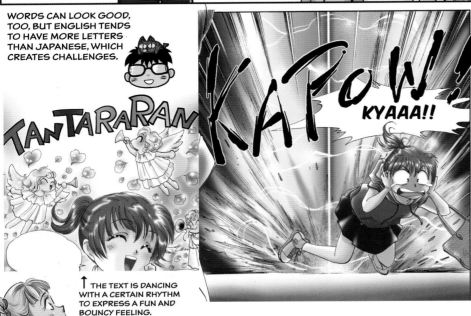

TANTARARAN

KAPOW!! KYAAA!!

↑ THE TEXT IS DANCING WITH A CERTAIN RHYTHM TO EXPRESS A FUN AND BOUNCY FEELING.

JAPANESE PEOPLE PERCEIVE TEXT AS GRAPHICS. SO IN MANGA, THE TEXT AND THE ART HAVE VIRTUALLY THE SAME QUALITY. THIS ALSO APPLIES TO DIALOGUE IN SPEECH BUBBLES.

THIS IS ESPECIALLY TRUE OF DRAWN LETTERS, WHICH HAVE HIGHLY GRAPHIC ELEMENTS. IN OTHER WORDS, IT IS FUNDAMENTALLY DIFFERENT FROM LETTERING, OR THE DESIGNING OF TEXT.

←
EXPRESSING "A HUGE SOUND OF SOMETHING LARGE FALLING NEAR YOU" WITH DYNAMIC MARKER LINES AND FADING. THE LOOSE, FAN-LIKE SHAPE RESULTS FROM MATCHING THE FLOW OF THE CONCENTRATED LINEWORK.

→
GOTHIC-BASED BOLD FONT WITH SHARP DOUBLE LINES THAT GIVE A SENSE OF SPEED. COMBINED WITH LINES THAT FLOW HORIZONTALLY, THIS CREATES MOMENTUM AND THE SENSATION OF A SWORD STRIKING ITS MARK, WITH THE WIELDER'S BODY SHAKING IN RECOIL.

YOU MEAN THE WHOLE THING MAKES UP A SINGLE PIECE OF ART?

IT HAS THE SAME ROLE AS EFFECT LINES. IT'S LIKE STIMULATING YOUR SENSE OF HEARING, VISUALLY.

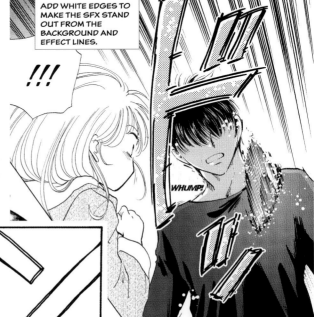

ADD WHITE EDGES TO MAKE THE SFX STAND OUT FROM THE BACKGROUND AND EFFECT LINES.

!!!

WHUMP!

↓ THE SIZE AND WEIGHT OF THE THICK, GOTHIC FONT–BASED LETTERS FILL UP THE ENTIRE PANEL, EXPRESSING A DEEP SOUND WELLING UP FROM THE GROUND. THE DOUBLE LINES, WHICH CORRESPOND WITH THE LINES OF THE CHARACTER, CONVEY THE GREAT INITIAL SHOCK OF A MAJOR EARTHQUAKE.

HAA ...

KEEP IT UP!

GASP

GASP

REPEATED TEXT WITH THE SAME SHAPE PLACED DENSELY IN THE PANEL, EXPRESSES THE REPETITIVENESS AND LOUDNESS OF THE SOUND.

→ A THICK, THORNY OUTLINE WITH A NOISY PATTERN IS VISUALLY LOUD AND INTENSE. BY MAKING THE TEXT SO BIG THAT IT STICKS OUT FROM THE PANEL, IT LOOKS COMICAL, EVEN THOUGH IT'S A TREMENDOUS SCREAM. (SOMETIMES, DRAWN LETTERS ARE PUT IN SPEECH BUBBLES.)

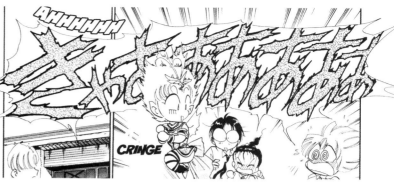

AHHHHHH

CRINGE

DRAWN LETTERS CAN BE HARD TO READ, BUT THAT'S NOT A PROBLEM. THEY ARE NOT "READ" IN THE USUAL SENSE. THE IMPORTANT THING IS FOR THE SHAPE AND POSITION TO BE RIGHT FOR THE SITUATION.

THESE ARE "SEEN" (HEARD) RATHER THAN "READ," SO EVEN IF THE WORD CAN'T BE PRONOUNCED OR IS NOT A REAL WORD, IT'S FINE AS LONG AS IT COMMUNICATES THE INTENDED FEELING.

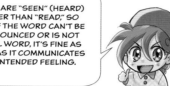

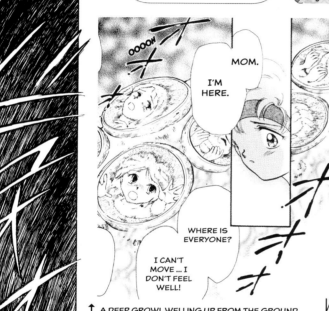

OOOOH

MOM.

I'M HERE.

WHERE IS EVERYONE?

I CAN'T MOVE ... I DON'T FEEL WELL!

↑ A DEEP GROWL WELLING UP FROM THE GROUND. EXPRESSED WITH BROKEN LINES DRAWN WITH A THICK MARKER.

WHOOSH

↑ WITH BRUSH LINES, THERE IS A STARK CONTRAST BETWEEN THICK PARTS AND THIN PARTS, AND BY USING THE EFFECT OF FADING, THE LETTERS LOOK DYNAMIC.

A SHARP GUST OF WIND ←

THE SLIM LETTERS WITH RAZOR-LIKE EDGES, EXPRESS SHARPNESS AND THEIR ARRANGEMENT IN LINE WITH THE BACKGROUND FLOW EXPRESSES THE MOVEMENT OF WIND.

→ THE OUTLINE OF THE TEXT IS SHIFTED TO EMPHASIZE THAT BRIGHT LIGHT IS BEING EMITTED FROM THE CENTER, AND THE ANGLE OF THE TEXT INCLUDING ITS SHADOWS IS POINTED TOWARD THE LIGHT SOURCE.

FLASH

WHAT DID YOU ...!

← ANOTHER WAY TO USE BRUSH LINES IS TO MAKE THEM QUIVER (WITHOUT ANY FADING) TO COMICALLY EXPRESS THAT THE CHARACTER IS DEEPLY MOVED.

LIKE MANPU, DRAWN LETTERS WERE BORN FROM THE CREATIVITY OF GREAT MANGA ARTISTS OVER MANY YEARS.

THE ABUNDANT USE OF ONOMATOPOEIA IN THE JAPANESE LANGUAGE IS PART OF THE REASON THEY ARE SO COMMON, BUT THEY AREN'T EXCLUSIVE TO JAPANESE.

IF YOU THINK OF A GOOD EXPRESSION, GO AHEAD AND ILLUSTRATE IT! IT MIGHT BE INTERESTING TO INCORPORATE JAPANESE SFX, LIKE: "DOKI DOKI."

FUKIDASHI (SPEECH BUBBLES)

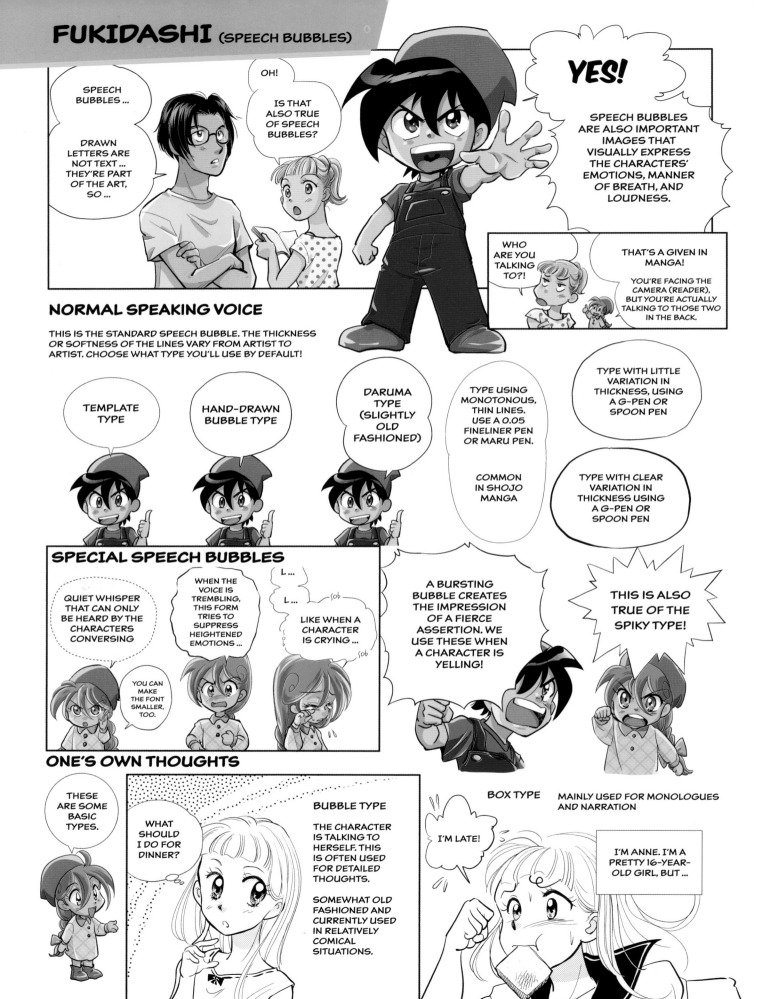

OTHER SPEECH BUBBLE POSSIBILITIES

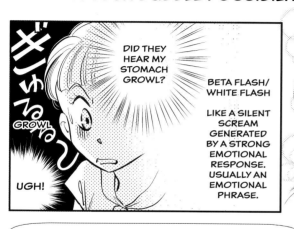

GROWL

UGH!

DID THEY HEAR MY STOMACH GROWL?

BETA FLASH/ WHITE FLASH

LIKE A SILENT SCREAM GENERATED BY A STRONG EMOTIONAL RESPONSE. USUALLY AN EMOTIONAL PHRASE.

IS THIS ...A DREAM?

FLUFFY TYPE

A WARM, FUZZY FEELING. AN EXPRESSION WHEN EMOTIONS ARE HEIGHTENED. THERE ARE MANY VARIATIONS, INCLUDING TYPES INVOLVING THE USE OF SCREENTONE.

WHAT AM I SUPPOSED TO DO WITH NOTHING ...

THERE'S NOTHING TO ACT OUT ...

NOTHING

GIVES A NEUTRAL IMPRESSION. IT IS COLORLESS AND TRANSPARENT, SO IT CAN BE USED IN VARIOUS SCENES, REGARDLESS OF GENRE OR SITUATION.

THERE ARE MANY OTHER PATTERNS, BUT IF THE BUBBLE DOESN'T HAVE A TAIL, YOU NEED TO MAKE SURE THE CONTEXT AND TONE MAKE IT CLEAR WHO IS SPEAKING!

THE TAIL OF A BUBBLE INDICATES WHO'S SPEAKING, BUT IT SHOULD NEVER BE THIS LONG!

IT LOOKS BAD!

TAIL

STRETCH ...

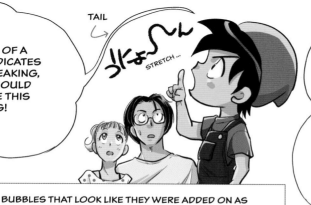

WHAT?

I'VE SEEN THAT DONE BEFORE ...

LIKE THIS!!

WHAT SHOULD I DO ...?

BUBBLES THAT LOOK LIKE THEY WERE ADDED ON AS AN AFTERTHOUGHT (USUALLY IN A COMICAL FONT OR HANDWRITING) GIVE THE IMPRESSION OF SOMETHING MUMBLED OR ADDED FOR A LIGHT EFFECT. IT'S SECONDARY TO THE MAIN DIALOGUE, BUT IT'S STILL IMPORTANT INFORMATION.

THAT'S PART OF THE DESIGN!

IT'S LONG AND WINDING—TO COMICALLY EXPRESS CONFUSION OR A TREMBLING VOICE.

JUST LIKE HER HAIR!

SOMETIMES YOU SEE A FACE DRAWN IN A BALLOON, LIKE THIS. IT IDENTIFIES THE SPEAKER AND THEIR EMOTIONAL EXPRESSION IN A SMALL AMOUNT OF SPACE. HOWEVER, DUE TO SPACE RESTRICTIONS, THE FACE TENDS TO BE DRAWN IN THE CHIBI STYLE AND IT LOOKS QUITE UNUSUAL, SO IT'S BETTER TO LIMIT THIS TO COMICAL SCENES.

IT CAN ALSO MAKE IT LOOK LIKE YOU'RE CUTTING CORNERS.

FOR A NON-HUMAN VOICE OR A NEGATIVE INNER THOUGHT

THE SEA URCHIN FLASH IS USED IN MANY SITUATIONS!

A LOUD OR CHEERFUL VOICE

SPEECH BUBBLES CAN MELT OR LOOK FLUSTERED!

THIS IS FOR VOICES EMITTED FROM MECHANICAL EQUIPMENT LIKE A MICROPHONE OR TV.

YOU CAN ALSO COMBINE DIFFERENT TYPES TO MAKE NEW ONES!

THIS LOOKS LIKE THE DIALOGUE STARTS IN A NORMAL TONE OF VOICE, THEN THE CHARACTER RAISES THEIR VOICE AT THE END!

COMPOSITION

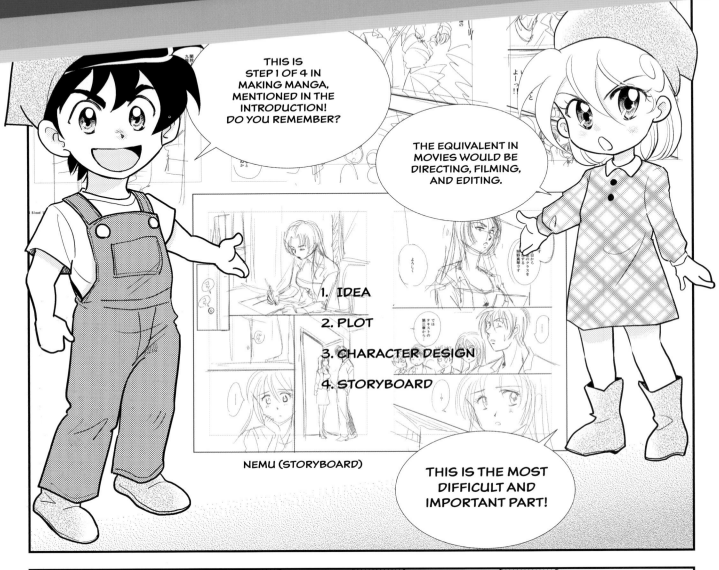

THIS IS STEP 1 OF 4 IN MAKING MANGA, MENTIONED IN THE INTRODUCTION! DO YOU REMEMBER?

THE EQUIVALENT IN MOVIES WOULD BE DIRECTING, FILMING, AND EDITING.

1. IDEA
2. PLOT
3. CHARACTER DESIGN
4. STORYBOARD

NEMU (STORYBOARD)

THIS IS THE MOST DIFFICULT AND IMPORTANT PART!

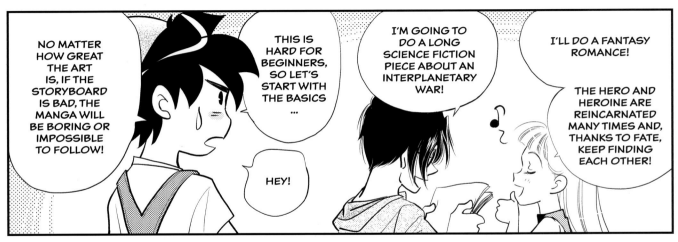

NO MATTER HOW GREAT THE ART IS, IF THE STORYBOARD IS BAD, THE MANGA WILL BE BORING OR IMPOSSIBLE TO FOLLOW!

THIS IS HARD FOR BEGINNERS, SO LET'S START WITH THE BASICS ...

HEY!

I'M GOING TO DO A LONG SCIENCE FICTION PIECE ABOUT AN INTERPLANETARY WAR!

I'LL DO A FANTASY ROMANCE!

THE HERO AND HEROINE ARE REINCARNATED MANY TIMES AND, THANKS TO FATE, KEEP FINDING EACH OTHER!

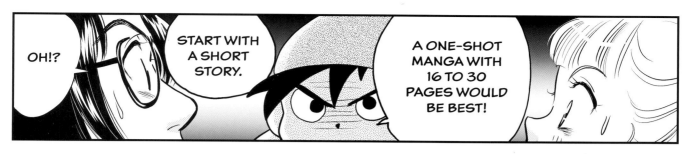

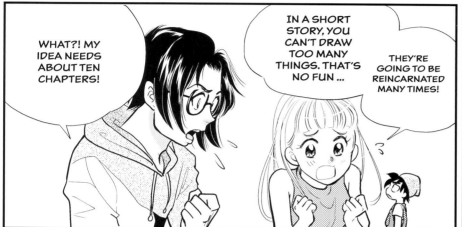

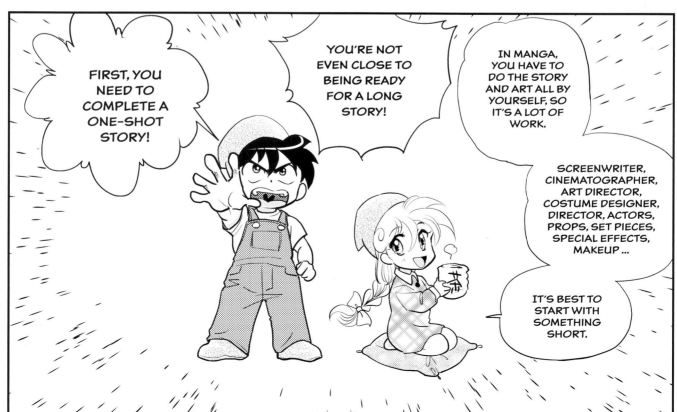

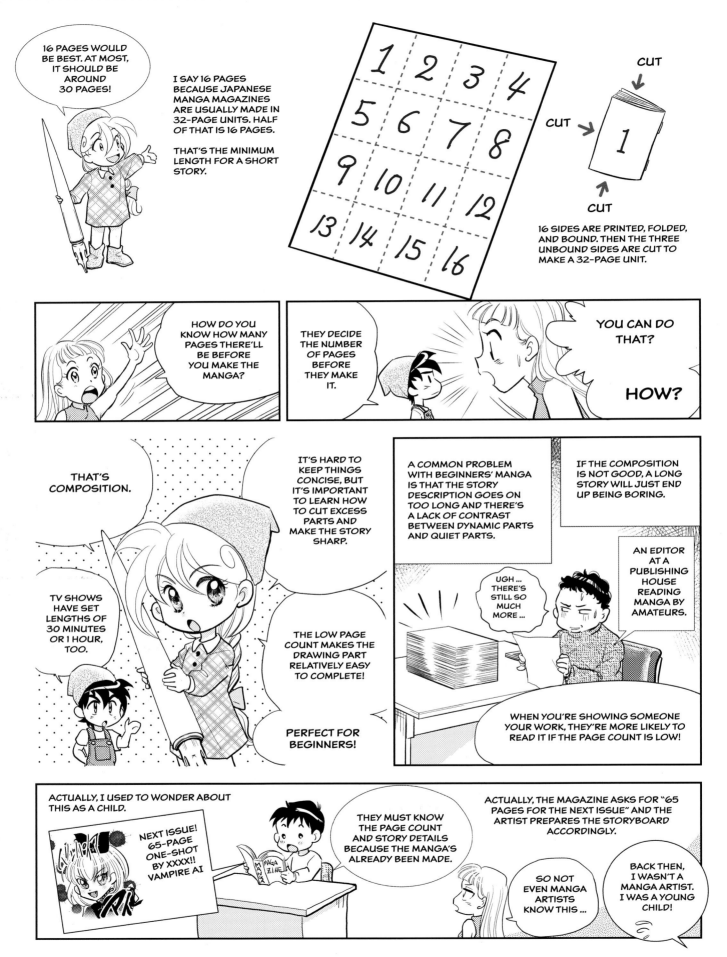

WELL THEN, HOW ABOUT DOING CHAPTER 1 OF A LONG STORY IN 16 PAGES?

I DON'T RECOMMEND THAT ...

A LONG STORY IS BASICALLY MANY SHORT STORIES GROUPED INTO ONE!

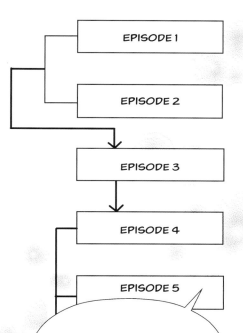

EPISODE 1

EPISODE 2

EPISODE 3

EPISODE 4

EPISODE 5

ALSO, YOU'LL LEARN FASTER BY DOING THREE 16-PAGE STORIES RATHER THAN ONE 60-PAGE STORY.

SO IF I WANT TO IMPROVE QUICKLY, I SHOULD MAKE ONE-SHOTS?

YES!

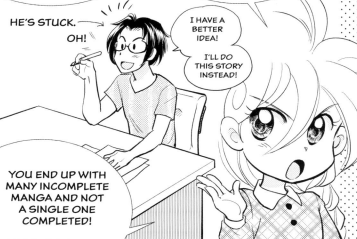

COMPOSING A LONG STORY IS DIFFICULT FOR BEGINNERS AND IT WILL TAKE YEARS TO FINISH THE WHOLE THING.

LOTS OF PEOPLE START, BUT MOST AREN'T ABLE TO COMPLETE THE STORY. THEY END UP QUITTING.

HE'S STUCK.

OH!

I HAVE A BETTER IDEA!

I'LL DO THIS STORY INSTEAD!

YOU END UP WITH MANY INCOMPLETE MANGA AND NOT A SINGLE ONE COMPLETED!

TO MAKE EACH EPISODE ENGAGING AND ENTERTAINING, IT'S BEST TO START BY LEARNING HOW TO DO SHORT STORIES.

YOU SHOULD START BY DOING AT LEAST 2 OR 3 ONE-SHOTS!

THE MOST IMPORTANT THING IS TO COMPLETE YOUR FIRST STORY!

... THAT SAID, AS AN AMATEUR, I DREW A LONG MANGA CALLED "SHINKU CHITAI: THE ISOLATED ZONE" FOR FUN. BUT BEFORE THAT, I HAD DRAWN MANY ONE-SHOTS. THEY WERE 8 TO 20 PAGES LONG.

BY THE WAY, I COMPLETED "THE ISOLATED ZONE" OVER MORE THAN 20 YEARS.

IT'S MORE THAN 1,500 PAGES LONG. HAHA!

DEDUCTIVE AND INDUCTIVE METHOD

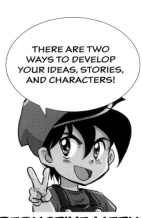

THERE ARE TWO WAYS TO DEVELOP YOUR IDEAS, STORIES, AND CHARACTERS!

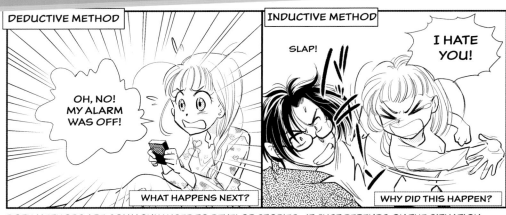

DEDUCTIVE METHOD

OH, NO! MY ALARM WAS OFF!

WHAT HAPPENS NEXT?

INDUCTIVE METHOD

SLAP!

I HATE YOU!

WHY DID THIS HAPPEN?

BOTH METHODS ARE COMMONLY USED TO DEVELOP STORIES—IT JUST DEPENDS ON THE SITUATION.

DEDUCTIVE METHOD

MANGA ARTISTS OFTEN HAVE A CHARACTER FIRST AND THINK OF THE STORY NEXT.

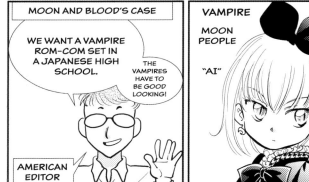

MOON AND BLOOD'S CASE

WE WANT A VAMPIRE ROM-COM SET IN A JAPANESE HIGH SCHOOL.

THE VAMPIRES HAVE TO BE GOOD LOOKING!

AMERICAN EDITOR

VAMPIRES DON'T LOOK THEIR ACTUAL AGE.

JAPANESE MANGA HAVE CUT MASCOTS.

WHAT WOULD AMERICAN READERS ENJOY SEEING?

......

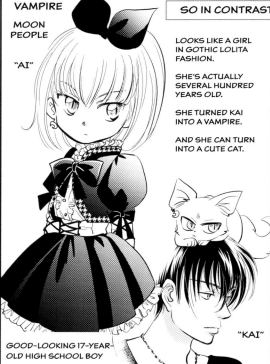

VAMPIRE

MOON PEOPLE

"AI"

LOOKS LIKE A GIRL IN GOTHIC LOLITA FASHION.

SHE'S ACTUALLY SEVERAL HUNDRED YEARS OLD.

SHE TURNED KAI INTO A VAMPIRE.

AND SHE CAN TURN INTO A CUTE CAT.

GOOD-LOOKING 17-YEAR-OLD HIGH SCHOOL BOY

"KAI"

SO IN CONTRAST, THE OTHER CHARACTERS ARE ...

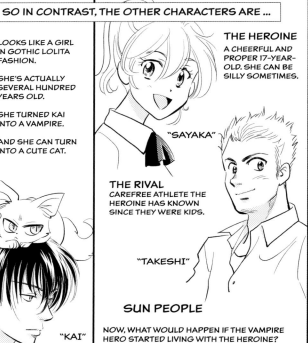

THE HEROINE
A CHEERFUL AND PROPER 17-YEAR-OLD. SHE CAN BE SILLY SOMETIMES.

"SAYAKA"

THE RIVAL
CAREFREE ATHLETE THE HEROINE HAS KNOWN SINCE THEY WERE KIDS.

"TAKESHI"

SUN PEOPLE

NOW, WHAT WOULD HAPPEN IF THE VAMPIRE HERO STARTED LIVING WITH THE HEROINE?

INDUCTIVE METHOD

SINCE YOU'RE AN ILLUSTRATOR, I'M SURE YOU'VE EXPERIENCED HAVING A VISUAL IDEA FIRST! YOU CAN START FROM THE FIRST SCENE THAT COMES TO YOU AND DEVELOP THE STORY AROUND THAT.

THAT STAPLE OF ROM-COMS: HATING EACH OTHER WHEN THEY FIRST MEET!

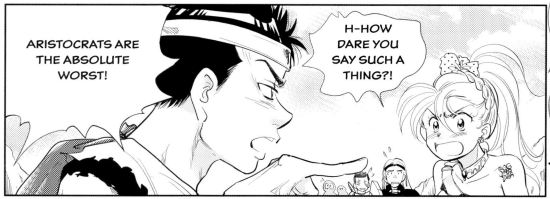

ARISTOCRATS ARE THE ABSOLUTE WORST!

H-HOW DARE YOU SAY SUCH A THING?!

WHAT COMES NEXT? WHY DID THIS HAPPEN? WRITE DOWN AS MANY STORY NUGGETS AS POSSIBLE.

DEVELOPING A STORYLINE

ONCE YOU HAVE ENOUGH IDEAS WRITTEN DOWN, CHOOSE THE BEST ONES AND ARRANGE THEM INTO A STORY THAT MAKES SENSE.

↓ START ↓

THE HERO TOOK A SHORTCUT TO A VILLAGE TO DELIVER A LETTER. SINCE HE DESPISES THE ARISTOCRACY, HE REFUSES TO GO AROUND THEM AND TAKE A LONGER ROUTE.

→

THE HEROINE AND OTHER ARISTOCRATIC CHILDREN ARE TRAINING OUTSIDE OF TOWN WHEN THE HERO ENCOUNTERS THEM.

←

THE HEROINE IS A SOLDIER, DOING HER BEST AS THE DAUGHTER OF A FEUDAL LORD. SHE'S PROUD OF HER TOP-RANKING MARTIAL ARTS SKILLS.

THE HERO THINKS THE HEROINE IS A TYPICAL ARISTOCRAT WHO IS ARROGANT BECAUSE OF HER NOBILITY AND PRETTY FACE.

→

THE HERO IS RUDE TO THE HEROINE, AND SHE BECOMES VERY UPSET.

THE VILLAGE IS NEXT TO A FOREST WHERE MONSTERS LIVE, SO THE LOCALS ARE ALWAYS VIGILANT.

THERE COULD BE A SCENE WHERE A SOLDIER TRIES TO PUNCH THE HERO FOR BEING RUDE TO THE HEROINE, BUT THE HERO DEFEATS HIM EASILY?

↑

THE HERO WANTS TO FINISH MAKING HIS DELIVERY, SO HE RUNS OFF. THE HEROINE CHASES AFTER HIM TO TEACH HIM A LESSON, BUT HE'S TOO FAST.

THE HEROINE BELIEVES IT'S HER DUTY AS AN ARISTOCRAT TO SHOW COMPASSION AND KINDNESS TO THE LOWER CLASSES, BUT SHE THINKS THE HERO IS UNPLEASANT AND UNWORTHY.

THE MOTHER AND DAUGHTER AT THIS HOME ARE CAUGHT BETWEEN THE QUARRELLING HERO AND HEROINE. THEY TAKE THE HEROINE'S SIDE BECAUSE SHE WAS KIND TO THEM.

→

THE HEROINE RUNS INTO THE HERO AGAIN AT A HOME ON THE EDGE OF THE FOREST WHERE THE LETTER NEEDED TO BE DELIVERED.

THE HEROINE IS HERE BECAUSE SHE VOLUNTEERED TO GUARD VILLAGERS ENTERING THE DANGEROUS FOREST TO GATHER MEDICINAL HERBS.

SHE'S SAVED BY THE HERO.

"I DON'T HAVE TIME TO WASTE ON THIS FOOL!" THE HEROINE LEAVES WITH THE DAUGHTER TO LOOK FOR HERBS.

THE HEROINE HAD NEVER MET SOMEONE HER AGE THAT WAS STRONGER THAN HER, SO HER HEART SKIPS A BEAT. SHE HAD ALWAYS BEEN THE ONE PROTECTING OTHERS.

THE HEROINE HATES TO LOSE, BUT SHE BELIEVES IN BEING FAIR AND SHE KNOWS SHE HAS TO BE GRATEFUL FOR BEING SAVED. AWKWARDLY, SHE SAYS THANKS.

THE TWO WOMEN ARE ATTACKED BY MONSTERS. THE HEROINE HELPS THE DAUGHTER ESCAPE, BUT SHE FINDS HERSELF FACING CERTAIN DEATH. THAT'S WHEN THE HERO APPEARS.

THE HERO SEES THE HEROINE DOING THIS AND CAN'T HELP BUT FIND HER ADORABLE.

"I DON'T NEED YOU TO PROTECT ME!" THE HEROINE TRIES TO APPEAR TOUGH. THE HERO SAYS, "I HATE YOU ARISTOCRATS, BUT I HATE THESE MONSTERS EVEN MORE! THEY KILLED MY FAMILY!"

THE HEROINE'S MOTHER HAD ALSO BEEN KILLED BY MONSTERS, MANY YEARS AGO.

END

PREPARE A SHORT SUMMARY TO EXPLAIN YOUR STORY.

IF YOU CAN'T, YOU DON'T HAVE A SOLID STORY!

LET'S LOOK AT THE 5 Ws AND THE H:
WHO, WHAT, WHEN, WHERE, WHY, AND HOW

WHO: A SOLDIER GUARDING A VILLAGE WHO IS ALSO THE DAUGHTER OF A FEUDAL LORD

WHAT: FALLS IN LOVE WITH A RUDE COMMONER

WHEN: IN A FANTASY WORLD SIMILAR TO THE EUROPEAN MIDDLE AGES

WHERE: A RURAL VILLAGE NEAR A FOREST INHABITED BY MONSTERS

WHY: IT WAS THE FIRST TIME ANYONE PROTECTED HER AND SHE LEARNED THEY HAD A SIMILAR BACKGROUND

HOW: HE SAVED HER FROM A CLOSE CALL WITH DEATH IN A BATTLE WITH MONSTERS

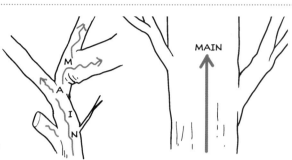

HAVE A SOLID GRASP OF YOUR PLOTLINE!
THE MAIN PLOT IS LIKE A STURDY TRUNK AND IT CAN BE DECORATED WITH VARIOUS BRANCHES.
IF YOU HAVE MULTIPLE TRUNKS OR IF THE BRANCHES ARE TOO THICK, YOUR STORY WILL LACK FOCUS.

4-PANEL COMICS

IN ANY DISCUSSION OF MANGA COMPOSITION, YOU'LL HEAR ABOUT "KI SHO TEN KETSU." THESE ARE THE FUNDAMENTALS OF NARRATING ANY STORY!

LIKE THIS

4-PANEL COMICS?

I KNOW THOSE ... THE PANELS ARE ALL THE SAME SHAPE.

4+1 PANELS

SOMETIMES YOU SEE THESE, TOO.

THE PANELS ARE ALL SHAPED THE SAME AND THE ART IS SMALL, SO IT DOESN'T REALLY LOOK LIKE MANGA.

THAT'S RIGHT. FOUR-PANEL COMICS HAVE A SET PANEL SHAPE, SO THEY LACK THE DYNAMIC LAYOUTS THAT MAKE MANGA UNIQUE.

STILL, MANY MANGA ARTISTS WORK IN THIS FORMAT. THE CONCEPT OF INTRODUCTION, DEVELOPMENT, TWIST, AND CONCLUSION IS THE BASIS OF 4-PANEL COMICS AND IS ALSO THE FRAMEWORK OF ANY STORY.

WHAT IS "KI SHO TEN KETSU"? IT ORIGINALLY REFERRED TO A TECHNIQUE IN CHINESE POETRY.

THE FOUR PARTS OF A STORY
It's a way of writing to make your story easy to understand. If you just tell a story off the top of your head, the listener will have trouble following. However, if you speak or write by keeping "introduction, development, twist, and conclusion" in mind, you will be able to communicate smoothly.

KI INTRODUCTION: THE BEGINNING
SHO DEVELOPMENT: THE STORY CONTINUES AND EXPANDS
TEN TWIST: SOMETHING HAPPENS AND THE STORY UNFOLDS
KETSU CONCLUSION: THE END OF THE STORY

起 KI

TRYING TO READ AN EBOOK ON A TABLET

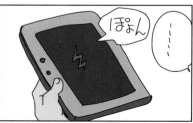

承 SHO

I TRY TO TURN IT ON, BUT IT'S OUT OF BATTERY!

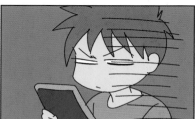
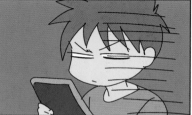

転 TEN

MY REACTION IS ... TIME FREEZES!

結 KETSU

4-PANEL COMICS ARE USUALLY COMEDIC, SO THIS PART CONTAINS THE PUNCHLINE.

IN THIS CASE, THE ENDING IS DYNAMIC, AND THE CONTRAST WITH THE QUIET ATMOSPHERE OF THE THIRD PANEL IS SUPPOSED TO MAKE IT FUNNY.

HMM ... SO IT'S DIFFERENT FROM THE 5 Ws AND THE H?

THE 5 WS AND THE H ARE FOR ORGANIZING AND SUMMARIZING INFORMATION LOGICALLY.

THEY'RE DIFFERENT FROM "KI-SHO-TEN-KETSU," WHICH ARE FOR TELLING A STORY IN AN ENGAGING WAY THAT'S EASY TO FOLLOW.

THE 5 Ws AND THE H WOULD BE ...

ONE DAY, NAO YAZAWA WAS IN HER STUDY AT HOME. SHE TRIED TO READ AN EBOOK ON HER TABLET BUT IT WAS OUT OF BATTERY, SO SHE BECAME FRUSTRATED AND LOST HER TEMPER.

THAT'S BORING ...

IF YOU JUST READ THE DIALOGUE, YOU WOULDN'T KNOW WHAT HAPPENED, RIGHT?

IF YOU CAN UNDERSTAND THE STORY JUST BY READING THE DIALOGUE, IT'S NOT A GOOD MANGA.

THE ART SHOULD TELL THE STORY AND THE DIALOGUE SHOULD BE KEPT TO A MINIMUM.

FINDING KI SHO TEN KETSU IN A STORY

You could say that all stories (not just 4-panel comics) are told by repeating this pattern.
For example, my manga "Moon and Blood" has four chapters around 70 pages each.

CHAPTER 1 = INTRODUCTION: THEY MEET

CHAPTER 2 = DEVELOPMENT: THEY DEVELOP FEELINGS FOR EACH OTHER

CHAPTER 3 = TWIST: THEY BECOME A COUPLE, BUT SOMETHING HAPPENS AND GETS IN THEIR WAY

CHAPTER 4 = CONCLUSION: AFTER A BATTLE, THEY OVERCOME THE OBSTACLES AND REACH A HAPPY ENDING

But even in chapter 1 alone, these four parts exist. Furthermore, the "introduction" can also be broken down into "introduction, development, twist, and conclusion" and so on. This is the basic structure of storytelling.

This creates momentum and a pleasant rhythm, which are important when reading manga. They get the reader to keep reading. Reading manga has to be an enjoyable experience. Introduction, development, twist, and conclusion can also be shown in one panel each, which creates good tempo.

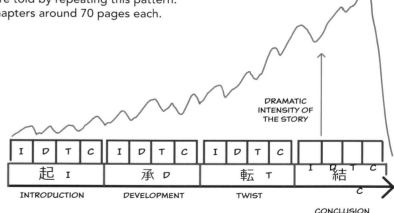

DRAMATIC INTENSITY OF THE STORY

起 I — INTRODUCTION
承 D — DEVELOPMENT
転 T — TWIST
結 C — CONCLUSION

LET'S START WITH THE RIGHT PAGE OF THE SPREAD BELOW AND STUDY THE PANELS THAT REPRESENT INTRODUCTION, DEVELOPMENT, TWIST, AND CONCLUSION.

A CLOSER LOOK SHOWS:

① INTRODUCTION: THE HEROINE IS DAY-DREAMING

② DEVELOPMENT: LOOKING AT THE HEROINE'S INNER THOUGHTS. A VOICE CALLS OUT TO HER. (WHOSE VOICE? A MYSTERY IS PRESENTED.)

③ TWIST: THE SPEAKER APPEARS. (THE ANSWER TO THE MYSTERY.)

④ CONCLUSION: WE SEE THAT THE HEROINE WASN'T LISTENING.

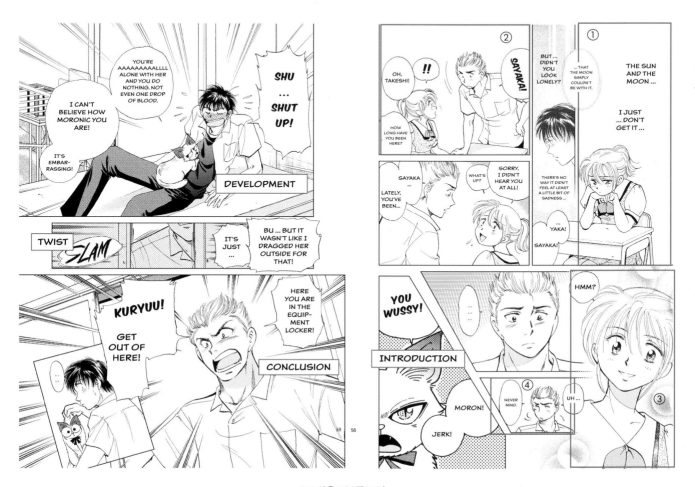

NOW THAT YOU UNDERSTAND INTRODUCTION, DEVELOPMENT, TWIST, AND CONCLUSION LET'S APPLY IT TO OUR STORY.

HMM

"INTRODUCTION" IS WHEN THEY MEET, I THINK ...

"TWIST" WOULD BE THE BATTLE SCENE.

KI BEGINNING	The heroine and other aristocrats are training as military guards outside a village. A shabbily dressed boy enters their space, despite a soldier warning him to stop. The heroine finds the boy's attitude disrespectful toward aristocrats; she feels insulted and becomes angry. However, the boy runs across their field with tremendous speed and vanishes from sight.
CAPTURE THE READER'S ATTENTION! PRESENT A MYSTERY OR CREATE ANTICIPATION ABOUT WHAT WILL HAPPEN AHEAD. 2 TO 3 PAGES	

I'M SURE THESE TWO ARE GOING TO MEET AGAIN. THAT'S HOW STORIES WORK.

SHO DEVELOPMENT	The heroine is doing her usual volunteer work as a guard for poor villagers who gather medicinal herbs in the forest when she meets the hero again. She starts to think better of him when she learns that he came to deliver a letter on foot, but then his biased attitude toward aristocrats makes her angry again.
THE STORY CONTINUES AND EXPANDS THE HUMAN RELATIONSHIPS AND DRAMA ARE INTRODUCED. 6 PAGES	

THE MEET AGAIN, AS EXPECTED, BUT THEY END UP FIGHTING SOME MORE ... GIRLS GOING INTO A FOREST INHABITED BY MONSTERS? SURELY THAT'S A SIGN THAT SOMETHING WILL HAPPEN ...

TEN CLIMAX	They go to gather medicinal herbs and monsters appear. The heroine is able to let the daughter escape, but then the heroine is surrounded by monsters and is about to be killed. Suddenly, the boy blocks the attack. The boy says to the heroine, "I don't like you, but I hate these monsters even more. They killed my entire family." She sees his sad expression, and her heart skips a beat because she can relate to how he feels. The hero is strong, but the monsters catch him off guard and are about to harm him when the heroine comes to his aid. They work together seamlessly to defeat the monsters. They were able to win because they're both highly skilled warriors.
THE SCENE WHERE THE CONFLICT RESOLVES USE LARGE PANELS EFFECTIVELY FOR ACTION AND CLOSE-UPS OF THE CHARACTER'S FACIAL EXPRESSIONS TO MAKE READERS EMPATHIZE WITH THE CHARACTERS. 8 PAGES	

THEY WORK TOGETHER? THEY MAKE GREAT PARTNERS! HOW COOL!

KETSU CONCLUSION	The two celebrate their victory and even grab each other's hands in excitement, but quickly separate. They look at each other awkwardly. She offers a clumsy thank you and he mumbles, "No ... I should be thanking you ... " They are both confused by how they feel, thinking "Why? I can't stand him/her!"
DO IT QUICKLY SO AS NOT TO DIMINISH THE AFTERGLOW OF THE EXCITEMENT AND EMOTION OF THE CLIMAX. LEAVE A LASTING IMPRESSION! 1 TO 2 PAGES	

OH, GOOD! WHAT HAPPENS NEXT?

Next, think about introduction, development, twist, and conclusion in each section as you decide the flow and sequence. If you think of any layouts or scene ideas, draw them. They'll be useful when you prepare the storyboard. In addition to character concepts, you need to create a solid world view for your story. It's fiction, so your world can have any characteristics, but once you've created it, stick with it. Like with character profiles, if your story starts to go against the basic concepts you created, your story and characters will lose coherence. Don't let that happen!

BEFORE YOU START, DECIDE WHAT YOU WANT TO SAY AND WHO YOUR AUDIENCE IS!

THE SAME PLOT CAN RESULT IN DIFFERENT STORY GENRES, DEPENDING ON WHAT YOU FOCUS ON.

SEINEN MANGA:
The heroine, who is kind but believes in the class system, and the hero, who thinks it's rubbish, are attracted to each other, but they can't quite develop a real connection.

SHONEN MANGA:
Cool battles between the hero and monsters. When he joins forces with the heroine, their coordinated moves are exhilarating, like skilled passing in soccer, and they win through the power of friendship!

SHOJO MANGA:
A drama about two shy, stubborn people who fall in love but can't admit it to themselves. A romance between people of different classes.

HAKOGAKI (WRITING A BEAT SHEET)

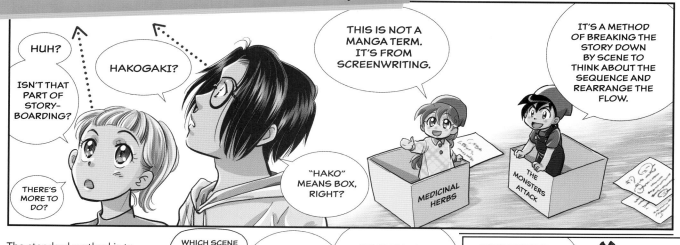

The standard method is to use chronological order, but you can still use "introduction, development, twist, and conclusion" without presenting the story on a linear time axis. You can write each scene on a card and consider different sequences.

| TRAINING SCENE | MEDICINAL HERBS | THE MONSTERS ATTACK |

BEING ABLE TO SEE THE WHOLE STORY AT A GLANCE IS HELPFUL.

WHICH SCENE SHOULD I START WITH?

YOU MEAN LIKE STARTING WITH A SHOCKING SCENE ...

AND THEN SHOWING WHAT LED UP TO IT THROUGH THE MAIN CHARACTER'S FLASHBACKS?

THAT'S PRETTY COMMON.

IT'S LIKE EDITING A MOVIE. YOU TRY DIFFERENT SEQUENCES BASED ON WHAT EFFECT THEY CREATE.

REMEMBER THAT THE SAME SCENE CAN HAVE A DIFFERENT EFFECT DEPENDING ON HOW YOU PRESENT IT.

For example, the introduction scene:

From a long shot of soldiers training on a big field ...

To a close-up of the boy's feet on the field. He steps forward. The camera pulls back and shows his whole body and the area in front of him is roped off, marked "Do not enter."

A sword is pointed at the hero and we hear a loud "stop!" The shot pulls back and the heroine and other soldiers surround the hero ... etc.

ONCE YOU'RE DONE, READ IT OVER TO CHECK!

Are you showing readers what you want to show and hiding the things you want to keep hidden?

Do any scenes drag on for too long?

Is the dialogue too long? Are the characters' words and actions consistent with the profiles you created?

And so on ...

For example, if the hero is about to be betrayed by a friend ...

WE'RE FINALLY READY TO PREPARE THE STORYBOARD. FOR EACH SPREAD (TWO FACING PAGES), DECIDE WHAT TO DRAW IN EACH SECTION.

YOU CAN USE WHATEVER METHOD SUITS YOU. IF YOU'RE STUCK, HOW ABOUT THIS METHOD?

ONCE YOU'VE DRAWN ON THE MANGA MANUSCRIPT PAPER, IT'S A LOT OF WORK TO FIX THINGS, SO YOU NEED TO PREPARE A SOLID BLUEPRINT DURING STORYBOARDING. YOU SHOULD REWORK YOUR STORYBOARDS MULTIPLE TIMES.

DOING 20 TO 30 PAGES SHOULDN'T BE THAT HARD.

PAGE COUNT	DESCRIPTION
1	COVER
2-3	
4-5	
6-7	
8-9	

PREPARING A LIST OF ALL PAGES IS A GOOD WAY TO CHECK THE OVERALL BALANCE OF THE STORY.

AT WHAT POINT DOES THE READER LEARN OF THE FRIEND'S TRUE INTENTION? BEFORE THE HERO DOES? THIS CREATES SUSPENSE.

OR IS THE READER SURPRISED TO FIND OUT AT THE SAME TIME?

OH!

HE'S BEING DECEIVED ... I WISH I COULD TELL HIM!

NEMU (STORYBOARD)

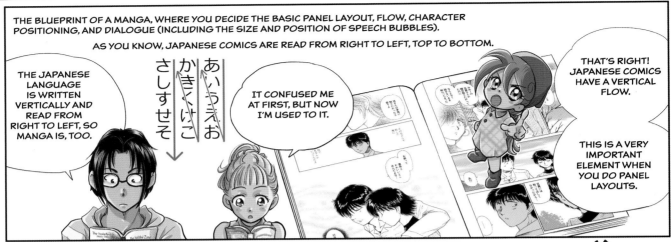

THE BLUEPRINT OF A MANGA, WHERE YOU DECIDE THE BASIC PANEL LAYOUT, FLOW, CHARACTER POSITIONING, AND DIALOGUE (INCLUDING THE SIZE AND POSITION OF SPEECH BUBBLES).

AS YOU KNOW, JAPANESE COMICS ARE READ FROM RIGHT TO LEFT, TOP TO BOTTOM.

THE JAPANESE LANGUAGE IS WRITTEN VERTICALLY AND READ FROM RIGHT TO LEFT, SO MANGA IS, TOO.

さしすせそ
かきくけこ
あいうえお

IT CONFUSED ME AT FIRST, BUT NOW I'M USED TO IT.

THAT'S RIGHT! JAPANESE COMICS HAVE A VERTICAL FLOW.

THIS IS A VERY IMPORTANT ELEMENT WHEN YOU DO PANEL LAYOUTS.

TO MAKE A STORYBOARD FOR A JAPANESE-STYLE COMIC, YOU NEED TO KNOW THE "GRAMMAR" OF MANGA! IN MANGA, THERE ARE MANY CONVENTIONS THAT HAVE DEVELOPED OVER ITS 70-YEAR HISTORY.

RULES CONCERNING MANUSCRIPT PAPER

THIS IS THE STANDARD FORMAT OF "MANGA MANUSCRIPT PAPER" SOLD IN JAPAN. THE DEFAULT TEMPLATE IN MANGA DRAWING SOFTWARE IS ALSO LIKE THIS.

"TACHIIRI"
DRAWING UP TO THE TRIM (DRAWING BEYOND THE SAFE AREA)

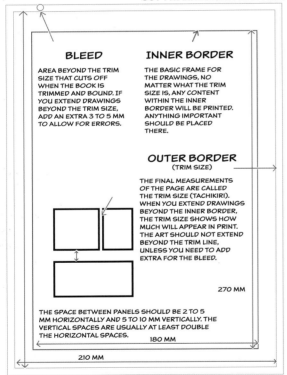

BLEED

AREA BEYOND THE TRIM SIZE THAT CUTS OFF WHEN THE BOOK IS TRIMMED AND BOUND. IF YOU EXTEND DRAWINGS BEYOND THE TRIM SIZE, ADD AN EXTRA 3 TO 5 MM TO ALLOW FOR ERRORS.

INNER BORDER

THE BASIC FRAME FOR THE DRAWINGS, NO MATTER WHAT THE TRIM SIZE IS, ANY CONTENT WITHIN THE INNER BORDER WILL BE PRINTED. ANYTHING IMPORTANT SHOULD BE PLACED THERE.

OUTER BORDER
(TRIM SIZE)

THE FINAL MEASUREMENTS OF THE PAGE ARE CALLED THE TRIM SIZE (TACHIKIRI). WHEN YOU EXTEND DRAWINGS BEYOND THE INNER BORDER, THE TRIM SIZE SHOWS HOW MUCH WILL APPEAR IN PRINT. THE ART SHOULD NOT EXTEND BEYOND THE TRIM LINE, UNLESS YOU NEED TO ADD EXTRA FOR THE BLEED.

270 MM

THE SPACE BETWEEN PANELS SHOULD BE 2 TO 5 MM HORIZONTALLY AND 5 TO 10 MM VERTICALLY. THE VERTICAL SPACES ARE USUALLY AT LEAST DOUBLE THE HORIZONTAL SPACES.
180 MM

210 MM

MANUSCRIPT PAPER IS STANDARD FOR COMMERCIALLY SOLD MAGAZINES IN JAPAN. A4 IS ALSO COMMON.

NODO (INSIDE MARGIN)

THE SIDE WHERE THE BOOK IS BOUND. IT'S NOT VERY VISIBLE WHEN THE BOOK IS OPENED, AND IT CAN BE CONFUSING WHEN A PANEL SPANS BOTH PAGES. IN GENERAL, DO NOT DRAW PAST THE INNER BORDER.

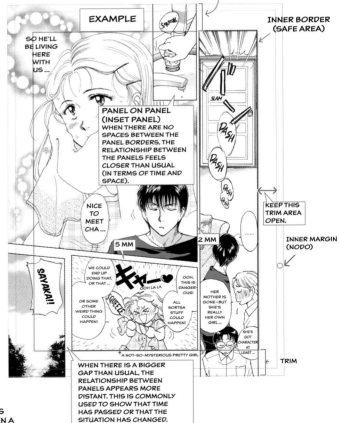

EXAMPLE

SO HE'LL BE LIVING HERE WITH US ...

INNER BORDER (SAFE AREA)

PANEL ON PANEL (INSET PANEL)
WHEN THERE ARE NO SPACES BETWEEN THE PANEL BORDERS, THE RELATIONSHIP BETWEEN THE PANELS FEELS CLOSER THAN USUAL (IN TERMS OF TIME AND SPACE).

NICE TO MEET 'CHA ...

KEEP THIS TRIM AREA OPEN.

5 MM

2 MM

INNER MARGIN (NODO)

WE COULD END UP DOING THAT, OR THAT ...

OR SOME OTHER WEIRD THING COULD HAPPEN!

OOH LA LA

ALL SORTSA STUFF COULD HAPPEN!

OOH, THIS IS DANGER-OUS!

HER MOTHER IS GONE—BUT SHE'S REALLY HER OWN GIRL ...

SHE'S GOT CHARACTER AT LEAST ...

SAYAKAI!

SQUEE!!

A NOT-SO-MYSTERIOUS PRETTY GIRL

TRIM

WHEN THERE IS A BIGGER GAP THAN USUAL, THE RELATIONSHIP BETWEEN PANELS APPEARS MORE DISTANT. THIS IS COMMONLY USED TO SHOW THAT TIME HAS PASSED OR THAT THE SITUATION HAS CHANGED.

RULES CONCERNING BORDER LINES

SET A STANDARD AND THEN USE VARIATIONS TO EXPRESS PRESENT AND PAST TENSE, REMINISCENCES, IMAGINATIONS, DREAMS, AND THE FUTURE. ARTISTS USE BORDER LINES TO EXPRESS DIFFERENT THINGS AND THE READER UNDERSTANDS FROM THE CONTEXT.

STANDARD 0.5 TO 1.0 MM 0.8 MM IS COMMON	THIN LINES	DASHED LINES	SCREENTONE: DOT PATTERN	SCREENTONE: SAND TEXTURE

SAMPLE STORYBOARD ("MOON AND BLOOD")

This rough sketch gives an idea of how the final manga will look.

Draw the overall flow and check it.

Text provides information as necessary.

Think of each pair of facing pages as a single unit.

Check the balance of the panels and the positioning of characters within the two facing pages.

Position the panels according to the page distribution you decided in advance. The size and position of the speech bubbles are very important.

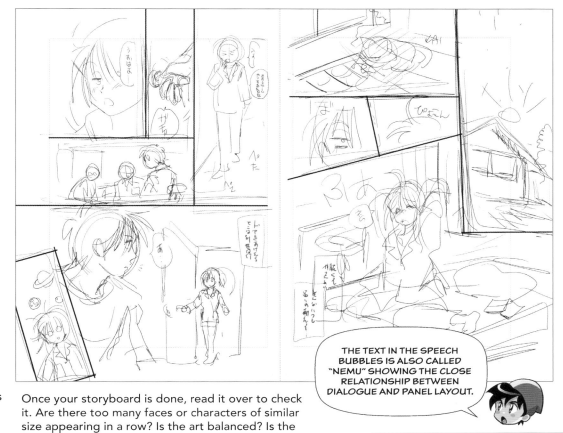

Once your storyboard is done, read it over to check it. Are there too many faces or characters of similar size appearing in a row? Is the art balanced? Is the composition monotonous? Are the situations clear?

THE TEXT IN THE SPEECH BUBBLES IS ALSO CALLED "NEMU" SHOWING THE CLOSE RELATIONSHIP BETWEEN DIALOGUE AND PANEL LAYOUT.

FLOW OF THE ART

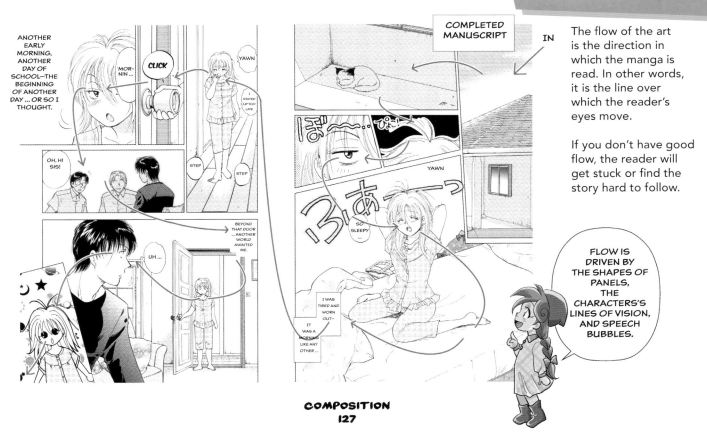

The flow of the art is the direction in which the manga is read. In other words, it is the line over which the reader's eyes move.

If you don't have good flow, the reader will get stuck or find the story hard to follow.

FLOW IS DRIVEN BY THE SHAPES OF PANELS, THE CHARACTERS'S LINES OF VISION, AND SPEECH BUBBLES.

RIGHT TO LEFT

Movement from right to left, which is consistent with the standard flow of reading in traditional manga, provides a comfortable reading experience, so it implies positive things like the future, hope, and progress. Conversely, movement toward the right and characters facing the right create discomfort in the reader, and they can imply negativity and regression.

Both A and B have arbitrary panel layouts, but A is in the standard order while B is in the reverse order. Arbitrary panel layouts refer to anything other than the standard vertical or horizontal border lines. They can be diagonal or the gutters can be omitted or they can have no border lines at all.

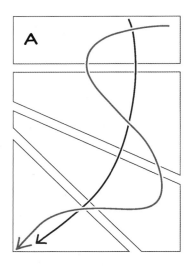

A: Smooth movement from in to out, in line with the flow. The panels start to be placed at an angle in regular order, creating a sense of acceleration. It gives the impression that the images appear in succession.

B: The in is fine, but as the flow progresses, the angles move in the opposite direction from normal flow. This confuses the reader. This can be used for an anxious scene or, by the guiding of the line of vision backward, it can avert the reader's eyes from the page on the left.

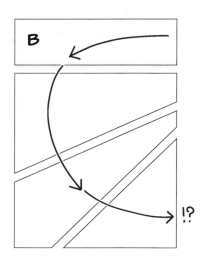

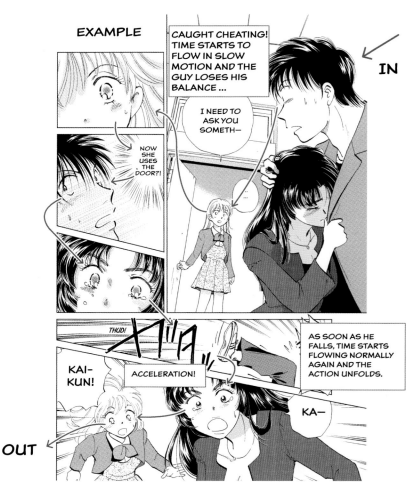

FLIP PANEL

THE FIRST PANEL YOU SEE AFTER TURNING THE PAGE IS CALLED "MEKURI GOMA" (FLIP PANEL). CAPTURE THE READER'S ATTENTION AND GUIDE THEIR VIEWING TO THE BOTTOM LEFT PANEL OF THE SPREAD!

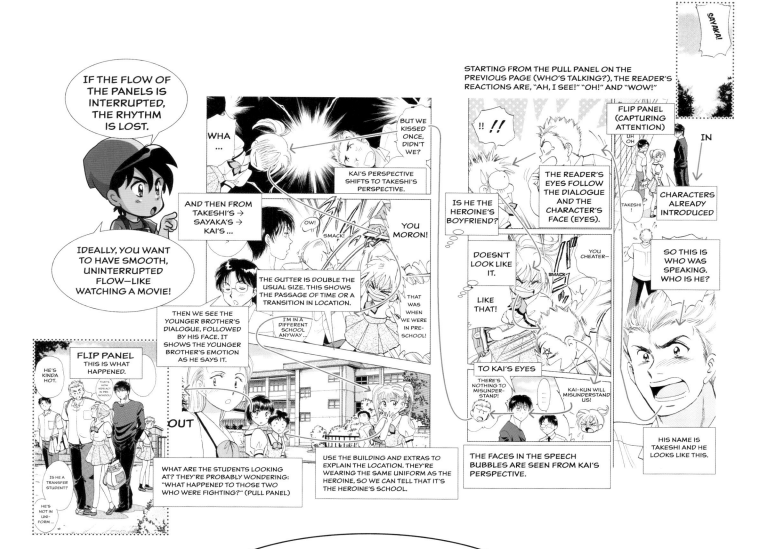

IF THE FLOW OF THE PANELS IS INTERRUPTED, THE RHYTHM IS LOST.

IDEALLY, YOU WANT TO HAVE SMOOTH, UNINTERRUPTED FLOW—LIKE WATCHING A MOVIE!

WHA...

BUT WE KISSED ONCE, DIDN'T WE?

KAI'S PERSPECTIVE SHIFTS TO TAKESHI'S PERSPECTIVE.

AND THEN FROM TAKESHI'S → SAYAKA'S → KAI'S ...

OW!

SMACK!

YOU MORON!

THE GUTTER IS DOUBLE THE USUAL SIZE. THIS SHOWS THE PASSAGE OF TIME OR A TRANSITION IN LOCATION.

THAT WAS WHEN WE WERE IN PRE-SCHOOL!

I'M IN A DIFFERENT SCHOOL ANYWAY ...

THEN WE SEE THE YOUNGER BROTHER'S DIALOGUE, FOLLOWED BY HIS FACE. IT SHOWS THE YOUNGER BROTHER'S EMOTION AS HE SAYS IT.

FLIP PANEL
THIS IS WHAT HAPPENED.

HE'S KINDA HOT.

THAT'S HOW KIDS ACT IN PRE-SCHOOL.

IS HE A TRANSFER STUDENT?

HE'S IN NO UNI-FORM ...

OUT

WHAT ARE THE STUDENTS LOOKING AT? THEY'RE PROBABLY WONDERING: "WHAT HAPPENED TO THOSE TWO WHO WERE FIGHTING?" (PULL PANEL)

USE THE BUILDING AND EXTRAS TO EXPLAIN THE LOCATION. THEY'RE WEARING THE SAME UNIFORM AS THE HEROINE, SO WE CAN TELL THAT IT'S THE HEROINE'S SCHOOL.

STARTING FROM THE PULL PANEL ON THE PREVIOUS PAGE (WHO'S TALKING?), THE READER'S REACTIONS ARE, "AH, I SEE!" "OH!" AND "WOW!"

!! //

SAYAKA!

FLIP PANEL (CAPTURING ATTENTION)

UH OH

IN

IS HE THE HEROINE'S BOYFRIEND?

THE READER'S EYES FOLLOW THE DIALOGUE AND THE CHARACTER'S FACE (EYES).

TAKESHI!

CHARACTERS ALREADY INTRODUCED

DOESN'T LOOK LIKE IT.

LIKE THAT!

YOU CHEATER—

SMACK!

SO THIS IS WHO WAS SPEAKING. WHO IS HE?

TO KAI'S EYES

THERE'S NOTHING TO MISUNDER-STAND!

KAI-KUN WILL MISUNDERSTAND US!

THE FACES IN THE SPEECH BUBBLES ARE SEEN FROM KAI'S PERSPECTIVE.

HIS NAME IS TAKESHI AND HE LOOKS LIKE THIS.

WHEN WATCHING A MOVIE IN A THEATER, THE AUDIENCE CAN'T PAUSE IT OR REWIND. SO MOST MOVIES ARE MADE IN A WAY THAT THE AUDIENCE CAN FOLLOW SIMPLY BY WATCHING. MANGA ARE MADE WITH THAT SAME GOAL IN MIND.

MOTION AND TIME

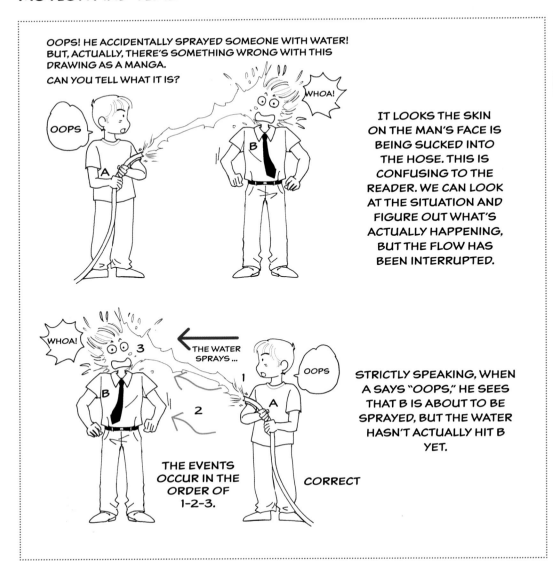

OOPS! HE ACCIDENTALLY SPRAYED SOMEONE WITH WATER! BUT, ACTUALLY, THERE'S SOMETHING WRONG WITH THIS DRAWING AS A MANGA. CAN YOU TELL WHAT IT IS?

OOPS

WHOA!

A

B

IT LOOKS THE SKIN ON THE MAN'S FACE IS BEING SUCKED INTO THE HOSE. THIS IS CONFUSING TO THE READER. WE CAN LOOK AT THE SITUATION AND FIGURE OUT WHAT'S ACTUALLY HAPPENING, BUT THE FLOW HAS BEEN INTERRUPTED.

WHOA!

3

THE WATER SPRAYS ...

1

OOPS

2

B

A

THE EVENTS OCCUR IN THE ORDER OF 1-2-3.

CORRECT

STRICTLY SPEAKING, WHEN A SAYS "OOPS," HE SEES THAT B IS ABOUT TO BE SPRAYED, BUT THE WATER HASN'T ACTUALLY HIT B YET.

SO IT'S LIKE WATCHING A MOVIE IN REVERSE?

THAT'S RIGHT. MANGA MOVES!

2 FOLLOWS 1 AND 3 FOLLOWS 2. THE INDIVIDUAL PANELS, SEPARATED BY BORDER LINES, BELONG TO DIFFERENT POINTS IN TIME.

BUT THIS IS ALSO TRUE OF SINGLE PANELS. REMEMBER THAT TIME FLOWS IRREVERSIBLY WITHIN EACH PANEL!

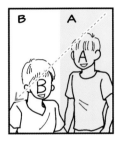

POINT B IS SLIGHTLY IN THE FUTURE COMPARED TO POINT A.

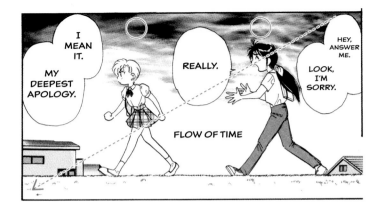

THE BOY'S SPEECH BUBBLES ARE POSITIONED INTENTIONALLY. TIME EXISTS WITHIN THE PANEL, SO BASED ON THE DISTANCE BETWEEN THE SPEECH BALLOONS, THE READER CAN SEE THAT THE WORDS ARE SPOKEN INTERMITTENTLY, WITH THE GIRL'S SILENCE FILLING EACH GAP.

The manga below is read in the American style, from left to right. In this scene, the demon character is holding the heroine and jumps high into the sky. The reader's eyes move from left to right (in a regular manga, this would be right to left) and top to bottom, so they first see the demon, who is in mid-air, and then their eyes move downward and see how high he has jumped. However, that alone doesn't create a sense of movement.

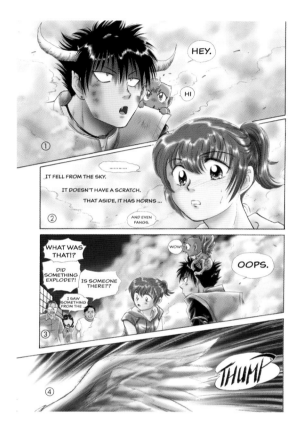
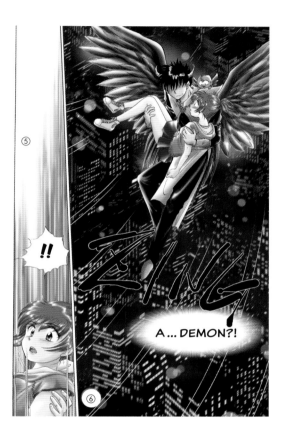

SO:

1. CLOSE-UP OF THE DEMON. The camera shows the heroine's perspective, and through the heroine's eyes, the reader's eyes meet with the demon's.

2. CLOSE-UP OF THE HEROINE. This shows the demon's perspective, and the heroine's large eyes draw the reader in to make them relate to her.

3. THE CAMERA PULLS BACK, showing the reader the overall view. Passersby speak, the heroine hears them, and the demon says, "Oops." All in a single panel.

4. A WING APPEARS FROM THE DEMON'S SHOULDER! Along with the stylized SFX, the angle of the speed lines and the direction of the wing all draw the reader's eyes toward the heroine at the bottom of the first panel on the opposite page.

5. THE VERTICALLY LONG PANEL, THE BLANK SPACE AT THE TOP, AND THE SPEED LINES flowing downward are all meant to guide the reader's eyes toward the bottom of panel 5 instead of panel 6 on the right.

6. THE LINE OF FLOW GOES DIAGONALLY UPWARD FROM THE HEROINE'S EYES IN PANEL 5. The large, striking drawn letters and the speech bubble with the bright flash pull the reader's eyes downward and then guide them upward with the character's movement. In this case, a low angle would create a more exciting feeling of rising up into the sky, but I wanted to show the building lights to emphasize the height, so I used this angle instead.

EMOTIONS AND LOGIC

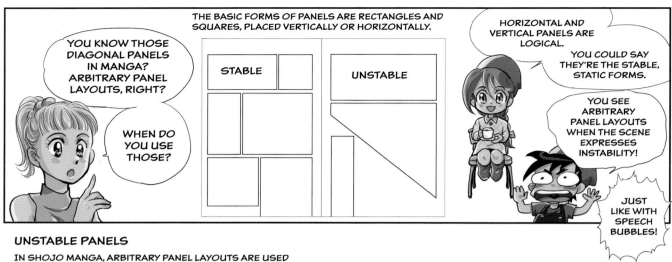

UNSTABLE PANELS

IN SHOJO MANGA, ARBITRARY PANEL LAYOUTS ARE USED FOR EMOTIONALLY CHARGED SCENES. THIS IS BECAUSE THE EXPRESSION OF EMOTIONS IS PRIORITIZED OVER THE GRAMMAR AND LOGIC OF PANEL LAYOUTS. WHEN IT COMES TO EXPRESSING EMOTION IN SHOJO MANGA, ANYTHING GOES.

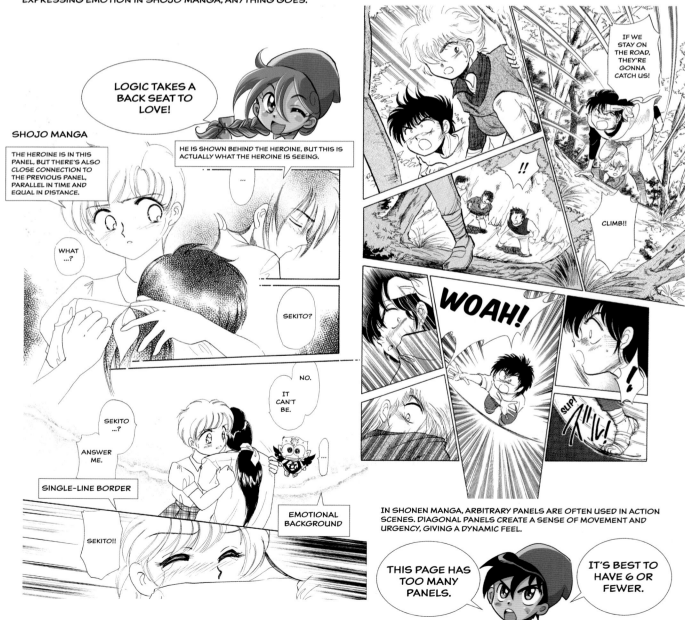

STABLE PANELS

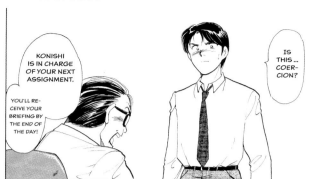

KONISHI IS IN CHARGE OF YOUR NEXT ASSIGNMENT.

YOU'LL RECEIVE YOUR BRIEFING BY THE END OF THE DAY!

IS THIS... COERCION?

FOR REALISTIC OR LOGICAL SCENES, BASIC VERTICAL AND HORIZONTAL PANELS ARE USED. THIS IS ANALOGOUS TO SOMEONE WHO HAS THEIR FEET FIRMLY ON THE GROUND. IN OTHER WORDS, THIS IS THE "NORMAL STATE." (NATURALLY, IN BOTH SHOJO MANGA AND SHONEN MANGA, ORDINARY SCENES ARE DEPICTED USING BASIC PANEL LAYOUTS.)

OTHER PANEL TYPES

REMEMBER THAT YOU HAVE TO ESTABLISH STABILITY FIRST FOR THERE TO BE AN EMOTIONAL EFFECT WHEN YOU USE AN UNSTABLE FORMAT.

IF ALL OF YOUR PANELS HAVE AN ARBITRARY LAYOUT, IT WILL BE MEANINGLESS!

HEY, NOGAMI...

THESE GUYS ARE BIG... TOO BIG.

NO, NOT DIRECTLY FROM HIM.

BUT I HAVE A LONG CAREER IN THIS FIELD, SO...

MR. KONISHI...

THE HEAD EDITOR TOLD YOU THAT?

THEY... PUT THE PRESSURE ON US.

THIS SORT OF THE THING IS THE FIRST TIME AS FAR AS I CAN TELL.

I PUT TWO AND TWO TOGETHER AND... YOU KNOW THE REST.

I HAVE A LOT OF CONNECTIONS AND MANY REPORTER COLLEAGUES.

EXPRESSING A FLASHBACK

PANEL LAYOUTS LIKE THIS ARE CONFUSING, BUT YOU CAN USE THEM WHEN THE PANELS DON'T NEED TO BE READ IN ANY PARTICULAR ORDER, OR WHEN YOU WANT TO PRESENT IMAGES RANDOMLY.

ALL PANELS OTHER THAN THE GOTHIC LOLITA VAMPIRE (③) ARE THE SAME DISTANCE FROM THE HEROINE IN THE CENTER. MANY IMAGES ARE MOVING IN TOWARD THE MIDDLE AT THE SAME TIME, SO THE ORDER IS NOT IMPORTANT.

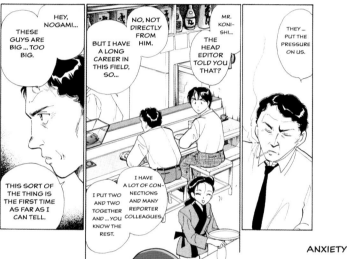

ANXIETY

THE DIAGONAL LAYOUT ENHANCES THE SENSE OF ANXIETY.

A SHOT OF THE TWO PROTAGONIST CHILDREN (CONFRONTING A SUSPICIOUS-LOOKING ADULT) IN A NORMAL PANEL.

A SHOT SHOWING THE CHILDREN'S VIEW OF THE ADULT. HE'S SMALL, BUT THE ABSENCE OF BACKGROUND IMPLIES THAT THE VIEWER (THE CHILDREN) IS FOCUSED ON THIS ADULT.

SHOT OF ONE OF THE BOYS. THE SOLID BLACK BACKGROUND REFLECTS THE BOY'S STATE OF MIND, INSTEAD OF THE VIEW FROM THE ADULT'S PERSPECTIVE. ALSO, THE BOY SENSES SOMETHING DERANGED ABOUT THIS ADULT, AND THE SOLID BLACK BACKGROUND EXPRESSES THAT. THE DIAGONAL BORDER LINES EMPHASIZE THE ADULT'S INSANITY AND THE CHILDREN'S ANXIETY.

THE BOYS GROW SMALLER AND SMALLER, AND THE MAN'S CRAZED EYES GET BIGGER. AND THEN ...

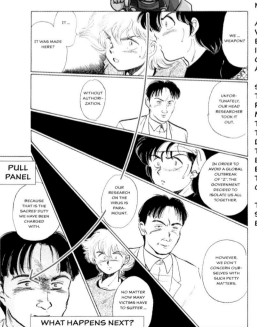

IT... IT WAS MADE HERE?

WE... WEAPON?

WITHOUT AUTHORIZATION.

UNFORTUNATELY, OUR HEAD RESEARCHER TOOK IT OUT.

IN ORDER TO AVOID A GLOBAL OUTBREAK OF "Z", THE GOVERNMENT DECIDED TO ISOLATE US ALL TOGETHER.

OUR RESEARCH ON THE VIRUS IS PARAMOUNT.

HOWEVER, WE DON'T CONCERN OURSELVES WITH SUCH PETTY MATTERS.

PULL PANEL

BECAUSE THAT IS THE SACRED DUTY WE HAVE BEEN CHARGED WITH.

NO MATTER HOW MANY VICTIMS HAVE TO SUFFER...

WHAT HAPPENS NEXT?

LAST NIGHT—?

YOU KNOW HOW WHEN SOMETHING SHOCKING HAPPENS, IT FEELS LIKE THE GROUND BENEATH YOU BECOMES SOFT AND MUSHY?

THAT'S WHAT IT'S LIKE!

SUBJECTIVITY AND OBJECTIVITY

CAMERA AND LINE OF VISION

TO EXPLAIN A GIVEN SITUATION, START FROM A LONG SHOT AND THEN USE THE CHARACTER'S EYES, THIRD PERSONS' EYES, AND NON-HUMAN EYES TO TELL THE STORY. PAY ATTENTION TO THE MOVEMENT OF THE CAMERA.

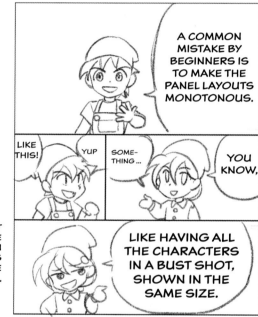

YES, IT'S IMPORTANT TO SHOW THE CHARACTERS IN DIFFERENT SIZES AND VARY THE CAMERA ANGLES.

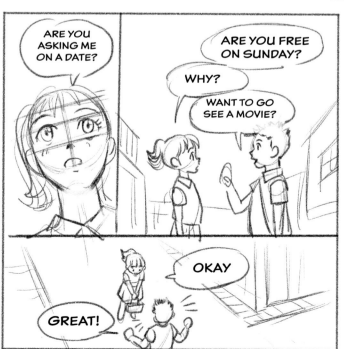

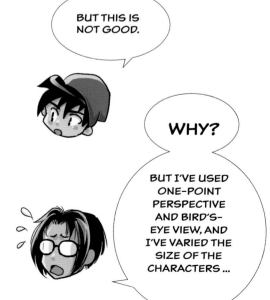

1. The characters are motionless in flat, one-point perspective view, creating a strong impression of flatness. (It would be good to create movement by making them walk, etc.) The dialogue "Want to go see a movie?" is a response to the heroine's question, so the boy's emotion should be different. That line should not be associated with the same facial expression. It goes against the passage of time, so it should be in a separate panel.

2. There's no reason to use a low angle here. The boy is excitedly awaiting the girl's response. Normally, you would show the reader the heroine's facial expression from the boy's perspective. Whose line of vision is this?

3. A bird's-eye view is the line of vision from the heavens. However, this makes the characters feel distant and harder to relate to. In this panel, the boy is relieved and overjoyed that she said yes, so his emotion should be communicated clearly for an empathetic response. The reader can't see the boy's facial expression, so they can't tell how he feels about her saying yes. This is frustrating.

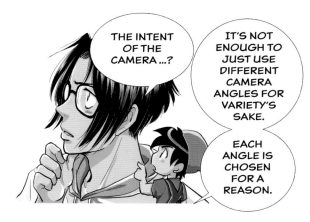

Also, the shift in camera view from the ground to the sky (in one panel) is too abrupt. You can do that in special cases where you want to create a sense of movement, but it's not suitable here.

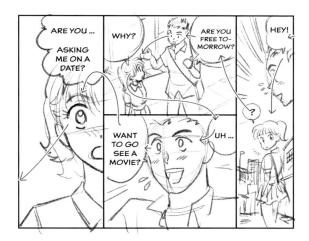

FOR EXAMPLE:

PANEL 1
The camera looks over the boy's shoulder toward the girl. It's focusing on the girl from the boy's perspective. The attention is pointed toward the heroine through the boy's eyes.

PANEL 2
The camera covers the ground and background to show the location and situation. Also, by positioning the camera low, we can follow the characters' facial expressions.

The angle and composition were determined by the overall sequence of panel. (The first and last panels were set first.)

PANEL 2 & 3
As the boy speaks to the girl, the perspective shifts to the girl's. We see a close-up of the boy from the girl's perspective. The girl sees how nervous the boy is.

The boy speaks, then the girl responds. This is where the shift to the girl's perspective happens.

PANEL 4
The girl's reaction is shown with dialogue. The inclusion of suspension points (...) suggests that the girl hesitates.

By showing only half her face, this panel emphasizes the girl's perspective rather than what the boy is seeing. The camera is not showing the girl's viewpoint, but the lead role here is the girl.

Obviously, the boy is looking at this face, but this panel is slightly different in nature from the previous ones. There's more of a nuance of expressing the girl's inner state.

THE PERSPECTIVE SHIFTS

IN THIS CASE "PERSPECTIVE" REFERS TO WHO IS TELLING THE STORY. IT DOESN'T NECESSARILY MEAN WHO IS BEHIND THE CAMERA.

FROM THE HEROINE TO THE FATHER TO THE YOUNGER BROTHER

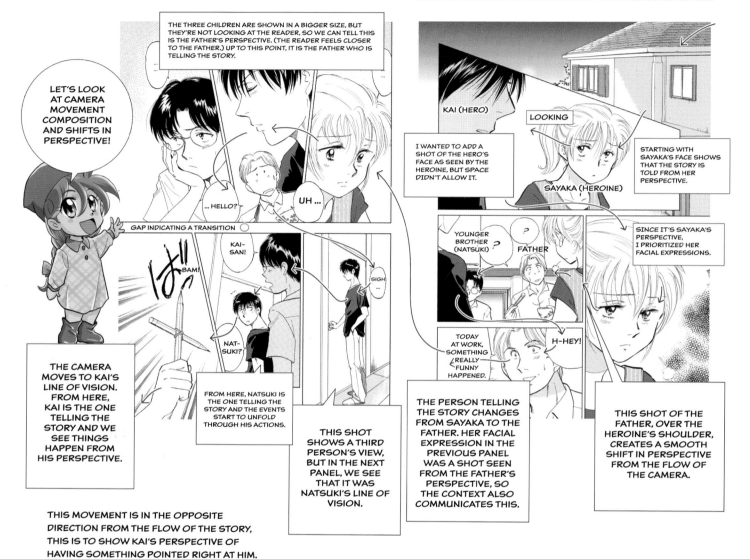

LET'S LOOK AT CAMERA MOVEMENT COMPOSITION AND SHIFTS IN PERSPECTIVE!

THE THREE CHILDREN ARE SHOWN IN A BIGGER SIZE, BUT THEY'RE NOT LOOKING AT THE READER, SO WE CAN TELL THIS IS THE FATHER'S PERSPECTIVE. (THE READER FEELS CLOSER TO THE FATHER.) UP TO THIS POINT, IT IS THE FATHER WHO IS TELLING THE STORY.

... HELLO?

UH ...

GAP INDICATING A TRANSITION

KAI-SAN!

BAM!

NAT-SUKI?

SIGH ...

THE CAMERA MOVES TO KAI'S LINE OF VISION. FROM HERE, KAI IS THE ONE TELLING THE STORY AND WE SEE THINGS HAPPEN FROM HIS PERSPECTIVE.

FROM HERE, NATSUKI IS THE ONE TELLING THE STORY AND THE EVENTS START TO UNFOLD THROUGH HIS ACTIONS.

THIS SHOT SHOWS A THIRD PERSON'S VIEW, BUT IN THE NEXT PANEL, WE SEE THAT IT WAS NATSUKI'S LINE OF VISION.

THIS MOVEMENT IS IN THE OPPOSITE DIRECTION FROM THE FLOW OF THE STORY. THIS IS TO SHOW KAI'S PERSPECTIVE OF HAVING SOMETHING POINTED RIGHT AT HIM. THE READER EXPERIENCES THE CROSS BEING THRUST TOWARD THEM, THROUGH KAI'S EYES. THIS ALSO SERVES AS A CUE THAT THE PERSPECTIVE HAS SHIFTED TO KAI'S.

KAI (HERO)

LOOKING

I WANTED TO ADD A SHOT OF THE HERO'S FACE AS SEEN BY THE HEROINE, BUT SPACE DIDN'T ALLOW IT.

SAYAKA (HEROINE)

STARTING WITH SAYAKA'S FACE SHOWS THAT THE STORY IS TOLD FROM HER PERSPECTIVE.

YOUNGER BROTHER (NATSUKI)

?

?

FATHER

SINCE IT'S SAYAKA'S PERSPECTIVE, I PRIORITIZED HER FACIAL EXPRESSIONS.

TODAY AT WORK, SOMETHING REALLY FUNNY HAPPENED.

H-HEY!

THE PERSON TELLING THE STORY CHANGES FROM SAYAKA TO THE FATHER. HER FACIAL EXPRESSION IN THE PREVIOUS PANEL WAS A SHOT SEEN FROM THE FATHER'S PERSPECTIVE, SO THE CONTEXT ALSO COMMUNICATES THIS.

THIS SHOT OF THE FATHER, OVER THE HEROINE'S SHOULDER, CREATES A SMOOTH SHIFT IN PERSPECTIVE FROM THE FLOW OF THE CAMERA.

THE INTRODUCTION is where the reader enters the story. The reader starts with an objective view but gradually empathizes with the characters and starts to identify with them. However, at the end, the reader says goodbye to the characters and returns to reality. So the subjective view shifts back to an objective one.

Therefore, it's common to use an objective long shot, such as a bird's-eye view. The bird's-eye view is particularly useful because the overall situation can be illustrated in one panel.

CHOOSE THE CAMERA ANGLE BASED ON WHAT YOU WANT TO SHOW, FROM WHOSE PERSPECTIVE, AND HOW YOU WANT TO SHOW IT!

A LONG SHOT IN A BIRD'S-EYE VIEW is useful because it can present a lot of information, but it's like a god is looking down from the heavens and the reader is able to see things that the characters have no way of knowing. There is a risk that the reader will not feel any connection to the character. That's why these shots are mostly used at the beginning and end of the story. When using this in the middle of a story, be sure to use it effectively.

THIS IS NOT THE BEGINNING OF A STORY, BUT IT'S AN EXAMPLE OF USING A BIRD'S-EYE VIEW AT THE BEGINNING OF AN EPISODE.

DAY ONE AT THE BEACH

IT'S AN OBJECTIVE SHOT, SO I INCLUDED A FULL-BODY SHOT OF THE HEROINE OVER MULTIPLE PANELS. THIS LETS THE READER DEVELOP A SUBJECTIVE VIEW RIGHT AWAY.

ARE YOU WEARING THAT?

THE READER'S EYES ARE DRAWN TO THE HEROINE ... AND THEY START TO FOLLOW THE HEROINE AND THE STORY.

? COME HERE FOR A SEC. HI, RIKA. ? MIZUKI.

THE HEROINE'S LINE OF VISION. THIS CHARACTER, RIKA, IS GAZING RIGHT AT THE READER THROUGH THE HEROINE'S EYES.

ARE YOU AND SEKITO TOGETHER OR SOMETHING?

Even when the angle is from above, if the camera is near and the character's facial expression is visible, the reader feels close to the character and can relate to them.

END OF THE CHAPTER

I CAN PROVE IT!

WHATEVER HAPPENS ...

I WILL BE A STRONG SURVIVOR!!

THIS IS A BIRD'S-EYE VIEW, BUT THE FOCUS LINES DRAW THE READER'S EYES TO THE PROTAGONIST, AND BY SEEING HIS INTENSE FACIAL EXPRESSION, THE READER STARTS TO EMPATHIZE WITH HIM. ALSO, THE DOWNWARD-LOOKING COMPOSITION EMPHASIZES HOW SMALL AND WEAK THE BOY IS. IT MAKES HIM SEEM FUTILE AND DESPERATE AS HE ANGRILY YELLS "STRONG SURVIVOR!"

VARIOUS TECHNIQUES OF EXPRESSION

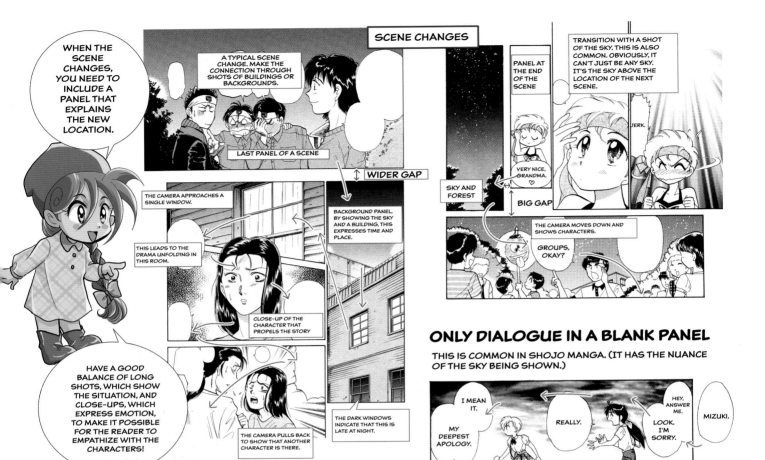

WHEN THE SCENE CHANGES, YOU NEED TO INCLUDE A PANEL THAT EXPLAINS THE NEW LOCATION.

SCENE CHANGES

A TYPICAL SCENE CHANGE. MAKE THE CONNECTION THROUGH SHOTS OF BUILDINGS OR BACKGROUNDS.

LAST PANEL OF A SCENE

WIDER GAP

TRANSITION WITH A SHOT OF THE SKY. THIS IS ALSO COMMON. OBVIOUSLY, IT CAN'T JUST BE ANY SKY. IT'S THE SKY ABOVE THE LOCATION OF THE NEXT SCENE.

PANEL AT THE END OF THE SCENE

JERK.

VERY NICE, GRANDMA. ♡

SKY AND FOREST

BIG GAP

THE CAMERA APPROACHES A SINGLE WINDOW.

THIS LEADS TO THE DRAMA UNFOLDING IN THIS ROOM.

BACKGROUND PANEL. BY SHOWING THE SKY AND A BUILDING, THIS EXPRESSES TIME AND PLACE.

THE CAMERA MOVES DOWN AND SHOWS CHARACTERS.

GROUPS, OKAY?

CLOSE-UP OF THE CHARACTER THAT PROPELS THE STORY

HAVE A GOOD BALANCE OF LONG SHOTS, WHICH SHOW THE SITUATION, AND CLOSE-UPS, WHICH EXPRESS EMOTION, TO MAKE IT POSSIBLE FOR THE READER TO EMPATHIZE WITH THE CHARACTERS!

THE CAMERA PULLS BACK TO SHOW THAT ANOTHER CHARACTER IS THERE.

THE DARK WINDOWS INDICATE THAT THIS IS LATE AT NIGHT.

ONLY DIALOGUE IN A BLANK PANEL

THIS IS COMMON IN SHOJO MANGA. (IT HAS THE NUANCE OF THE SKY BEING SHOWN.)

I MEAN IT.

MY DEEPEST APOLOGY.

REALLY.

HEY, ANSWER ME.

LOOK. I'M SORRY.

MIZUKI.

IT'S LIKE HEARING A VOICE FIRST, BEFORE ANYTHING IS VISIBLE.

THIS LONG SHOT OF THE MAIN CHARACTERS SHOWS THE TIME, PLACE, AND THE RELATIONSHIP BETWEEN THE TWO AT THIS MOMENT. THE READER IS AT AN EQUAL DISTANCE FROM BOTH CHARACTERS, SO IT'S HARDER TO EMPATHIZE WITH EITHER OF THEM. IN THIS SENSE, IT'S SIMILAR TO A BIRD'S-EYE VIEW. IN THIS PANEL, THE READER IS LIKELY TO BE IN THE MIDDLE BETWEEN OBJECTIVITY AND SUBJECTIVITY.

BLANK PANEL

STARTING FROM A SHOT OF THE SCHOOL WOULD WORK FINE, BUT I INSERTED A PANEL TO ESTABLISH A BREAK FROM THE PAGE ON THE RIGHT. THIS CAN ALSO BE DONE WITH A SOLID BLACK PANEL, A PANEL WITH GRADATION, A COMPLETELY BLANK PANEL, AND MANY OTHER TYPES.

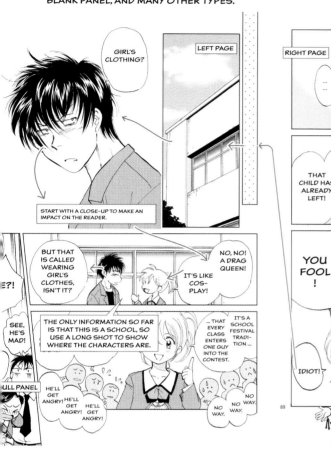

GIRL'S CLOTHING?

LEFT PAGE

START WITH A CLOSE-UP TO MAKE AN IMPACT ON THE READER.

BUT THAT IS CALLED WEARING GIRL'S CLOTHES, ISN'T IT?

...E?!

NO, NO! A DRAG QUEEN!

IT'S LIKE COS-PLAY!

SEE, HE'S MAD!

THE ONLY INFORMATION SO FAR IS THAT THIS IS A SCHOOL, SO USE A LONG SHOT TO SHOW WHERE THE CHARACTERS ARE.

... THAT EVERY CLASS ENTERS ONE GUY INTO THE CONTEST.

IT'S A SCHOOL FESTIVAL TRADI-TION ...

PULL PANEL

HE'LL GET ANGRY! HE'LL GET ANGRY!

HE'LL GET ANGRY!

NO WAY.

NO WAY.

NO WAY.

RIGHT PAGE

...

...

THAT CHILD HAS ALREADY LEFT!

YOU FOOL !

IDIOT!

89

WORKING IN REVERSE

STARTING WITH A *CLOSE-UP* OF A CHARACTER

YOU CAN USE THIS WHEN THE LOCATION OF THE CHARACTER HAS ALREADY BEEN INTRODUCED AND THE READER CAN UNDERSTAND WITHOUT SEEING THE EXTERIOR OF THE BUILDING, ETC. BY SHOWING A CLOSE-UP OF A STRIKING FACIAL EXPRESSION, YOU CAN CAPTURE THE READER'S ATTENTION AND CREATE A STRONG CONNECTION.

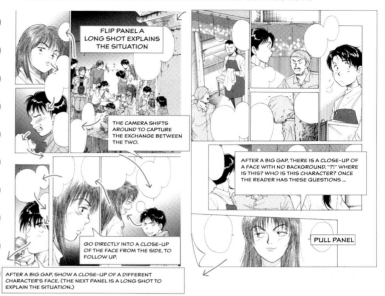

FLIP PANEL A LONG SHOT EXPLAINS THE SITUATION

THE CAMERA SHIFTS AROUND TO CAPTURE THE EXCHANGE BETWEEN THE TWO.

GO DIRECTLY INTO A CLOSE-UP OF THE FACE FROM THE SIDE, TO FOLLOW UP.

AFTER A BIG GAP, SHOW A CLOSE-UP OF A DIFFERENT CHARACTER'S FACE. (THE NEXT PANEL IS A LONG SHOT TO EXPLAIN THE SITUATION.)

AFTER A BIG GAP, THERE IS A CLOSE-UP OF A FACE WITH NO BACKGROUND. "?!" WHERE IS THIS? WHO IS THIS CHARACTER? ONCE THE READER HAS THESE QUESTIONS ...

PULL PANEL

DO NOT INSERT AN EXTERIOR SHOT OF A BUILDING AFTER THE CLOSE-UP OF A CHARACTER. THAT WOULD RUIN ANY EMOTIONAL CONNECTION THE READER FELT FROM SEEING THE CLOSE-UP. SHOW THE EXTERIOR OF THE BUILDING, FOLLOWED BY THE CLOSE-UP OF THE CHARACTER, FOLLOWED BY A LONG SHOT INCLUDING THE CHARACTER, AS SHOWN IN THE EXAMPLE ON THE LEFT.

PASSAGE OF TIME

IN THIS CASE, THE WOMAN THOUGHT THE MAN WOULD SAY SOMETHING, SO SHE WAITED FOR THREE PANELS' WORTH OF TIME, BUT THERE WAS ONLY SILENCE. EVEN WITHOUT THE PANEL SEPARATION, THE INTENT WOULD BE CLEAR FROM THE HORIZONTALLY LONG COMPOSITION, BUT THE SEPARATE PANELS CREATE THE IMPRESSION THAT AN EVEN LONGER TIME PASSED.

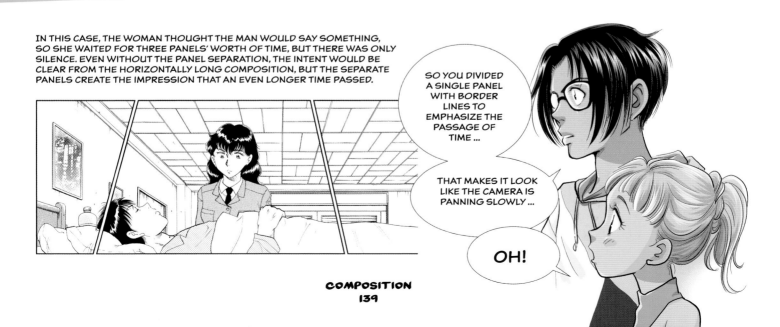

SO YOU DIVIDED A SINGLE PANEL WITH BORDER LINES TO EMPHASIZE THE PASSAGE OF TIME ...

THAT MAKES IT LOOK LIKE THE CAMERA IS PANNING SLOWLY ...

OH!

GRADATION EXPRESSES THE SUBJECTIVE LENGTH OF TIME THROUGH THE CHANGES IN TONE. IN THIS CASE, IT IS ALSO LINKED TO THE SITUATION OF THE CHARACTER LOSING CONSCIOUSNESS.

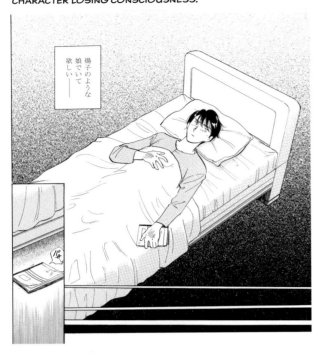

場子のような娘でいて欲しい——

HORIZONTAL MOVEMENT IS STRONGER (HENCE SHORTER GUTTERS BETWEEN HORIZONTALLY ADJACENT PANELS, SO SPLITTING A PANEL HORIZONTALLY CREATES AN IMPRESSION OF A RELATIVELY SHORTER PERIOD OF TIME.

—"GOODBYE"—

I ...

I ...

I LOVE

YOU ...!

BY DIVIDING THE SPEECH BUBBLES, THE CADENCE OF THE WORDS AND THE HEIGHTENED EMOTION IS EXPRESSED. THE ADDITION OF THE BORDER LINES FURTHER EMPHASIZES THE PASSAGE OF TIME BETWEEN THE WORDS.

BY THE WAY ...

I MADE THIS MANGA IN FULL COLOR, NOZOMI, IN THE AMERICAN COMIC STYLE OF READING LEFT TO RIGHT, AT THE REQUEST OF A CERTAIN COMPANY.

I ACCEPTED THE JOB WITHOUT MUCH THOUGHT AND I ENDED UP GOING THROUGH HELL BECAUSE OF IT.

I DIDN'T REALIZE THIS UNTIL I ACTUALLY DID THE PANEL LAYOUTS, BUT WHEN USING HORIZONTAL TEXT, IT IS VERY DIFFICULT TO GUIDE THE READER'S EYES WITH STANDARD MANGA TECHNIQUES.

THE READER'S EYES WOULD READ THE SPEECH BUBBLE AND THEN NATURALLY FLOW ON TO THE OPPOSITE PAGE ... LIKE THIS:

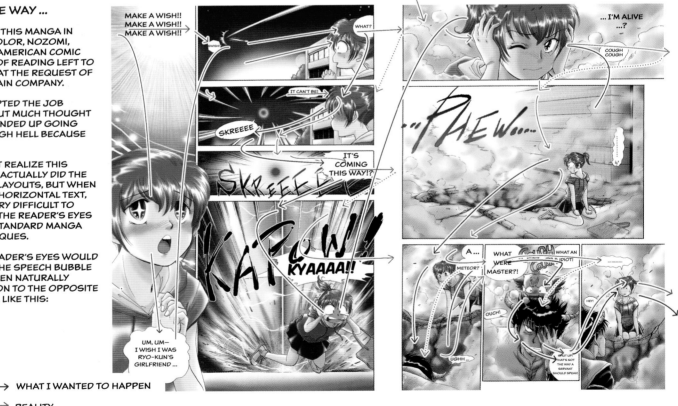

⟶ WHAT I WANTED TO HAPPEN

⟶ REALITY

I LEARNED A LOT FROM IT, BUT IT WAS REALLY TOUGH ...

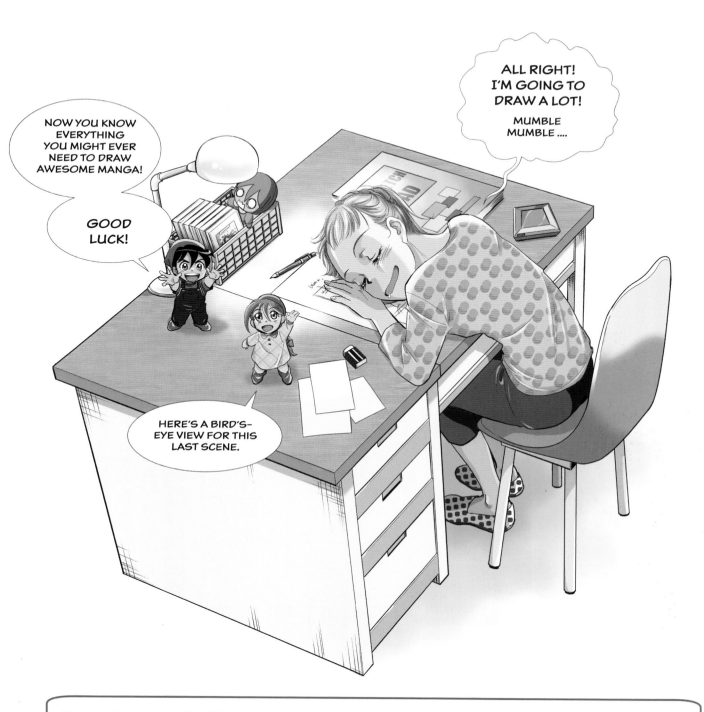

The techniques I introduced here are just a small sample. There are many different styles and genres in manga, and there are subtle differences depending on the artist.

Manga artists make lots of calculations as they compose their art. Obviously, not every piece is a success. If something is hard to understand or difficult to read, that means it was a failure. But instead of just being disappointed that you bought a boring manga, it's good practice to figure out why it failed. Think about how you would do it differently. You can do this when you read a good manga, too!

Most readers just read and enjoy without thinking about this, but now that you know the ins and outs of making manga, you may be able to pick up on the various creative measures used by the artist.

I hope you read lots of manga and keep learning!

GLOSSARY

ARBITRARY PANEL LAYOUTS: panels that have anything other than the standard vertical or horizontal border lines. They can be diagonal, the gutters can be omitted, or they can have no border lines. Dynamic panels typically used in Shojo manga to express emotionally charged scenes.

ATARI: guidelines

BEAT SHEET: a method of breaking the story down by scene to think about the sequence and rearrange the flow; also known as Hakogaki

BIRD'S-EYE VIEW: line of vision from the heavens, looking down from above; often used to emphasize a character's sense of isolation and let the reader know things that the characters have no way of finding out. Mostly used at the beginning and end of the story.

BLANK PANEL: a panel that acts as a transition between scenes or as a break between pages

BLEED: the area on a page beyond the trim size that is cut off when the book is trimmed and bound

FLOW OF ART: visual guidance to help the reader follow the story and art on the page

FUKIDASHI: speech bubbles

GRADATION: a gradual change from light to dark; it can be used to imply a change in emotions, to indicate a reminiscing back in time, or, conversely, to isolate the character from time and give a sense that time has stopped

HAKOGAKI: a beat sheet (*see* Beat Sheet)

IRI: when drawing with a dip pen, it is the beginning of the line, or entry. To create a thick "iri," one must apply pressure (*see* Nuki)

INNER BORDER: on a page, the basic frame for drawings; no matter the trim size, any content within the inner border will be printed

KAKEAMI: cross-hatching

KI SHO TEN KETSU: the four parts of a story; KI = Introduction, Sho = Development, TEN = Twist, KETSU = Conclusion

LONG SHOT: line of vision from afar to show the full situation or scene

MANPU: symbols typically expressing emotions

MEKURI GOMA: the first panel seen after turning the page; also known as flip panel

NEMU: (1) the storyboard; (2) the text in speech bubbles (name)

NODO: inside border/margin of a manga manuscript page; gutter; where the book will be bound

NUKI: (1) when drawing with a dip pen, it is the end of the line, where it thins and disappears, or release (*see* "Iri"); (2) applying white-out to the edges of the lines that overlap a character

OTAKU: someone with hobby-related interests that might be regarded as obsessive

OUTER BORDER: the final measurements of a page; also known as trim size or tachikiri

PERSPECTIVE: who is telling the story; not necessarily who is behind the camera

PSYCHOLOGICAL BACKGROUNDS: detailed backgrounds that help express a character's psychological state and the mood of a given situation, such as lightning bolts, flowers, and flames

PULL PANEL: the last panel seen before turning the page

SCREENTONE: preprinted patterns that can be applied to manga pages to create different effects, such as shading, texture, and cross-hatching

SEINEN MANGA: manga genre targeted toward young adult men

SFX: symbols or drawn words that represent sound effects

SHIRO NUKI: applying white-out to the edges of lines that overlap a character; also known as Nuki

SHOJO MANGA: manga genre targeted toward teenage girls

SHONEN MANGA: manga genre targeted toward teenage boys

SPEECH BUBBLES: space reserved for dialogue; also called fukidashi

> **BETA FLASH/WHITE FLASH TYPE:** typically acts as a silent scream generated by a strong emotional response
>
> **BOX TYPE:** typically used for monologues and narration
>
> **BUBBLE TYPE:** used when the character is talking to themselves
>
> **FLUFFY TYPE:** represents a warm, fuzzy feeling

TACHIIRI: drawing up to the trim area of a page

TACHIKIRI: trim size of a page

TERI-BETA (SHINY FILLING): a method of expressing hair flow by using a calligraphy pen or the like to show glossiness or highlights

ACKNOWLEDGMENTS

MARYANN HALL:
Thank you for approaching me to create this book. I'm grateful for your support and for always accepting my ideas! This all started with that one email.

IYASU NAGATA:
Thank you for translating my Japanese and answering my questions and my requests with great patience. It is not easy to explain manga skills, even in my mother tongue Japanese, but because of you, it's delivered very well in English!

MY FRIENDS, MARK AND FAITH:
Thanks for your feedback. Your opinions about what you expect from a manga how-to book gave me many ideas!

MY CATS, KURO AND MEI:
Thanks for bothering me, interrupting me, and making me laugh! You are so cute and fun. I'm sorry that I could only draw one of you (Kuro) on my head!

ABOUT THE AUTHOR

NAO YAZAWA is a Japanese manga artist born in Tokyo. She taught herself how to draw manga.

Nao won Shogakukan's rookie competition in 1987 and made her debut in *CoroCoro Comic* magazine in 1988 drawing Shonen manga. Later, she moved to *PyonPyon* magazine and changed her target audience from young boys (Shonen) to girls (Syojyo).

Her most notable series is *Wedding Peach* (1994–1996), a graphic novel which was later made into an anime TV show. Because of *Wedding Peach*, Nao received invitations from manga/anime conventions to hold manga workshops in the United States and Europe.

Her self-published, post-apocalyptic *Shinku-Chitai* (The Isolated Zone) adult Seinen manga was picked up by the German magazine *Manga Power* and released in France as a paperback.

Nao currently teaches manga to English-speaking learners at Manga School Nakano in Tokyo.

INDEX

Adults, 71
Age(s), 40–41, 70–71
Anger, expression of, 46, 47, 51, 85
Arbitrary panel layout, 128, 132
Atari (guidelines), 26–27, 29, 56, 57, 62, 67

Babies, 40, 67
Background, 98–115
Beat sheet (hakogaki), 125
Beta (painting black part), 15, 36
Beta flash, 108, 115
Bird's-eye view, 74, 75, 77, 85, 137
Blank panels, 138, 139
Bleed, 126
Body, 55–93
Body axis, 62, 77
Border lines, 126, 128, 139, 140
Box type, 114
Boys, 32, 34, 35, 60–61, 63, 65
Braids, 97
Brushes and brush pen, 15
Bubble type, 114

Center of gravity line, 62, 63
Character inking, 13, 14
Character variations, 93
Chibi characters and style, 29, 40, 49, 57, 60, 65, 68, 71
Children, 40, 70, 71
Cinematic methods, 23
Clenched fists, 84, 85
Close-ups, 22, 23, 131, 138, 139
Clothing, 86–89
Composition, 116–140
Concentrated line work/dots, 107, 108, 109, 110
Conclusion of story, 122–124
Cross hatching, 97
Cross-legged characters, 83

Deductive method, 120
Desk mat, 108
Development of the story, 122–124
Diagonal layout, 132, 133
Dip pen, 96, 107, 109
Double focus lines, 108
Downward, face looking, 33, 35
Downward-looking composition, 131, 137
Drawn letters, 112–113
Dynamic panelling, 22

Ears, 26, 31
Effect lines, 106–109
Elderly people, 41, 70
Emotions, expressing, 23, 46–51, 84–85, 132–133
Erasers, 95, 96, 107
Expression(s)
 with the body, 84–85
 cinematic method, 23
 facial, 46–53
 techniques of, 138–139
Eyebrows, 30, 32
Eyelashes, 42, 43, 44
Eyes, 26, 27–28, 30, 31, 32, 35, 41, 42–45

Faces, 25–53
Facial expressions, 46–53, 135
Fear, expression of, 85
Feet, 61, 68–69
Fineliner pen, 96, 97, 109, 114
Fingers, 66
Fists, 67. See also clenched fists
Flashbacks, 133
Flip panel, 129
Flow of the art, 127–130
Fluffy type, 115
4-panel comics, 122–124
French curve, 109
Front of the face, 26–28
Front view of the body, 58–61
Fukidashi (speech bubbles). See speech bubbles

Gekiga, 22
Girls, 32–33, 34, 58–59, 60, 64
G-pens, 14, 15, 96, 107, 114
Gradation, 16, 97, 111, 140
Guidelines (Atari), 26–27, 29, 56, 57, 62, 67
Guidelines, perspective and, 102–103

Hair, 27, 28, 35, 36–39, 97
Hakogaki, 125
Hands, 61, 65, 66–67, 78
Happiness, expression of, 46, 84
Head-to-body ratio, 58, 59, 70
Heroes/heroines, 90–92
Highlights, 42, 43, 44
History of manga, 19–23
Horizontal movement, 140
Horizontal panels, 132, 133

Ideas, writing down your, 11
Inductive method, 120
Inking, 96–97
Inner border, 126
Introduction of story, 122–123, 137
Iri, 107, 108
Iris, eye, 27, 32, 42, 43, 44

Jagged focus lines, 108
Jaw/jawbone, 27, 29, 30, 32, 35, 41
Joints, body, 56–57, 58, 76, 78, 79
Joy, expression of, 47

Kabuki, 23
Kakeami, 97
Ki Sho Ten Ketsu, 122–123, 122–124
Knees, 58, 60, 61, 62, 71

Laughter, 84
Layout, 132–133
Leaning characters, 83
Left to right, reading manga from, 131
Legs, 59, 64, 65
Letters, 112, 113
Lightbox, 95

Lines/linework, 97, 106–109, 126. See also guidelines (Atari)
Logic, 132
Long shot, 134, 137, 138, 139
Low angle, 74, 75, 77, 84

Manga
 beginning to learn, 7–13
 history of, 19–23
Manpu, 48–49
Manuscript paper, manga, 126
Map pin, 108
Maru-Pen, 15, 96, 107, 109
Materials, 13–16
Mechanical pencils, 96
Mekuri Goma (flip panel), 129
Monotone panelling, 22
Motion/movement, 23, 39, 76–79
Movies, manga coming from the, 21–23
Multiple characters, 80–81
Muscles/muscular bodies, 73, 97

Nemu (storyboard), 116, 126–130
Neutral expression, 46, 47
Nibs, 96
Nodo (inside margin), 126
Nose, 30, 31, 32, 41
Nuki, 107, 108, 109

Objective view, 137
Older characters, 41, 70
One-point perspective, 100, 101
One-shot manga, 117
Outer border, 126

Pages, number of, 117–119
Panels
 dividing a single, 139, 140
 forms of, 132
 layout, 132–133
 space between, 126
Paper, 13, 126
Patterns, 111, 113
Pencil(s), 13, 94–95
Pens, manga, 14, 15, 96, 107, 109, 114
Perspective, 14, 99–105, 136
Plot, 12, 121
Profile of the face, 29–31
Profiles, character, 90–92
Psychological effects, 110
Pull panel, 129, 133, 139
Pupil, eye, 27, 42, 44

Reverse, working in, 139
Right to left, reading manga in, 126, 128
Round objects, 104
Rulers, 15, 107, 109
Running characters, 76–77

Sadness, expression of, 46, 84, 85
Saji-pens, 14, 15, 96
Scene changes, 138

Scraping, 16
Screentone, 16, 36, 111, 126
Seinen manga, 42, 59, 61, 124
SFX (sound effects), 112–113
Shiro nuki, 107
Shoes, 69
Shojo Manga, 36, 42–43, 45, 59, 96, 114, 132, 133, 138
Shonen Manga, 38, 44–45, 124, 132, 133
Side view angle, 33, 62–63
Sitting characters, 82–83
Size of characters, 105, 134
Skeletal frame, 57, 60, 61, 73
Sound, 22, 23, 108
Sound effects (SFX), 112–113
Sparkling eyes, 42–43
Speech bubbles, 113, 114–115, 127, 130, 140
Speed lines, 106, 109
Spoon pen, 107, 109, 114
"Stars in the eyes," 43
Storyboard, 116, 126–130
Storyboard name, 13
Subjective view, 137
Surprised expression, 46, 47

Tachiiri, 126
Tachikri, 126
Teenagers, 58–61
Teri-Beta (shiny filling), 36
Text, 112–113. See also speech bubbles
Tezuka, Osamu, 22, 23
Three-point perspective, 100
¾ view of the body, 64–65
Time, passage of, 139–140
Tone, 111
Twist in the story, 122–124
Two-point perspective, 100, 101, 102

Unstable format, 132, 133
Upward angles, 33, 35

Vanishing point, 14, 75, 99, 101, 103, 104–105
Variations, character, 93
Vertical flow, 126
Vertical lines, 49, 85
Vertical panels, 132, 133
Vertical perspective, 101
Vertical pupil, 44
Vertical vanishing point, 75, 100
Visual guidance, 131–133

White flash, 108, 115
White ink, 15, 43
White-out, 107, 108
Windows, 16, 138
Words, 112–113. See also speech bubbles
Wrinkles, in clothing, 86, 87, 89
Wrinkles, on characters, 41

Yasuhiko pose, 65
Young people, 40, 70. See also teenagers